Understanding
Your Digital Camera
Art and Techniques

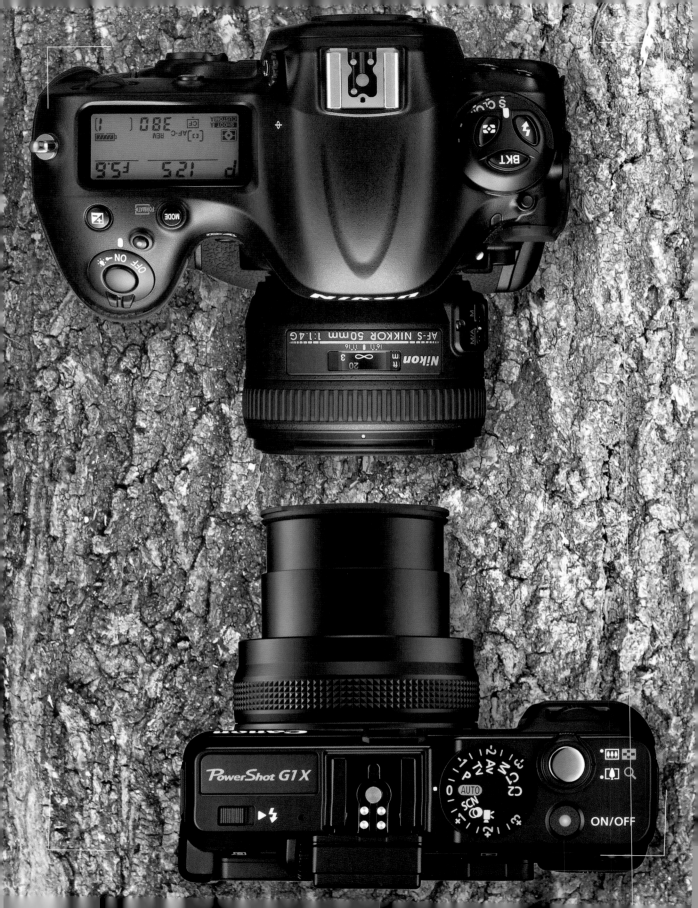

Understanding
Your Digital Camera
Art and Techniques

Tim Savage

CROWOOD

First published in 2014 by
The Crowood Press Ltd
Ramsbury, Marlborough
Wiltshire SN8 2HR

www.crowood.com

British Library Cataloguing-in-Publication Data
A catalogue record for this book is available from the British Library.

ISBN 978 1 84797 802 8

Frontispiece
Fig 1 A Nikon DSLR and Canon compact camera

Graphic design and layout by www.peggyandco.ca
Printed and bound in Malaysia by Times Offset (M) Sdn Bhd

CONTENTS

ACKNOWLEDGEMENTS

I wish to extend my sincerest thanks to everyone who has assisted in the creation of this book. This includes each and every person who posed, indulged, argued, listened or entertained my odd ideas for photographs. Specific thanks are due to Roger Buchannan and Beytan Erkmen for reading the drafts and lending me their technical expertise. Thanks to the publishers for their guidance, support and faith during the production of this book and my colleagues at UCA for their enthusiasm and support.

By far, the greatest and most humble thanks are due to my wife Kelly-Marie for her limitless patience and tolerance of my unreasonable working hours, critical proofreading, and posing for many of the photographs included within this book. Thank you also to my daughter Rose, who was born midway through the writing process. She has perched on my lap, sometimes quietly, as I've written into the small hours.

IMAGE ACKNOWLEDGMENTS

Figs 1, 3, 21, 25, 26, 27, 29, 30, 39, 45, 46, 61, 140, 234 and 329 are used courtesy of Nikon UK. Figs 1, 22, 24, 33, 49, 56, 58 used courtesy of Canon. Figs 218, 231 and 232 provided by Metz. Fig 226 from Ray Flash and Fig 31, 32 from SanDisk. Screen shots used: Fig 36, App store, Fig 37 Google Play and Fig 13 Flickr.com. Thanks to West Dean College (West Sussex) for support and location permissions (Figs 77, 79, 95, 122, 154, 156, 279, 280 and 322) and to Edward Adelson for allowing unrestricted reproduction of Figs 19 and 20. All other photographs' copyright retained by the author.

▲ Fig 2
Tim Savage (@timsavagephoto, timsavage.co.uk).

Introduction

Few areas have been more significantly affected by advances in digital technology than photography. Digital cameras have become ubiquitous and more accessible than anyone could ever have foreseen and this accessibility has led to a general increase in the practice of photography and picture-making. Ease of use does not necessarily correspond to quality, and it should not be forgotten that photography is a technical art, and that an understanding of the tools and technology is essential for anyone wishing to progress from happy snapper to master photographer.

This book does not replace the camera manual; instead, it seeks to describe and explain the core functions of digital cameras while connecting purpose to particular settings or mode. Books on digital photography tend to meander into issues of general photographic workflow. This book does not. The brief is simple: to understand the digital camera. The book assumes no prior knowledge in photography but does seek to quickly set the reader on a trajectory of deeper learning to reveal the possibilities that are afforded by skilled use of the camera.

The book begins by encouraging you to identify your own visual tastes and become aware of your own image preferences. The genius of photography is that success lies within the eye of the beholder. Having identified their own preferences, students of photography are more likely to create work in which they have confidence. My own specialism, which is frequently illustrated in this book, is portraiture. Creating images of people is one of the most challenging areas of photography. As a basis for learning about camera settings such as exposure, colour, flash, and so on, portraiture provides many useful examples that connect purpose to camera control. These techniques, once learned, may be applied to whichever genre of photography you prefer.

In order to achieve my aim, which is defined by the title of this book, a road map of photographic development is provided. The camera has been broken down into a sequence of chapters that should be read in the order in which they are presented. Techniques are introduced gradually, to expose the reader to fundamental concepts before building more advanced knowledge on a solid foundation. Certain subjects are introduced as concepts before being explained more fully in later chapters. Although the Contents list allows the reader to skip ahead for the answer to a specific question, beginners are advised to read the chapters in the correct order. In this way, it is possible to gain a reasonable understanding of each feature, and thus to acquire cumulatively a comprehensive understanding of the whole camera.

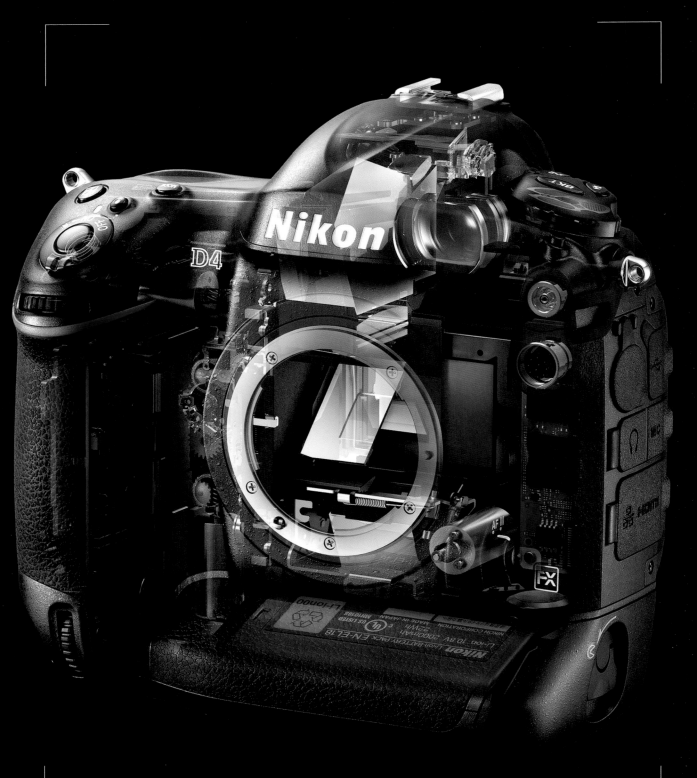

Chapter 1

Inspiration

- What makes a 'good' photograph?
- Composition and shooting tips.
- Sharing, learning and reflecting upon your own photographs.

In recent years photography has increased exponentially in popularity, with almost everyone owning a camera of some type. Whether it is a DSLR, compact, hybrid or even a mobile phone or tablet camera, digital technology continues to produce better, faster, cheaper, smaller and more feature-rich options. Indeed, few would argue against the fact that photography has become a great deal easier than it was a decade ago. In the days of film, a photographer would be required to load the film, specify the film speed, compose the scene, focus the lens, and specify the exposure using a combination of aperture (the size of the hole that admits light) and shutter speed (the length of time the hole is open) in relation to the meter reading. If using the flash, calculations would be required in relation to the distance between camera and subject. After each exposure the film would need to be wound forward manually, before eventually being rewound, removed, processed and printed, incurring both financial cost and time delays. In contrast, modern digital cameras have become so sophisticated that photographers can all but disregard exposure parameters. This flexibility and freedom allows contemporary photographers to concentrate their full attention upon the subject, timing and composition. Within seconds of the shutter firing, feedback is immediate, with an image being displayed without delay or financial cost.

Ease of production is matched by virtually limitless manipulation, duplication and sharing possibilities. Digital photographs can be instantly stylized through a range of enhancements and online tools such as Instagram. These images can then be distributed within seconds. This increase in production and sharing has led to a surge of mediocre images created by photographers using automatic camera settings combined with image-processing algorithms. In order to stand out from the crowd, the creative photographer must seek to rise above this level of mediocrity; to understand the camera and to use it as a tool to realize his or her own vision rather than accept the unexceptional results generated by automated modes.

WHAT MAKES A 'GOOD' PHOTOGRAPH?

A great camera is perfectly capable of taking a poor photograph. A picture may be sharp, well exposed and technically correct, but if it does not engage the interest of the viewer then the photographer has failed. Photography is like food or music, in the sense that an appreciation of it is largely an issue of personal preference. This lack of certainty can be disconcerting to photographers seeking a formula for success and many choose to use the reactions of others to their images as a barometer of success. This can be a useful way of receiving feedback, but the person best qualified to judge the quality of a photograph is the person who took that photograph. Gaining confidence in your own image-making is an essential aspect of becoming a photographer.

◀ Fig 3
A Digital Single-Lens Reflex camera.

◀ Fig 4
Collecting photographs is an
effective way of identifying
your own tastes and
preferences.

One effective method of defining your own personal taste is to collect photographs. Browse online and in print, magazines, newspapers and social media. Collect and store pictures that stand out. Once a few hundred images have been accumulated it is usually possible to identify some common traits. You may see trends emerging in features such as subject, lighting, focus, depth, textures and colour. For example, textures rendered in black and white could be a recurring theme, or perhaps isolated areas of focus within portraiture. Once you have identified your own personal tastes, they can be consciously applied when creating images.

COMPOSITION AND SHOOTING TIPS

Understanding personal taste is the first step towards making work that will appeal to your own preferences. For many students of photography this process begins by considering composition. Composition refers to the arrangement of the key elements within the boundaries of the photographic frame. There are numerous 'rules' and guides that can assist with geometric aids to production. For readers interested in compositional theory an online search for 'the golden section' will provide detail of the mathematical formula commonly used within the creative arts. The golden section underpins the photographer's 'rule of thirds' (*see* Chapter 3). In terms of compositional theory there are a few simple pointers that, when combined with the lessons learnt from collecting images, may help when you are seeking to improve the aesthetics of your images.

First, when framing a subject, you should be clear and bold about what the image is about. The job of the photographer is to direct the eye of the viewer.

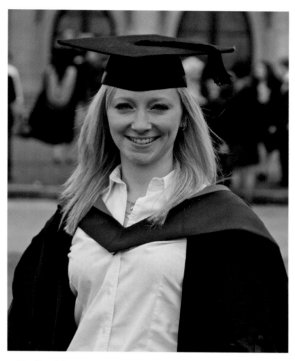

▲ Figs 5 and 6
Keeping the composition simple avoids distracting elements within the frame.

Distracting elements can draw attention away from the main subject. Simplify an image wherever possible. In the examples, Fig 5 was shot against a busy graduation background, but for Fig 6 the photographer moved closer to the model and shot from an angle that provided a less distracting background. The flash was used to lighten facial shadows and provide a 'catch light' in the eyes. These changes provide a clearly defined subject and background, and a better picture.

Having considered the way in which the viewer's eye engages with the subject, consider how, once the eye has landed within the composition, it explores out towards the boundaries of the frame. Does attention drift towards the edges or is interest focused upon a specific point? Using lines is an effective way of directing the path of the eye. In Fig 7, the lines naturally present combine with perspective to draw the eye towards the centre of the photograph into the main subject.

▲ Fig 7
Lines and contrast can be used to direct the viewer's eye within the composition.

◀ Fig 8
Lines can be combined with pattern and symmetry and to provide a sense of balance within an image.

▲ Fig 9
Adopting an unfamiliar viewpoint can give an interesting perspective.

▲ Fig 10
Opposite hues used within the same image.

Lines can also be used to define patterns, symmetry and provide a sense of balance with the photographic frame. Human perception responds positively to the symmetric placement of subjects or scenes. In Fig 8, the composition frames the axis of symmetry.

Another point to consider is the viewpoint adopted by the photographer. Most adults experience the world from a height of between five and six feet. Changing the camera's perspective through height, angle or pitch is a simple way of representing objects and environments in an unfamiliar way. Fig 9 is an image of two children playing inside a shower cubicle. By photographing them from above, the camera captures them from an interesting perspective.

Colour may also be used by a photographer to draw the eye and to create a sense of balance and visual harmony. In Fig 10, the colour relationships within the photographs are opposites in the colour

▶ **Fig 11**
A slow shutter speed can be used to convey a sense of movement.

▶ **Fig 12**
Text within photographs can alter the meaning of the image.

wheel: green is complementary to red while blue is complementary to orange. The subject of these images is not what they are of, but what they are 'about': colour.

A photograph is sometimes referred to as a frozen moment. In fact, however brief the exposure, some time passes while the light-sensitive sensor is exposed. Learning to control and convey movement at the simplest level by avoiding camera shake, or making it a feature in the photograph, helps to create a sense of moment. In Fig 11, the passing of time has been communicated to the viewer by allowing a moving subject to blur. With the camera static, the photographer dictates how movement is rendered.

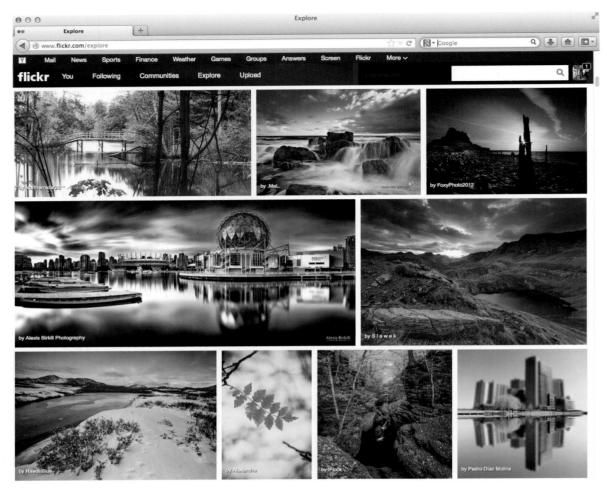

▲ Fig 13
Online photographic communities are a great way of finding
inspiration, learning technique and gaining feedback from peers on
your own images.

Photography is a mode of communication. The language of the message is frequently ambiguous and clarity is dependent as much upon the recipient as on the photographer. Text can be used within, or to accompany images as a directive tool. Through association with the picture, words provide a multi-cognitive experience that can reinforce or completely change the meaning of a photograph for its audience. Text may accompany a photograph as a caption (which is common practice in advertising and journalism), or it may be naturally present within the composition. In either case, care should be exercised because text can alter the meaning of the image. Fig 12 shows how text can assist a viewer in making sense of an image or constructing meaning.

Such simple tips are aimed simply at kick-starting the creative process, and it is through experimentation, innovation and critical reflection that the photographer's eye will be refined.

SHARING, LEARNING AND REFLECTING UPON YOUR OWN PHOTOGRAPHS

There are a number of ways of gaining effective feedback: show your photographs to your friends, exhibit your work or join a camera club. For a more robust, critical perspective on your photography, formal training or the pursuit of a qualification may be more appropriate. Online feedback is also effective and there is a vast range of forums and websites designed to connect photographers through shared interests. Some of the better known include Flickr, Pinterest, Deviant Art, Tumblr and Behance. These websites offer critique and discussion forums on the technical, theoretical and aesthetic aspects of photography.

SUMMARY

Cameras are more popular today than they have ever been, partly owing to ease of use and low costs. These factors have combined to contribute to an increased appetite for photography. The majority of images shared online and via social media are produced using a combination of automatic mode and processing algorithms, leading to a generic look. Photographers with aspirations to stand out must use the camera as a tool to realize their own ideologies for a subject or scene, rather than being content to produce more automated representations.

An awareness of image preferences can help aspiring photographers to be discerning and critical when producing their own images. Although tastes are individual, there are guides and good practices that should be observed while learning. Applying established shooting technique and compositional theories can improve the general aesthetic of photographs. Basic concepts such as keeping the composition simple and using tools such as line, shape, contrast, colour and viewpoint to direct the viewer's eye can be particularly helpful. There are many excellent resources available detailing photographic theory. True masters combine technical excellence with creativity to convey meaning beyond the appeal of the visual aesthetic.

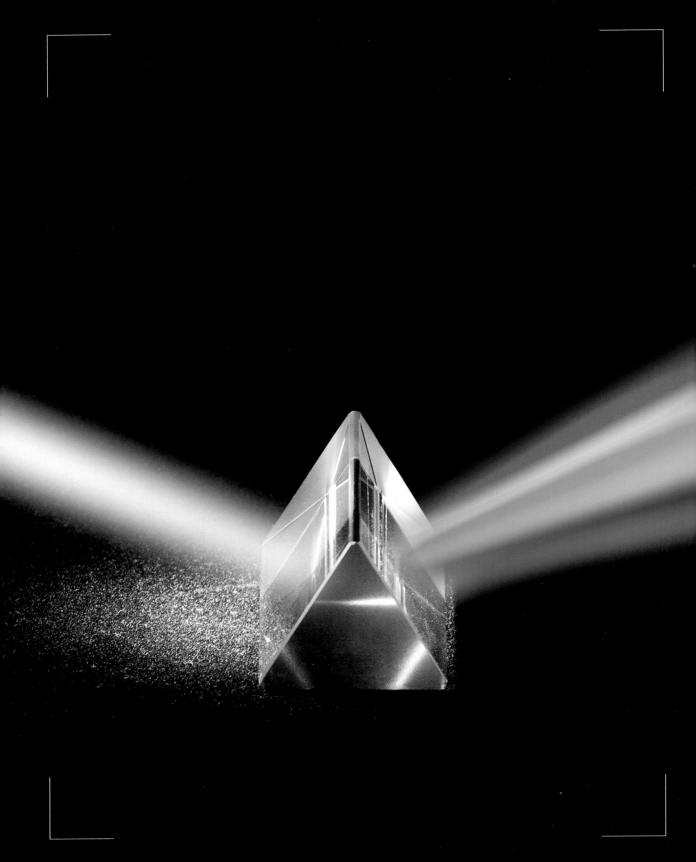

Chapter 2

Understanding Light

- What is light and why is it important to photographers?
- The behaviour of light.
- How humans perceive light.
- How cameras interpret light.

Light is the fuel of photography. An understanding of light and its properties represents an important step towards a better understanding of the camera. This chapter will briefly describe the key principles of light theory, which relate directly to camera settings introduced in later chapters.

WHAT IS LIGHT AND WHY IS IT IMPORTANT TO PHOTOGRAPHERS?

Light is fundamental to picture-making, enabling brightness and colours to be experienced. When light changes, perception of the world changes. Photographers interpret variations in light and use them to change the flavour and mood of an image. Light exists as a band of radiation located upon the electromagnetic spectrum (Fig 15). Visible light exists as a narrow range of wavelengths upon the spectrum experienced by humans as colour. Certain wavelengths fall outside the visible section, but, although invisible to the eye, both infrared and ultraviolet rays can be detected by specialist emulsions and digital sensors. It could be argued that X-rays are

in effect photographs, but, excluding nuances such as X-rays and infrared, the visual spectrum is of the greatest interest to photographers. It is represented by the colour wheel (Fig 16), which is a visualization of the longest to shortest wavelengths presented in a circular sequence.

There are two main types of colour wheel. The first (subtractive colour) is used by artists to mix pigments, dyes and paint. This wheel uses red, yellow and blue as the primary colours. The second colour wheel (additive colour) was first theorized by Sir Isaac Newton and relates to the mixing of light. Newton's wheel uses red, green and blue (RGB) as the primary colours. When mixed in equal amounts, and in sufficient quantity, RGB combined equals white. This is opposite to the artist's colour wheel, which creates black/brown.

THE BEHAVIOUR OF LIGHT

There are rules defining the behaviour of light: first, it travels in straight lines (creating shadows); and second, the speed of light slows when travelling through materials such as water or glass (including lenses; see Chapter 4). Different wavelengths (colours) of light travel at different speeds through transparent materials, as can be seen when using a prism (Fig 18). As light travels through curved glass it refracts into its component colours. Rainbows are formed by light travelling and bending through curved water droplets and dividing into individual wavelengths.

◀ Fig 14
White light may be separated into component colours using a prism.

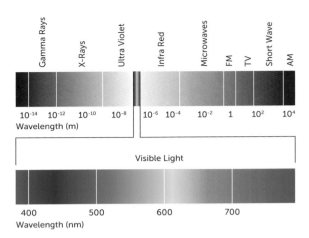

▲ Fig 15
The position of visible light on the electromagnetic spectrum.

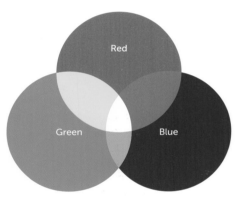

▲ Fig 17
The primary colours of red, green and blue (RGB) combine to produce secondary primaries.

▲ Fig 16
The colour wheel (used to illustrate the relationships of colours).

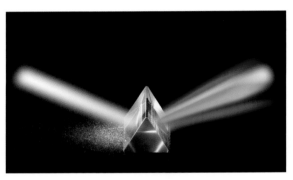

▲ Fig 18
White light can be divided into component colours by using a prism.

HOW HUMANS PERCEIVE LIGHT

Human vision and perception are easily fooled, particularly in relation to tone and colour. Optical illusions frequently expose the subjective nature of assumptions made by the human brain. One illusion designed by Edward H. Adelson gives a good demonstration of the frailties of human perception. Looking at Fig 19, most would agree that squares A and B exhibit significantly different brightness values. The human visual system is confused in this example by a number of issues: shadow is important to perception and the brain needs to establish whether a white tile in shadow is darker than a grey tile in light. To add to the confusion, the shadow has feathered soft edges against the hard tiled edges, further muddling the brain's interpretation of tone. Fig 20 demonstrates that both squares are actually identical in brightness terms. The effect is so powerful that, even when values are known, the squares still appear different to the eye.

The eye uses a combination of rods and cones to measure the levels of light admitted via the pupil.

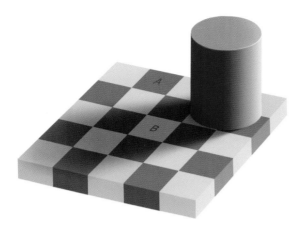

▲ Fig 19
Is A darker than B?

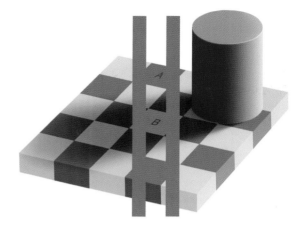

▲ Fig 20
Two bars of continuous tone prove that the squares are of the same colour and brightness.

Rods make up the majority of the light-gathering tools by dealing with brightness, whereas cones are receptive to the wavelengths of red, green and blue (the primary colours of light). The human system of vision works by detecting brightness and levels of each of these colours and converting this information in the brain into sight and colour. Adelson's Illusion proves that human vision and perception are fallible and subjective.

HOW CAMERAS INTERPRET LIGHT

The camera is similar in many ways to the eye. Light enters the camera via a small hole (usually a lens), then the digital sensor carries out a similar task to the cones in the eye, by using millions of tiny light-sensitive cavities. A key difference is that humans separate the acquisition of colour and brightness information via rods and cones, whereas cameras and computers do not. These devices can only see levels of brightness (although they are fitted with coloured

SUMMARY

This chapter has introduced basic principles of light and human perception in relation to photography. Visible light, which consists of the colours detectable by human sight, exists as part of a narrow section of the electromagnetic spectrum (represented as a colour wheel). Newton's model uses red, green and blue as primary colours, which, when overlaid in different ratios, are capable of producing any colour in the visual spectrum.

Humans perceive light and colour information in a different way from cameras. Humans see in colour whereas cameras can only record filtered brightness levels. Human vision is subjective and easily fooled while cameras are much less prone to optical confusion.

filters that enable the camera to derive colour values; *see* Chapter 17 for more on this). For this reason, the camera's perception of colour and brightness is less easily fooled by illusions such as Adelson's.

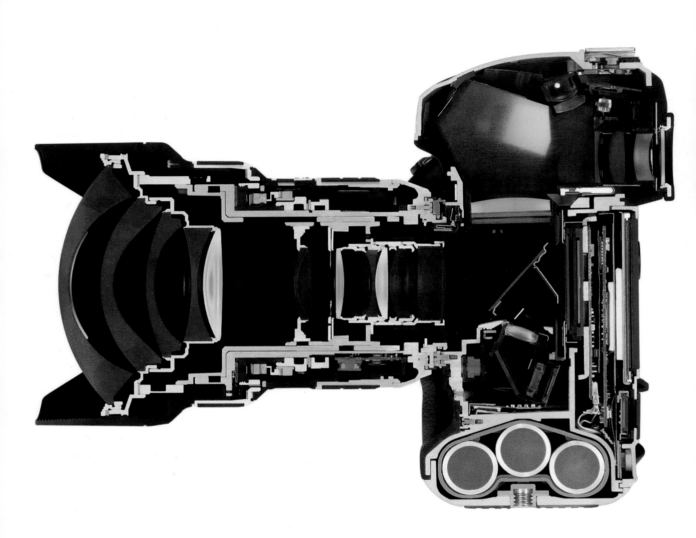

Understanding Equipment

- Choosing a camera.
- Camera types: ultra-compacts (or mobile phones); compact cameras; bridge cameras; micro four-thirds cameras; DSLR cameras.
- Entry-level DSLR versus pro specification.
- Memory cards.
- Care of the memory card: good practice.
- Connectivity.
- Camera manuals and apps.

There is a bewildering range of choice when it comes to choosing a digital camera. The most common starting point when choosing is budget, but a weighty price tag does not necessarily translate into the best equipment for a photographer's needs. This chapter begins by encouraging the photographer to assess the features that they require, before considering common formats and features of photographic equipment found on the market today.

CHOOSING A CAMERA

Many photographers have a tendency to be obsessive about a particular camera brand, and will offer enthusiastic testimony to their personal experiences of Canon, Nikon, Pentax, Olympus, Sony, and so on. However, the technology arms race has provided a reasonably level playing field. As manufacturers compete to introduce new features, the currency of a camera is now less than two years. Historically, photographers were more likely to be committed to a single brand through having a stock of lenses. In modern times, the popularity of zoom lenses has meant that photographers own fewer lenses, and it is now much cheaper and easier to migrate between manufacturers.

For photographers choosing a model without being influenced by brand preference, there is no substitute for actually handling a camera. Feeling the camera's weight while assessing ergonomics and build quality can go a long way to informing choice. The menus and interface are also important. Some smaller compacts try to cram as many features as possible into a tiny body, and this can result in an ugly design, and an overcrowded screen with too many functions buried deep in menus. One good rule of thumb is that there is no point having a feature if it takes more than five seconds to find it. The process of viewing a scene, assessing how to capture it and accessing the appropriate camera settings should be natural once practised.

In addition to feel and interface, specification is critical. Digital cameras are on the leading edge of technology, with updates and new features being launched every few months. To get the best value it is helpful to compare the specification of a range of cameras. There are many useful online tools for comparing specifications, including the website dpreview.com, which allows direct comparison of models.

◀ **Fig 21**
Cross section of a DSLR and lens.

CAMERA TYPES

Apart from brand and feel, the two most significant factors when selecting a camera are likely to be type and then price. There are five main options in terms of type:

- ultra-compact (or mobile phone);
- compact;
- bridge camera;
- mirrorless micro 4/3 (MFT) or four-thirds; and
- DSLR.

Although other formats are available and technologies continue to blur the boundaries, these types cover the majority of cameras. Before concentrating on the various types, it is helpful to consider the nature of the photography for which the camera will be used. Certain situations may have specific requirements: a hill walker may prefer an ultra-compact due to weight, portability and bag space; a studio photographer would choose a DSLR for quality; while a traveller who needs both portability and good-quality optics might choose an MFT camera. As with most things photographic, the choice of camera represents a compromise.

Ultra-Compacts (or Mobile Phones)

It is pointless owning an expensive camera if it is left at home because it is too heavy or bulky. Increased

▲ Fig 22
An ultra-compact camera (Canon IXUS 140).

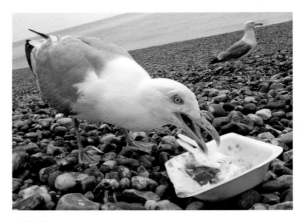

▲ Fig 23
An image captured by an iPhone. Resolution and colour are perfectly acceptable for printing up to A5 in size.

portability can be the difference between getting the shot and not getting the shot. Ultra-compact cameras (Fig 22) are designed to slip easily into pockets and bags.

Mobile phones and tablet computers also feature built-in cameras. They are seemingly ubiquitous and recent improvement in their design has meant that such cameras are genuinely capable of producing worthwhile pictures – such as when a seagull steals your chips (Fig 23)!

Mobile-phone cameras provide reasonable optics, combined with built-in image processing and instant web access. This enables a sharp, well-exposed image to be uploaded to the web and shared within seconds. The popularity of these devices is clear – indeed, the iPhone has taken over from the DSLR as the most popular camera in use on Flickr.

The main advantages of ultra-compact cameras are that they are cheap, convenient and simple to use. They are also very discreet through their size and virtually silent in operation. Sadly, the downsides of these tools are very significant. There is a heavy price to pay for portability in terms of pretty much everything else. The lens optics are soft and lack contrast, there is a shutter lag (time delay between pressing the shutter and the picture being taken), and the user has minimal control over

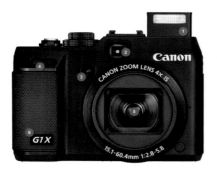
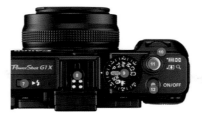

▲ Fig 24
The anatomy of a compact camera (Canon G1X).

the exposure. The camera is unlikely to provide an option to change the shutter speed or aperture. Also, there are no moving elements in the lens, meaning that the zoom function is digital rather than optical – the pixels increase in size to create an illusion of zooming, which degrades image quality.

Compact Cameras

Compared with phones and smaller equivalents, compact cameras feature higher-quality lens optics, increased resolution (more pixels), higher bit depth (more colours) and a more powerful built-in flash. At the top end of the compact market, cameras include many features and specifications that would be comparable with those on an entry-level DSLR. Perceived drawbacks of compact cameras relate mainly to the inherent compromise between size and quality. They are larger than phones (making them less portable), yet do not provide the quality of a DSLR. For many users this compromise presents the best of both worlds.

Compact cameras frequently use a digital viewfinder or separate optical viewfinder. The disadvantage of a digital viewfinder is that it can be hard to see in bright light and be misleading in regard to brightness and colour. An optical viewfinder is easier to see through but it introduces 'parallax error' – in other words, the camera records the picture through the lens, while the same picture is composed by the photographer through the optical viewfinder, which

is an inch or so away from the lens. This is like composing an image with the right eye and photographing it with the left. This can easily result in framing mishaps, particularly when shooting close up.

The anatomy of a typical compact camera (Canon G1X) is annotated in Fig 24.

1 Pop-up flash
2 Optical viewfinder
3 AF illuminator light/self-timer lamp
4 Command dial
5 Lens
6 Camera model ID
7 Pop-up flash activation switch
8 Hot shoe (for mounting external flash)
9 Mode dial
10 Zoom switch
11 Shutter release
12 On/off switch
13 Viewfinder dioptre adjustment
14 Direct print button (requires computer connection)
15 Hinge for articulated viewfinder
16 Flash sync socket cover
17 Optical viewfinder
18 Playback mode
19 Record button (movies)
20 Focus point selection/Delete button
21 Auto exposure lock
22 Function button and menu navigation wheel
23 Delete images button
24 Menu button

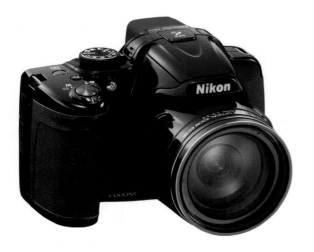

▲ Fig 25
A bridge camera (Nikon Coolpix P520).

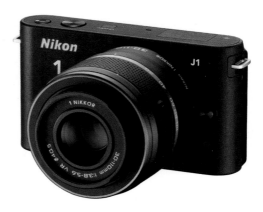

▲ Fig 26
A Micro Four-Thirds camera (Nikon J1).

Bridge Cameras

A bridge camera is basically a bigger version of a compact, with more features and a much larger lens. This type of camera provides another step up in terms of image quality but increases in both size and weight from a compact (Fig 25).

Compared with a DSLR, bridge cameras can save money, weight and space by combining many features into one piece of equipment. Arguably the greatest benefit of the bridge camera is the lens (sometimes referred to as a 'superzoom'). The built-in lens cannot be changed like a DSLR's, but it does offers a huge range of focal lengths so is likely to suit most subjects. In analogue 35mm terms the average range of a superzoom is 28mm–800mm. Bridge cameras also feature large sensors, which, when combined with the superzoom, results in images that are better in quality and higher in resolution than those produced by a compact.

Many bridge cameras feature Wi-Fi connectivity and NFC (Near Field Communication) allowing wireless contact between the camera and devices such as a mobile phone or iPad. Shooting rates are much faster than on compact cameras, providing speeds of up to seven frames per second.

Another benefit is the wide range of scene modes included in the exposure options. Some are very useful, such as 'portraiture', while others are more bizarre, such as 'tropical fish tank mode'. (See Chapter 5 for more detail on scene modes and how they work.) The flash on a bridge camera is also likely to have a higher guide number (more power) than those on most compact cameras.

So, with all these benefits, why doesn't everyone use a bridge camera? The answer is that, in comparison with a compact, the bridge camera is disadvantaged in terms of size and weight. And, in comparison with a DSLR, the bridge camera is limited in terms of specification and quality. Compared with DSLRs, bridge cameras lack exposure control (particularly with aperture settings and ISO), and, while the superzoom lens provides a fantastic range of focal lengths, this is at the expense of lens quality and optical flaws (when compared with most DSLR lenses).

Micro Four-Thirds Cameras

The MFT camera is a relatively new type that is gaining market share. Like the bridge camera, it also represents a compromise between portability and quality. These cameras are mirrorless, which means they can be much smaller than DSLRs, and they feature interchangeable lenses and larger sensors than compact cameras. The main advantages of MFT cameras are excellent lens optics, particularly when compared with compact or bridge cameras, and impressive specifications that are similar to those on entry-level DSLRs.

The downside of an MFT camera is that the small body is achieved by removing the mirror and prism. This means there is no optical viewfinder. Instead, an electronic viewfinder is used, which makes both framing and focusing harder, especially in extremes of bright or dark conditions. The auto-focus also tends to be generally slower than on a DSLR camera. Some photographers find the extensive range of menu items difficult to navigate and, while the idea of the design is that the camera body is portable, when accompanied by a couple of lenses the MFT system can start to require bags rather than pockets.

DSLR Cameras

DSLR stands for 'Digital Single Lens Reflex'. 'Digital' refers to the fact that the light is recorded by a sensor rather than film, while 'SLR' is descriptive of the camera's form and function. 'Single Lens' means that the light coming through the lens is delivered to the photographer's eye via the viewfinder. This is achieved because the light entering the camera reflects from a hinged mirror before being reflected up in to a penta-prism (basically a five-sided block of glass that corrects and rotates the image for the photographer's eye).

With a single lens there is no parallax error and the viewfinder is optical rather than electronic. This means that the viewfinder is a real-time preview of the scene and enables the camera to be held to the eye rather than at arm's length.

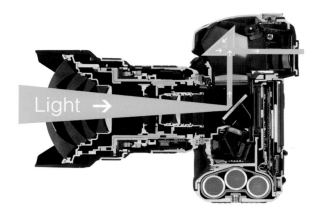

▲ Fig 27
The route of light through the lens, mirror and penta-prism of a DSLR.

The 'reflex' refers to the camera's behaviour when the shutter release is depressed. First, the mirror flips up on its hinge (which also blacks out the viewfinder). This allows the light from the lens to expose the sensor. When the exposure is finished the mirror flicks back down again and the viewfinder becomes active, ready for the next shot. This process is incredibly fast – some DSLRs can complete the reflex up to ten times per second.

A secondary characteristic of DSLR cameras is the capacity to use interchangeable lenses. This connectivity provides access to a vast range of lens possibilities (far greater than the range of focal lengths of a bridge camera). Additionally, using the lens mount, the camera body can be connected to a range of specialist applications such as microscopes and telescopes. Before going on to explain the principles and features of the DSLR it is helpful to orientate a camera and discuss the anatomy and common functions of a DSLR camera (Fig 28).

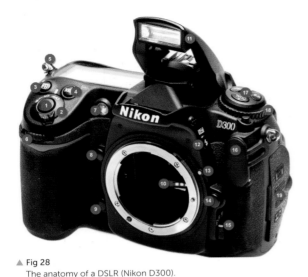
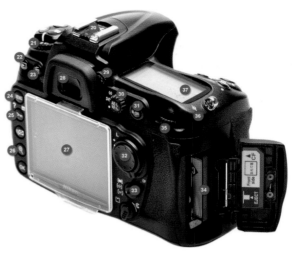

▲ Fig 28
The anatomy of a DSLR (Nikon D300).

1 Shutter release
2 Power switch
3 Exposure compensation
4 Mode button (also featured as a dial in most cameras)
5 Eyelet for camera strap
6 Sub-command dial
7 AF illuminator light/self-timer lamp
8 Custom/function button
9 Depth of field preview button
10 Mirror inside the DSLR body
11 Lens release button
12 Flash control button
13 Lens line-up marker
14 Lens release button
15 Auto/manual focus switch
16 Flash sync socket cover
17 Quality/ISO and white balance
18 Drive mode selector
19 Port cover (AV, HDMI and USB)
20 Hot shoe (for mounting external flash)
21 Self-timer
22 Playback mode (for reviewing images)
23 Delete images button
24 Menu button
25 Protect images from deletion button
26 Zoom buttons for use when reviewing images

27 LCD screen and protector
28 The viewfinder window
29 Dioptre adjustment (eyesight correction)
30 Exposure lock and metering mode selector
31 Active focus button
32 Dial for navigating camera menus
33 Focus point selection option
34 Memory card slot
35 Command dial
36 Focal plane mark

In addition to the optical viewfinder and interchangeable lenses, DSLRs offer a vast array of benefits and flexibility when compared with smaller cameras. The bulk of these are concerned with image quality and camera controls. Despite variances in specification, DSLR cameras share a general shape and form. This is due to a combination of the internal components, such as prism, mirror, lens mount, card and battery, and the basic ergonomics of the human hand. When held to the eye, the right hand naturally grips the battery compartment while the index finger rests upon the shutter release. The right thumb is conveniently located for the command dial and other commonly used shooting settings.

Compact-camera technologies are constantly evolving, but currently DSLRs are still much faster

than other cameras in numerous ways. For example, when a DSLR is switched on it can take a photograph almost immediately, whereas many compacts have a delay of a second or more. DSLR auto-focus systems are faster than those on compact cameras and the shutter release is less prone to shutter lag. The frames per second (fps) is much faster than on compacts, with modern cameras shooting between 5fps and 10fps. These gains combine to make the DLSR a much more responsive camera system.

In addition to being faster, DSLR auto-focus systems are more flexible and able to track subjects, and provide a greater number of focus points compared with compact cameras. DSLRs also give the photographer the option to switch to manual focus (which is imprecise when using a compact).

Perhaps the strongest argument in favour of a DSLR is the size and quality of the image sensor. A DSLR will generally use a larger sensor than other types of cameras and provide a greater number of megapixels. Combined, this provides better low-light performance and improved noise reduction.

Ease of use is a benefit that is not always associated with DSLRs. In fact, while they may look more intimidating than compacts, DSLR are often easier to use. Many of the automated functions have buttons and dials that are more accessible on the DSLR than they are on a compact camera. On a DSLR, it is simple to switch between exposure modes, to change the flash settings or dial in exposure compensation. On a compact camera, these options are likely to be buried in a menu, and, when shooting, will take time and dexterity to change. A further advantage of the DSLR system is that the photographer is able to take charge of the most important aspects of photography with fine increments of control. Settings such as white balance and focus modes are modifiable independently, making these options more responsive than the automated adjustments found in compacts.

Despite all this controllability, it is perfectly possible to turn off all the manual settings on a DSLR and shoot in automatic. In fact, many DSLR users never take the camera off automatic mode, using it simply as an expensive and bulky point-and-shoot device.

ENTRY-LEVEL DSLR VERSUS PRO SPECIFICATION

Camera manufacturers tend to delineate DSLR cameras for the purposes of marketing. In reality, there are a number of specifications that range from entry-level (cheaper and basic) to professional-level (advanced and expensive). Cost and specification largely define whether or not a camera is considered to be pro level, but there are particular traits and features that help define where a given camera belongs on the spectrum. An entry-level DSLR will be relatively inexpensive, sometimes even cheaper than a high-spec compact or bridge camera. Entry-level DSLR cameras usually combine many of the automated modes found on compacts while the specification of the camera sensor is likely to match the pro-level cameras of around two years before. Typically, pro-range cameras are much larger and heavier, and have a more robust construction than the cheaper alternative.

Professional-level cameras tend to be made of metal or alloy, making them more durable than their plastic cousins, and may also include weather sealing. Pro-level cameras also feature multiple memory card slots and may lack the built-in pop-up flash found on consumer cameras. The shutter mechanism will be guaranteed for a longer life (typically up to 250,000 actuations), while the sensor will be larger, usually providing more megapixels and a greater capacity to record tone (dynamic range). Pro cameras are unlikely to feature a fully automatic mode and will not offer preset scene modes such as landscape, portrait, sport, and so on.

▲ **Figs 29 and 30**
Nikon D40 (entry) Nikon D4 (pro).

MEMORY CARDS

Memory card specification is less frequently considered – until a card corrupts or important shots are missed due to a lag in writing speed – but there are a number of key factors that should inform your choice of card:

- Format – does the camera require SD (secure digital), Compact Flash, or other? (Fig 31).
- Capacity – how much data do you need the card to hold?
- Speed – how fast can the card read or write data?

Increasingly, SD cards are the staple of digital photographers. They are widely available and come in a variety of specifications.

The main factor for photographers choosing a memory card is capacity, specifically the amount of data that the card can hold. Cards typically come in sizes of 2GB, 4GB, 8GB, 16GB, 32GB, 64GB and 128GB. The size listed on the label is not the true capacity of the card; when formatted, a 32GB card is likely to have a capacity of around 30GB. The capacity required depends very much on the number of photographs that need to be recorded, although, if the photographer is shooting raw files (*see* Chapter 18) or recording movies, a larger card may be needed. If this is the case, in addition to size, speed will become an issue too. The speed at which the card can write and read data is important because, when using a slow card, a camera cannot take more pictures while it is writing data (once its built-in buffer is full). A 'fast' memory card is likely to be able to read and write at over 50MBS (megabytes per second). A professional card such as those in the San Disk Extreme Pro range will record data at 95 MBS.

Not all manufacturers explicitly state the speed of their cards in MBS. Some rate their product's speed in 'x' terms (for example, 100x), in a throwback to CD burning. The method takes 150KB per second as a unit, so a card that transfers data at 100x will write data at 15MB per second.

For landscape and travel photographers, weatherproofing and robust build quality are important. Professional cards are waterproof and shock-proof, resilient to magnets and X-rays and can work in extreme temperatures. It can be disastrous if a memory card becomes corrupted, so to reduce the risk of corruption it is good practice to turn off the camera

▲ Fig 31
Different formats of memory card (SD card, Compact Flash, Memory stick Pro Duo and Micro SD).

▲ Fig 32
SanDisk Extreme Pro memory card.

▲ Fig 33
Some cameras facilitate the use of dual memory cards. In this example, both SD and Compact Flash may be used.

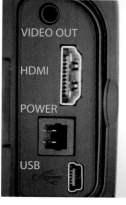

▲ Fig 34
A typical selection of camera connectivity ports.

CONNECTIVITY

Cameras have a range of ports and interfaces facilitating connection to a large number of different devices (Fig 34).

Video out connects analogue cables (featuring the distinctive red, white and yellow plugs). These can connect to a composite or SCART interface of a DVD recorder or television. A more contemporary alternative is the HDMI (High Definition Media Interface). This cable carries a digital video signal and plugs the camera directly into HD screens and projectors. These can be a great way to view images or movies captured by the camera. The HDMI interface also allows other devices to control the camera remotely.

The power port allows the camera to run from mains electricity rather than battery. This is useful for animators or photographers who create time lapse or use extremely long exposures.

USB (universal serial bus) is a digital cable that connects the camera to a computer. When connected via USB, the camera may act as a webcam, be controlled remotely or provide access to the photographs on the memory card.

when removing or inserting a memory card. The metal contacts on the card should never be touched and if the card is swapped between cameras it should be formatted each time.

For more comprehensive information and standards on memory cards, see SDcard.org.

Some DSLR cameras include dual memory card slots, allowing use of both SD and Compact Flash cards. Usage may be configured specific to purpose. For example, the first slot can act as a duplicate back-up of the second, slot 1 can record JPEG while slot 2 stores raw, or slot 1 may record photographs while movies are stored on the second slot.

▲ Fig 35
Electronic copies of manuals can be downloaded and carried using mobile devices.

SUMMARY

There is a wide range of camera types currently on the market, with the first decisions generally being made between portability versus quality. Camera purchasers should be aware that the digital camera market is on the leading edge of technology and that formats, specifications and features are continually evolving at pace. The lines between the different types of camera blur with each new release. Consideration should also be given to the level of manual control required. For those intending to learn photography, it is sensible to allow space within the specification to experiment as knowledge grows. For most enthusiasts and professionals, the DSLR is the camera of choice, and lens choices can then further influence quality and expand the range of possibilities for the photographer.

CAMERA MANUALS AND APPS

Cameras are usually supplied with a comprehensive manual and, although well written, these documents are sometimes prohibitively large. Most camera manufacturers now supply their manual as a PDF file, which can be downloaded to a mobile phone or tablet computer. These are helpful if problems occur with the camera while on location (Fig 35).

The camera is one part of a larger digital toolbox that photographers use in order to make, edit and share images. A wide range of applications are available that expand its functionality. Some of the most useful apps for photographers include GPS tracking (which embeds location detail within photographs) and camera remote controls (enabling the camera to be operated from a mobile phone). Other general applications can be useful to photographers, for example, tools such as a compass, moon calendar and sunset times can assist with working out the ideal time to visit a location. Both the Apple App Store and Google Play feature dedicated areas for photographers providing a huge range of low-price software (Fig 36).

▶ **Fig 36**
The photography section of the Apple App store.

▶ **Fig 37**
Photography apps featured in Google Play.

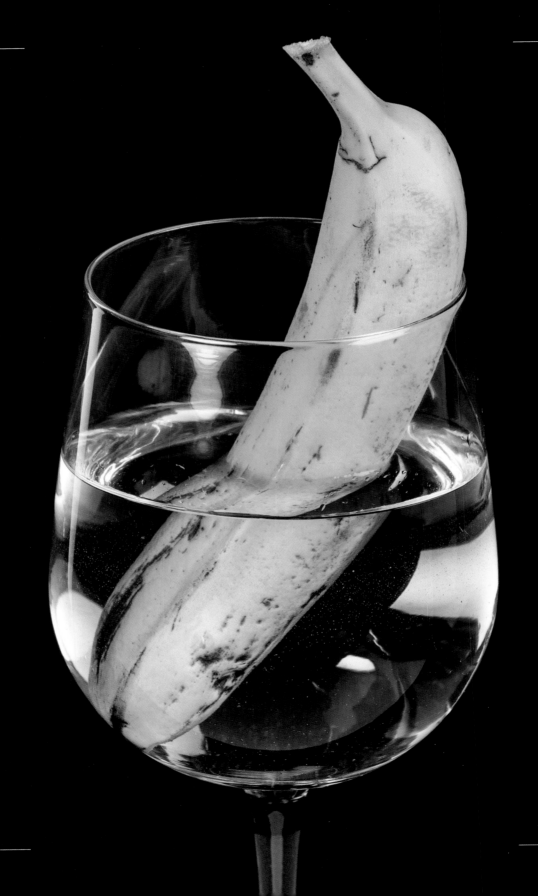

Chapter 4

Understanding Lenses

- An introduction to lenses.
- Lens construction.
- Focal length and angle of view.
- Focal lengths and sensor size.
- Touring the anatomy of a lens.
- Focal length – prime versus zoom.
- Why purchase the kit lens?
- Lens aberrations.

▲ Fig 39
A range of Nikon lenses.

Camera specification can be seductive, but it is a false economy to purchase a high-end DSLR with a low-quality lens. This chapter outlines the form and function of lenses before exploring the creative application of lenses in the image-making process.

Photographers choose different lenses depending on their subject; for example, a sports photographer would choose a very different lens to a macro photographer. Lenses share common features and principles and once the general principles are understood, lens selection is reasonably straightforward.

AN INTRODUCTION TO LENSES

Photographers sometimes prize megapixels as a key measure of picture quality, but this is a mistake. For example, some mobile-phone cameras are capable of creating huge files yet give poor results. This is because, no matter how many pixels are collected by the sensor, if the lens is poor the image will lack clarity, contrast and colour rendition. An 8-megapixel DSLR will create finer images than a 40-megapixel camera phone. This is due to a number of factors but the most significant contributors are the size and construction of the DSLR lens.

LENS CONSTRUCTION

Lenses are constructed from several pieces of glass; each part is called an element. The elements are individually tailored and constructed to provide the desired focal length, while correcting lens aberrations (optical faults). A lens works by bending and changing the speed of the light that travels through it. When light passes through glass that has non-parallel sides, it changes direction, so the curved surface of a lens element will bend light. The light is altered and stretched in a process known as refraction. Refraction occurs when light enters or leaves glass (or water); as the light enters the water from the air, it changes speed. In the example (Fig 40), the result of refraction is that the edges of the banana appear to fail to join up where they break the surface tension of the water.

◀ Fig 38
Water and curved glass change the path of light.

▶ Fig 40
Refraction: light changes
speed as it travels through
water.

Although it is an overly simplistic representation, a lens may be thought of as a series of glasses of water on their side, in a pipe. The difference is that the surfaces are not flat like water. Some have convex elements, while others diverge. Some elements stand alone while others are clumped together to form groups. Lens designers use mathematical formulae to work out how to expand or widen the field of view, while at the same time managing light-gathering and correcting faults and flaws (aberrations). The shape and arrangement of elements combined with protective lens coatings (to reduce internal reflections) are the key factors in a successful lens.

FOCAL LENGTH AND ANGLE OF VIEW

Arguably the most important specification of a lens is its focal length, represented by a number (and usually measured in millimetres). Focal length describes the level of magnification that a lens provides. For example, a 28mm lens would be considered to be a wide-angle lens whereas a 200mm lens would be considered a telephoto. The actual number relates to the distance between the middle of the lens and the image sensor when the photograph is in focus. When using a zoom lens the figures of focal lengths at both ends of the range are quoted, for example 35mm–70mm.

The focal length of the lens has a significant impact on the way in which the camera renders a scene. As a guide, the human eye is estimated to have a focal length of around 50mm. As a result, a 50mm lens is known as a 'standard' lens and considered to be neutral in terms of being neither wide-angle nor telephoto. This variance is because the measure of the standard lens on a camera is approximately equal to the diagonal length of the camera's sensor. For full-frame DSLRs this would be 50mm but for MFTs and compacts the number would be much smaller.

Differing lenses provide an alternative view of the same scene. The focal lengths used in Fig 41 were 10.5mm, 18mm, 35mm, 50mm, 80mm, 105mm, 210mm and 300mm. The camera remained in the same position for each photograph. Changing the focal length has affected the image in a couple of ways: first, the duck on the island has become larger and more prominent within the frame as the focal length was increased (due to the increased magnification); second, the extent of the surroundings in the scene is reduced as the angle of view narrows (Fig 42).

It is a common misconception that wide-angle lenses change the perspective within an image. This is, in fact, false; if the photographer's position remains constant, there is no change in perspective as a result of changing lens. However, if the photographer's position does change (moving closer or further away from the subject), then there is an exaggerated change in how perspective appears. However, this variation will be due to the viewpoint of the camera rather than lens choice. Consider how the image of the duck may have looked if, instead of zooming in on the duck, the photographer had simply walked closer to it, keeping the 10.5mm lens on the camera. The duck would have become larger in the frame (through proximity rather than magnification), while the angle of view would have remained large.

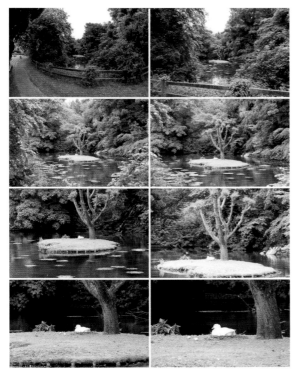

▲ Fig 41
The same scene captured with a range of focal lengths.

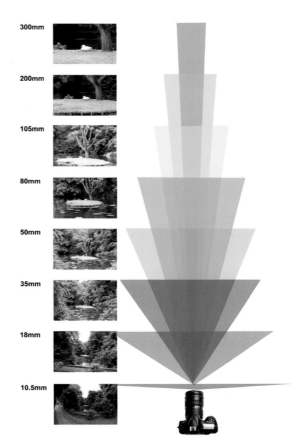

300mm

200mm

105mm

80mm

50mm

35mm

18mm

10.5mm

▲ Fig 42
As focal length increases, the angle of view proportionately decreases.

Focal length and varying distances has an important impact on a portrait (Fig 43). The image on the far left was taken using a 200mm lens at a distance of around five metres from the subject. The result is that the head and shoulders fill the frame and the proportions within the face are similar to how the human eye perceives them. In the second image, a 18mm lens was used (which has a far greater angle of view). In order to fill the frame with the head and shoulders, the photographer needed to move within one metre of the subject. The image on the right was shot with a 10.5mm lens at a distance of half a metre.

The differences between these images demonstrate the powerful effect of both lens focal length and the position of the photographer in relation to the subject. Interestingly, the change in camera position, accompanied by the change in lens, can even alter the spatial relationships between the facial features. At 18mm the nose appears bloated

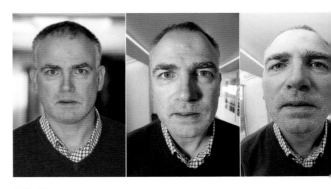

▲ Fig 43
The effect of changing focal length (and distance to subject) alters the perspective relationships within a photograph.

▶ Fig 44
Cameras with different
sensor sizes change the focal
length of the lenses with
which they are used.

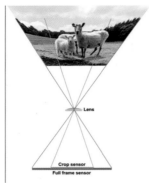

while the ears seem to have moved a long way back. The detail in the background seems further away (because, in relation to the camera-to-subject distance, they are). These effects are exaggerated even further at 10.5mm. When shooting a portrait, stepping away from the subject and zooming in provides a more flattering perspective. The same principle works in reverse. A photographer taking pictures for a travel brochure will use a wide-angle lens to make a swimming pool or bedroom appear bigger than it really is; shot with a longer focal length from further away, both pool and bedroom would appear compressed.

FOCAL LENGTHS
AND SENSOR SIZE

Before exploring lens specifications further, an important principle needs to be acknowledged. The focal length of a lens can vary depending on the camera with which it is used. A 50mm lens on one camera may perform as a 70mm lens when attached to another. Understandably, this may appear confusing at first – if it says 50mm on the lens, why would

it change when connected to a different camera? The answer relates to variations in sensor size. In the days of film, focal length was consistent because cameras were all using film of the same size. Light entering the camera was converged and focused on a film plane measuring exactly 36 × 24mm. Lenses were designed to provide a particular magnification based on the dimensions of a standard piece of film. Digital cameras have changed things, and modern cameras (DSLRs, MFTs and compacts) feature different-sized image sensors. The smaller lenses found on phone and tablet computers reflect tiny sensors, meaning that a short focal length does not necessarily translate to a wide-angle field of view.

Currently, the most common formats for DSLR are crop sensor and full frame. The crop sensor measures around 24 × 16mm, while the full frame is a similar size to the 35mm film frame. The difference between these sizes is known as a 'crop factor' (also known as the 'focal length multiplier'). As a rule of thumb, a crop sensor's lens should be multiplied by 1.5 times if used with a full-frame sensor. So a full-frame 18mm–200mm zoom lens would become a 27mm–300mm lens if used with a crop sensor. To illustrate on the cause and effect of the crop factor, *see* Fig 44.

THE ANATOMY
OF A LENS

With some understanding about how lenses are designed and constructed, it is helpful to apply this information and take a tour of a specific lens – the example used here is a Nikon 18mm–200VR zoom. The distribution of the glass elements in the Nikon 18–200VR is shown in Fig 45.

When viewed as a collection of elements, the lens is more of a mathematical diagram than a piece of photographic equipment. It is helpful to understand the lens as a functional item before exploring the specific dials and buttons that relate to it. The lens name identifies its specification: 'Nikon AF-S-DX VR Zoom-Nikkor 18–200mm ƒ3.5-5.6G IF-ED'. Broken down into its component parts, the name means the following:

1 Nikon: Manufacturer (and compatibility)
2 AF-S: Auto-focus
3 DX: Sensor size with which the lens is designed to work (in this case DX is a smaller sensor than 35mm)
4 VR: Vibration reduction (anti-shake)
5 Zoom-Nikkor: Zoom lens (rather than a lens with a fixed focal length)
6 18–200mm: Range of zoom
7 ƒ3.5-5.6G: Maximum aperture at either end of the focal length. 'G' is specific to Nikon lenses and refers to the absence of a traditional aperture ring on this lens
8 IF: Internal focusing. The exterior of the lens does not rotate or extend while focusing. This is because the lens elements are divided into three groups: front, middle and rear. When focusing, only the middle group moves
9 ED: Extra-low dispersion glass (designed to minimize lens aberrations)

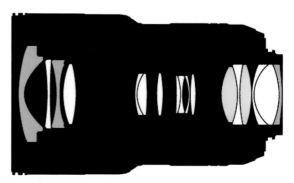

▲ Fig 45
The lens construction of the Nikon AF-S-DX VR Zoom-Nikkor 18-200mm ƒ3.5-5.6G IF-ED lens.

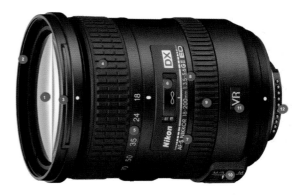

▲ Fig 46
Nikon AF-S-DX VR Zoom-Nikkor 18-200mm ƒ3.5-5.6G IF-ED zoom lens, with key controls and information indicated:
1. Front element
2. Filter thread
3. Lens hood mount
4. Zoom ring
5. Zoom index
6. Distance scale
7. Lens specification
8. The maximum aperture of the lens
9. Focus ring
10. Auto-focus/manual focus
11. Vibration reduction settings (anti-shake technology)
12. Lens contacts

The key controls of the lens are labelled in Fig 46.

Front element

The front element is critical to the performance of the lens; it is the gateway that admits light en route to the sensor. The surface is treated with coatings to reduce reflections, lens flare and aberrations. This

▶ **Fig 47**
Clear UV filter provides
protection to the front
element and can be left on
the lens all the time.

▲ **Fig 48**
Lens flare coming from the sun can reduce contrast.

element is the camera equivalent to the surface of
a human eye and it should be protected at all times;
raindrops and fingers should never come into con-
tact with the glass. A convenient way to protect the
lens is to use a screw-in clear filter (Fig 47), which
can be left in place full time. It is much cheaper to
replace a damaged filter than a damaged lens.

Filter thread

The filter thread allows a filter to be fitted to the lens.
This is also the space into which the lens cap clips.

Lens hood mount

Lens flare is a phenomenon caused by light travel-
ling across the front element of the lens. When stray
light enters the lens at an oblique angle, the light
is more prone to reflect internally within the lens.
Visually, the effect can range from a subtle (some-
times barely perceivable) lack of contrast, through
to a repeating pattern of hexagons across the whole
photograph. Alternatively, light may separate into
wavelengths (Fig 48).

Preventing lens flare can be as simple as shad-
owing the lens with a hand acting as a visor (as if
looking in the direction of the sun or wearing a cap).
A better option is to use a lens hood that affixes to
the front of the lens. A lens hood is usually supplied
with a lens, and will have been designed by the
manufacturer to protect that specific lens and its fo-
cal lengths from flare. Generally, a deeper lens hood
provides greater protection from flare than a shorter
hood but it does carry an increased risk of vignetting
(darkening in the corners). Lens hoods take different
forms, with various depths and with either petal or
cone configurations (Fig 49).

▲ **Fig 49**
Lens hoods are available in a range of shapes and sizes (lenses are
usually supplied with the bespoke model optimized for the focal
length).

Zoom ring

The zoom ring is a textured strip that, when rotated,
modifies the focal length of the lens.

Zoom index

This numeric guide signifies the focal length to
which the zoom lens is currently set. The number
that corresponds to the position of the white dot
indicates the current setting.

Distance scale

This window displays the distance from the camera
to the subject in focus (displayed in both metres and
feet).

Lens specification

This is the name of the lens, which can be broken down to reveal the specification.

The maximum aperture of the lens

The maximum aperture size is also known as the 'speed' of the lens. (Briefly, the larger the hole inside the lens, the greater amount of light it can admit into the camera. For more on apertures, *see* Chapter 8.) Lenses with greater light-gathering power benefit from faster and more responsive auto-focus systems. Additionally, the viewfinder appears brighter and the greater amount of light provides increased flexibility when making an exposure. For example, faster shutter speeds can be used with large apertures. In low light, this may be the difference between having to use a tripod and being able to hand-hold the camera, and may allow the photographer to avoid using the flash.

The maximum aperture of the lens is the most significant defining factor in regard to price. In short, faster is better. It takes a lot of glass to construct a fast lens and this is one of the reasons why they are expensive (and frequently physically much larger and heavier than slower lenses). It is also worth noting that, while a large-aperture lens commands a high price tag, the optical quality of a lens is not necessarily improved. In fact, the most simplistic fixed focal length 50mm standard lenses often provide the best optics because the light is not being bent and corrected. Fast lenses also enable photographers to achieve very shallow depths of field.

This Nikon lens controls the aperture via the camera. Some lenses have an adjustable aperture ring on the body, allowing the aperture value to be set independent of the camera.

Focus ring

When the focus ring is rotated the lens will focus between infinity and the minimum focus distance (which is 50cm in the case of this particular lens).

Auto-focus/manual focus

Allows the photographer to toggle between the manual focus and auto-focus.

Vibration reduction settings (anti-shake technology)

Vibration reduction (also known as image stabilization) enables hand-held shooting at slower shutter speeds than would normally be possible.

Lens contacts

The camera's central processor communicates with the lens using electrical contacts. These provide the interface for the camera to gather data to inform metering, focus, flash power, focal length and more.

FOCAL LENGTH – PRIME VERSUS ZOOM

In the earlier days of photography lenses were manufactured with a fixed focal length, and were known as prime lenses. Modern cameras tend to use a zoom lens. The range of the zoom is expressed in terms of focal length as 16mm–24mm, 17mm–35mm, 18mm–55mm, 55mm–200mm, and so on. The advantages of a zoom lens are numerous. Most significantly, a good zoom lens can replace a whole bag full of fixed focal length lenses. Another benefit is that it does not need to be removed from the camera so frequently, which reduces the risk of dust getting inside the camera. The arguments in favour of prime lenses include the fact that they require less glass to make and fewer elements to construct, providing finer quality.

Just like prime lenses, zooms also have a maximum aperture. On more expensive zoom lenses this is fixed throughout the whole focal range. For example, a 24mm–70mm ƒ2.8 lens gives a maximum aperture of ƒ2.8, regardless of the focal length setting. Such a lens would cost around £1500. A

▲ Fig 50
Light travelling through curved glass bends and distorts.

▲ Figs 51 and 52
Bloating and pinching of the lens pattern cause stretching and unnatural distortion within photographs.

24mm–70mm (f3.5–f5.6) expresses the maximum aperture as a range. When using the 24mm end of the zoom the maximum aperture is 3.5, but when zoomed in to 70mm the maximum aperture drops to f5.6. As maximum aperture reduces, so does the price. A lens like this is more likely to cost around £300.

THE KIT LENS

A DSLR camera may be purchased as 'body only' or as a kit, featuring a standard lens (usually a medium-range zoom such as a 18mm–55mm f3.5–f5.6). This kit lens is often discounted by the supplier when bought at the same time as the camera. Before purchasing the tempting kit lens, it is wise to review other lenses that may provide better range of focal lengths, or wider maximum aperture. Perhaps a fixed 50mm f1.4 would be better value (as a starter lens)? Alternatively, depending on the subject, other specialist lenses may be more suitable. For example, macro lenses have a small minimum focus distance, enabling the camera to focus on subjects within a few centimetres of the front element. Other subjects may demand perspective control (tilt/shift lenses), or for wildlife perhaps a longer focal length and a weatherproofed lens could be more appropriate. Often, spending a little extra above the cost of the kit lens will allow an upgrade to a wider range of focal lengths such as 18mm–200mm, meaning that the lens will be far more flexible to a wider range of subjects and there will be no need to carry spare lenses.

▲ Fig 53
Spherical distortion affects vertical lines and can curve the horizon.

▲ Fig 54
Vignetting darkens the corners of the photograph.

LENS ABERRATIONS

A lens alters the path of light, and doing this can introduce faults and flaws. For example, as light travels through glass, strange things can happen (Fig 50).

Lens designers seek to minimize problems but unresolved flaws will manifest themselves as a range of optical defects (known as aberrations). There are numerous types of aberration; the most common are chromatic aberration, curvilinear distortion, spherical distortion and vignetting.

Chromatic aberration refers to unexpected colour fringing, while curvilinear distortion (also known as barrel, or pin-cushion distortion) has the effect of either bloating or pinching the centre of the lens pattern (Figs 51 and 52).

Spherical distortion is similar to curvilinear distortion and extends to barrelling at the edges of the frame. Spherical distortion can be so extreme that, when photographing buildings, the vertical lines and horizon may appear to curve. It is common with extremely wide-angle focal lengths and fisheye lenses.

Vignetting is another common aberration; it is particularly evident when using cheaper telephoto lenses and wide-angle lenses combined with large apertures. Vignetting is a term that refers to uneven illumination of the field, resulting in darker areas at the periphery. Although it is technically an aberration, vignetting can sometimes be aesthetically pleasing, with the darker edges in the corners naturally drawing the viewer's eye to the centre of the frame.

SUMMARY

When considering lenses, it is useful to have an understanding of their general function and specification, and an appreciation of the principles of lens construction. The function of the glass is to bend light and the amount of bending is determined by focal length, which in turn has an effect on both magnification and angle of view. Both of these dramatically alter the way in which the subject is recorded. A tour of a particular Nikon lens (an 18mm–200mm zoom), gives an introduction to popular lens features, the concept of maximum aperture and common lens aberrations.

Chapter 5

Understanding the Viewfinder

- Different types of viewfinder.
- Dioptre adjustment.
- Articulated viewfinders.
- LCD screens.
- Camera information displayed inside the viewfinder.
- Compositional aids displayed inside the viewfinder.
- Live view.

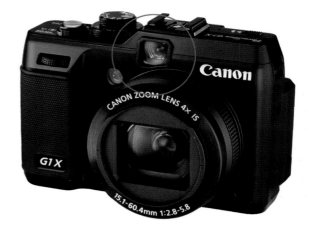

▲ Fig 56
A compact camera featuring both an EVF and optical viewfinder (circled).

The viewfinder is the interface between the photographer, the camera and the scene or subject to be recorded. It is the place where the photographer makes critical decisions such as focus, framing, timing and exposure. At the most simplistic level it is a pre-visualization of the scene facing the camera and, therefore, of the photograph about to be taken.

DIFFERENT TYPES OF VIEWFINDER

Regardless of camera format the viewfinder is likely to be the starting point when making an image. At its most basic the viewfinder provides the frame of inclusion, indicating, for example, if a subject's head is about to be chopped off. Different cameras feature differing types of viewfinder. Some cameras, phones and devices have an EVF (electronic viewfinder) or

digital LCD screen, while others (including some compacts and all DSLRs) have an optical viewfinder; some cameras have both types of viewfinder (*see* Fig 56).

Each type of viewfinder has both benefits and limitations. Electronic viewfinders are common on ultra-compact cameras, tablet computers and mobile phones. The main advantages are that the photographer can hold the camera at arm's length (rather than to the eye), which enables the viewfinder to be shared with others while composing and capturing an image. The EVF can also be set to display a real-time preview of the photograph and provide a preview of how the digital file will look by pre-visualizing the effect of white balance and exposure settings. There are a number of additional advantages: metering information is displayed in real time, a 100 per cent view is provided, and many EVFs also update overlay histogram information

◄ Fig 55
A viewfinder display.

allowing assessment of exposure decisions to be made prior to the photograph being taken (*see* Chapter 17).

An LCD screen (usually located on the back of the camera) combines the most useful features of an EVF with a wealth of shooting information. It is also the window through which camera menus are navigated and where photographs that have been taken are reviewed. The advantage of an EVF is that it displays what the lens sees. The optical viewfinder on the camera shown in Fig 56 suffers from parallax error (*see* Chapter 3). Disadvantages of EVFs are that they are sometimes difficult to read in bright conditions, focus decisions can be problematic (especially in low light) and they can also drain the camera battery quickly when used extensively.

DSLR cameras combine the best of both worlds because the optical viewfinder displays the scene through the same lens that takes the picture. This is sometimes termed as 'WYSIWYG' ('what you see is what you get'). Most DSLR camera viewfinders display 100 per cent of the frame (although cheaper models provide slightly less). This type of optical viewfinder has many advantages. It consumes no power from the camera battery and detail shown is not dependent on the resolution of a screen. Subtle highlight and shadow details are perceivable (the visible range of tone is specific to the photographer's vision rather than depending on the camera's interpretation of the scene). An optical viewfinder requires the camera to be held to the eye, which can be of benefit in some shooting situations or restrictive in others. This sort of viewfinder also comes with a rubber cup, partly to cushion the eye and partly to isolate the viewfinder and protect it from stray light entering the camera.

Assessing the scene before taking a photograph demands an attention to detail. Where possible, make an effort to look all around the viewfinder and identify unwanted elements creeping in at the sides of the frame. This will also avoid the need to crop off parts of objects and people. It is important to learn

to evaluate the viewfinder as if it were a photograph, although this analysis must be much faster and take place in a dynamic and changeable shooting situation.

DIOPTRE ADJUSTMENT

For photographers who wear spectacles, most DSLR viewfinders provide a built-in correction facility to mitigate short- or long-sightedness. The strength of the correction varies depending on the camera model; most provide correction up to two dioptres in either direction.

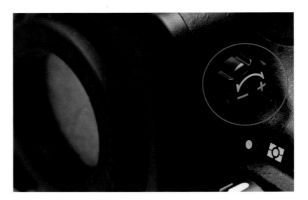

▲ Fig 57
Dioptre adjustment for the viewfinder can be adjusted to suit the eyesight of the photographer.

ARTICULATED VIEWFINDERS

Some DSLR, bridge and compact cameras feature an articulated viewfinder. This is a hinged LCD display that rotates to allow viewing from different angles. This type of viewfinder is particularly useful for taking photographs at arm's length, from a height or from an unusual angle. For example, when taking photographs at a concert the photographer can

▲ Fig 58
An articulated viewfinder is particularly useful for shooting when it is not possible to look through the viewfinder (such as when the camera is held above head height).

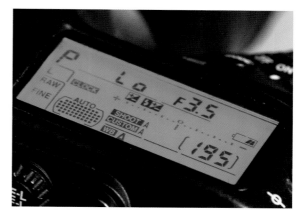

▲ Fig 59
The camera's LCD panel mirrors the information displayed in the viewfinder.

hold the camera above the crowd but still compose, focus and zoom using the rotated display. This type of viewfinder will also allow the shooting of objects at low level, such as flowers or insects, without the photographer having to stoop or bend down. The screen may also be tilted around 180 degrees to provide a live preview, which can also be useful for self-portraits.

LCD SCREENS

Some mid-range and upper-level DSLR cameras include a top-mounted monochrome LCD screen in addition to the viewfinder and rear screen. This screen mirrors the exposure information displayed in the main viewfinder (Fig 59). It is particularly useful when working with the camera on a tripod, enabling exposure settings to be changed at a glance without the photographer needing to look through the optical viewfinder. The same information can also be displayed on the back of the camera (Fig 60). A number of recent DSLRs, bridge cameras and compacts also include touch-screen technology enabling a wide range of camera control.

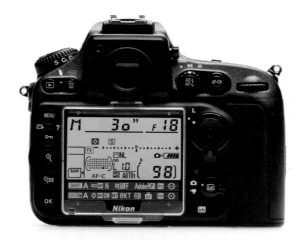

▲ Fig 60
The camera's main LCD screen is used for playback and navigating menus.

CAMERA INFORMATION DISPLAYED INSIDE THE VIEWFINDER

Cameras display a comprehensive range of exposure settings inside the viewfinder. For a DSLR using an optical viewfinder this information needs to be easily read. With practice the photographer should be able to change settings such as shutter speed, aperture and focus points without taking the eye away

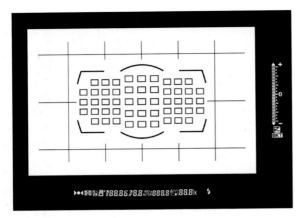

▲ **Fig 61**
Typical viewfinder display.

COMPOSITIONAL AIDS DISPLAYED INSIDE THE VIEWFINDER

Cameras provide a range of visual aids to assist with composing and framing while taking photographs. These normally manifest as an overlay to the viewfinder window and may include the following:

The virtual horizon

Rather like the flying instrument, this setting illustrates the camera's position relative to the horizontal plane, indicated as a graphic overlay on the scene. This is most helpful when subjects feature straight lines such as the horizon or architecture. Some cameras also have meters that indicate gradients or camber on the vertical axis (Fig 62).

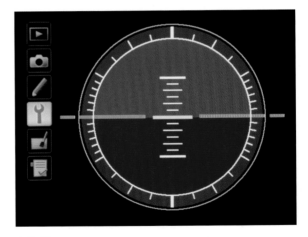

▲ **Fig 62**
The virtual horizon (indicates that the camera is level).

from the viewfinder. Typically, the DSLR viewfinder appears similar to that in Fig 61.

The viewfinder area is normally divided into separate sections. The clear section is the window used to compose the scene, whereas the bottom of the frame notifies the photographer of a range of camera settings. The clear section also offers some information regarding camera operation; most usefully, there are focus points showing which of the auto-focus points is active and which subject they are locked on to. Depending on the exposure mode selected, the viewfinder may also display metering information. Most cameras will also notify the photographer of the status of a whole range of functions, including exposure lock, shutter speed, aperture, whether the flash is ready to fire, the battery level indicator, the exposure mode selected, the camera's meter, exposure compensation values, bracketing settings, ISO, the number of shots remaining (and the number of shots before the memory buffer fills) and white balance settings.

The rule of thirds

This option is featured in most cameras and is designed in reference to an artistic compositional theory known as 'the golden section', or the 'divine proportion'. The golden section was first defined thousands of years ago by mathematicians (most notably Pythagoras). Celebrated as the most aesthetically pleasing ratio, it was later adopted by artists

▲ **Fig 63**
The rule of thirds: the scene is divided into nine equal parts by two horizontal and two vertical lines. Subjects should be placed at one of the points where the lines intersect.

▲ **Fig 64**
Live view in use.

and then, in the 1800s, interpreted and reinvented as the 'rule of thirds' for painters. The theory is extensive, and fascinating; however, in the interest of clarity and for the purpose of explaining the grid view in the viewfinder, it can be simplified. When the rule of thirds is applied, the viewfinder is divided by two horizontal lines and two vertical lines creating nine sections within the frame (resembling a noughts and crosses grid).

Photographers observing the rule of thirds seek to place areas of detail and significance within the composition at the point where the lines intersect (marked with red dots in Fig 63). This has the simplistic effect of avoiding central framing but also avoids landscapes appearing to have been divided in half by land and sky. Observing the rule of thirds may also preserve a sense of balance within the composition.

LIVE VIEW

Live view (also known as 'live preview') refers to the electronic display of the scene (as interpreted by the lens) on the LCD screen. This has been the default viewfinder mode with compact cameras and mobile phones for many years, although it is a relatively recent innovation on DSLR cameras.

One benefit of live view is that it can previsualize the effect of exposure and white balance decisions upon a scene. Focusing is also theoretically more accurate – when set to live view the camera is focusing the image directly from the sensor rather than reflecting it from the mirror and bouncing it around the prism to the viewfinder.

SUMMARY

There are various types of viewfinder, all are used as the window through which photographic images are composed and created. Both electronic and optical viewfinders have a range of customizable features such as dioptre adjustment, compositional aids and controls. DSLRs are increasingly including a 'live view' mode enabling real-time preview of exposure and colour settings. Modern cameras include mobile viewfinders (articulated) and interactive touch screens.

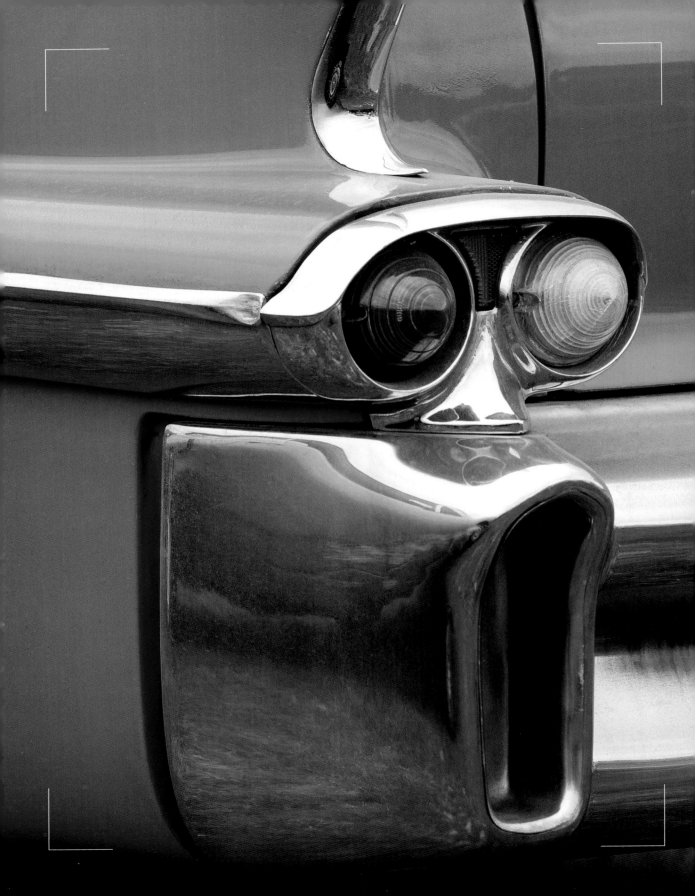

Chapter 6

Understanding Exposure (Auto and Program)

- What is a photographic exposure?
- Selecting an exposure mode.
- Advantages of automatic exposure mode.
- Decisions the camera makes in automatic mode.
- Advantages of P mode.
- Controlling the flash.
- Exposure compensation.
- Program shift.
- Further variables of P mode.

Once you are confident in your choice of camera, tools and equipment, it is time to learn how to apply and configure them to create a photographic exposure. Exposure is the most basic foundation of photography and mastering it is an essential component of understanding the camera. Depending on both subject and shooting conditions, techniques for creating an exposure can be simplistic or incredibly sophisticated. Although they are often dismissed as settings for the novice, understanding how automated exposure modes work is an effective platform to learning about more advanced camera features.

WHAT IS A PHOTOGRAPHIC EXPOSURE?

The word 'photograph' originates from Latin, with 'photo' meaning 'light' and 'graph' meaning 'draw'. It is an appropriate name, because the process of taking a picture is the act of drawing with light. The role of photographer in this process is both to control the amount of light that enters the camera, and the method by which it enters.

Any camera is simply a light-proof box with a hole in it (the lens). Exposure is the name given to the process of admitting light into the camera to create a picture. Three variables specify how a sufficient amount of light enters the camera (*see* the 'exposure triangle' in Fig 66). These variables may be modified by the photographer or by the camera itself, when it is set to automatic mode. Returning to the concept of the camera as a light box, the three variables of exposure on the triangle are:

1. Shutter speed = the length of time the hole (lens) is open.
2. Aperture = the size of the hole through which light enters.
3. ISO = the degree of sensitivity to light of the camera's sensor.

◀ Fig 65
Auto and Program are useful when movement or depth of field is less critical.

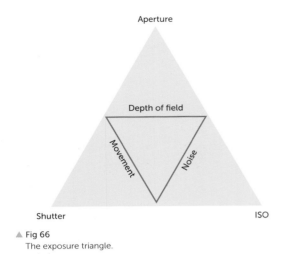

▲ Fig 66
The exposure triangle.

▶ Fig 67
The exposure mode dial.

(For more on these variables, *see* later chapters.) In automatic mode the corners of the triangle are simply points to be acknowledged that the camera is managing to maintain a sufficient exposure. Each corner of the triangle may be varied individually. A change made in one corner must be compensated for in another (or the picture will be too light or dark). There are many combinations of letting the same amount of light in to the camera in different ways. For example, if the size of the aperture is increased, more light will enter the camera; this can be compensated for by using a faster shutter speed (letting less light in). In automatic mode this happens on the fly, while in fully manual mode the photographer controls all three variables independently.

Each corner of the triangle has an effect on how the image is created, and can be used for creative effect. Shutter speeds can freeze or exaggerate movement, different aperture values reduce or increase the depth of field while ISO reduces or introduces digital noise. However, before modifying the exposure triangle directly it is helpful to learn how the camera's automatic exposure function works and understand what decisions it is making on behalf of the photographer.

SELECTING AN EXPOSURE MODE

The mode dial is one of the most important controls on the camera. For this reason the majority of camera manufacturers place it on the top right of the camera, so that it is conveniently adjustable by the photographer's right thumb. The mode dial of the Nikon camera (Fig 67) has functions that are shared across all manufacturers. The core function of the mode dial is to assign how much control of the camera the photographer wishes to access in order to create an exposure. In some situations it may suit the photographer for the camera to make all of the exposure choices; in other situations, the photographer may want to make some, or all, of the decisions.

At first glance the mode dial may appear confusing – settings such as P, S, A and M are not initially self-explanatory. Many cameras may also include a range of icons depicting different subjects and scenarios (scene modes) (*see* Chapter 7).

Depending on the camera manufacturer, automatic mode may be represented as a green square (Canon), or it may explicitly state 'Auto' (Nikon). (Note that 'A' mode does not stand for automatic, but for aperture.) While most cameras have a fully automatic exposure mode, most pro-level DSLRs do not. Automatic is the starting point on the journey to understanding and mastering exposure.

◄ Fig 68
The exposure mode dial
(automatic mode).

ADVANTAGES
OF AUTOMATIC
EXPOSURE MODE

Kodak famously marketed its film cameras with the slogan, 'You push the button, we do the rest.' Their aim was to make photography more accessible and to launch cameras to appeal to a wider audience. Camera technology has evolved apace since Kodak launched the Brownie, but photographic novices have not changed all that much – automatic is usually still the starting point used by those starting out. Equally, many experienced photographers treat automatic modes as just one more tool in their tool-box, available to be used if needed. Camera snobbery aside, in most situations shooting in automatic mode generally gives great results.

Auto can be selected for many reasons and for a range of subjects. Street photography, for example, benefits from being fast and discreet. When shooting scenes of conflict or riots, or paparazzi-style images, automatic may be the difference between getting the photograph and missing the shot. In automatic mode the photographer is free to concentrate on framing the composition, interact with the subject and choose the precise moment at which to press the shutter release without having to make adjustments for changes in light levels.

DECISIONS
THE CAMERA MAKES
IN AUTOMATIC MODE

It is important to understand that in automatic mode the photographer has no control over any of the three variables contained within the exposure triangle. The benefits of automatic mode come at the expense of surrendering exposure decision-making to the camera. This is not necessarily a negative thing; the camera will always try to set the most appropriate settings to match the subject and conditions. Automatic mode varies between manufacturers, although it is common that, when engaged, the camera's other 'auto' options are also activated. These include auto-focus (AF), auto white balance (AWB) and auto ISO. The most common behaviour for a camera set to automatic mode is that, as promised by Kodak, you press the button and the camera does the rest.

To understand the decisions that the camera is making in fully automatic mode it is helpful to describe the sequence. Once the shutter release is pressed halfway, the camera will attempt to identify the subject and select a point of focus. Once focus is locked, the camera knows exactly how far away the subject is. Next, the camera will measure the amount of light present in the scene (known as metering the ambient lighting levels). Based on these measurements, it will then decide how to modify the corners of the exposure triangle (shutter speed, aperture and ISO) to admit enough light to create the photograph. The camera will attempt to choose a shutter speed that enables it to be hand-held without camera shake (normally faster than 1/60th of a second). If the scene is dimly lit this may not be possible; the camera will open the aperture to the widest possible value and may also increase the ISO setting. Depending on the distance to subject, the camera may also activate the flash. If so, the camera will aim to match the ambient light level with flash output,

working out how powerfully to fire the flash to ensure that, by the time the flash light has travelled the distance (specified by the point of focus), it has sufficient brightness to produce an accurately exposed subject.

Once the shutter closes, the camera's internal processor analyses the resulting image data and applies a range of post-production algorithms (such as setting a white balance value, sharpening, specifying colour saturation, vibrancy, levels, clarity, adding contrast) before compressing the file and saving it as a JPEG. The result is displayed on the camera's LCD screen and is usually a well-exposed, pin-sharp photograph.

With technology making it so easy, why are all photographs not taken in automatic mode? Well, automatic can be limiting. Fully automatic is great for many scenes, but there are times when all the wizardry gets it wrong...really wrong. On a technical front, challenging scenes such as snow and strong backlighting are good examples of when auto may be fooled. Equally, the camera's automatic mode cannot be relied upon to produce the photographer's vision. It does not know if part of the subject should be blurred, or out of focus, or isolated from its surroundings using depth of field. If automatic mode is used for every shot, there will be times when the photographer witnesses a scene very differently from the way the camera records it.

ADVANTAGES OF P MODE

P mode (programmable automatic) is a gentle step-up from fully automatic. Virtually all DSLRs have P mode (including professional models) and, as the name suggests, the camera retains most of the control over exposure. When P mode is selected, the camera will meter and make the same exposure decisions that it would have done if set to fully automatic. The difference is that the photographer

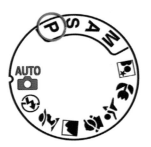

Fig 69
Programmable automatic mode.

has the opportunity to make changes to the camera's suggestions, unlike in automatic mode, when the camera's chosen settings are not up for debate. When P mode is selected on the mode dial, a number of buttons and menu options that did not seem to do anything in automatic become active options. The three most significant settings available to the photographer in P mode are: controlling the flash, exposure compensation and program shift.

Controlling the Flash

In automatic mode the camera evaluates the scene's brightness and chooses whether or not to activate the flash, depending on whether there is enough light present to create a picture. Sometimes, in automatic, the camera will get this decision wrong. For example, the camera may be fooled by the brightness of the background and fail to consider that the subject in the foreground will be underexposed (Fig 70).

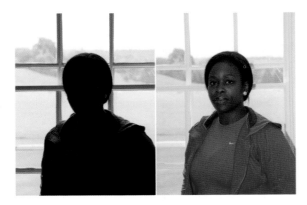

Fig 70
In automatic mode the camera would not fire the flash; in P mode the flash can be 'force-fired' to combat strong backlighting and paint in foreground detail.

Figs 71 and 72
The flash activation button, and pop-up flash.

Fig 73
When the flash is activated a 'catch light' (white dot) appears in the subject's eyes (magnified).

To force the flash to fire in P mode, pressing the flash control button (Figs 71 and 72) will activate the camera's built-in flash. The photographer can choose between forcing the flash to fire or select other flash options (such as anti-red-eye) (*see* Chapter 12). When used in daylight the flash fills shadows as a supplementary light source, so it is sometimes known as 'fill flash'. It also gives humans and animals a white dot where the flash reflects, known as a 'catch light' in the eyes (Fig 73).

Fig 74
Suppressing the camera flash.

This fill light and the resulting catch light are particularly important when photographing people. When looking at a portrait the viewer naturally attempts to make eye contact with the subject and meet his or her gaze. The catch light provides this engagement, while the fill light lightens subtle facial shadows. The opposite to force-firing the flash is suppressing the flash, a function represented by a particular icon (Fig 74).

When in automatic mode the camera will usually choose to fire the flash in dark conditions. For most scenes this will suit the subject, although there are occasions when it will not be ideal. When used in dim lighting the flash is a blunt instrument; the harsh light can dominate a scene by changing subtle lighting, introducing colour variations and

Fig 75
Suppressed flash used on a night landscape.

eliminating gentle textures. Another reason to suppress the flash is when the distance to the subject exceeds its power. One example might be when photographing a landscape at night (Fig 75); if the flash had fired, the subject would have been far too large and distant to be affected.

There are a number of other flash-related controls (*see* Chapter 12).

▲ Fig 76
The exposure compensation control icon.

▶ Fig 77
The image on the right is as metered. The left-hand image has received +2 exposure compensation brightening the entire image and making the snow white.

Exposure Compensation

Program mode also grants access to a feature called 'exposure compensation'. This is a useful tool when seeking to lighten or darken images. Exposure compensation is activated by pressing the button on the camera with the + and - displayed (Fig 76). Some cameras offer this feature in menus rather than buttons.

Exposure compensation allows the photographer to slightly deviate from the camera's chosen exposure by varying how much light is admitted to the camera. In most shooting conditions, automatic mode gets it about right, but there are times when the meter can be fooled. Very dark objects against a dark background or bright subjects against a light background can be problematic, because of the way in which the camera 'sees' the subject. The founding principle of metering (see Chapter 14) is that the camera does not see colour; instead, it perceives everything in terms of brightness (black, white and shades of grey). The meter works by mixing all the shades together and admitting sufficient light to

expose the blended tones as a middle grey (sometimes known as 18 per cent reflectance grey). This grey is perceptually about halfway between black and white on the lightness scale. Middle grey is the universal measurement standard in cameras. For the majority of scenes, metering at middle grey is perfectly fine. Most subjects feature a range of light and dark tone with plenty in between. However, issues arise when the subject or conditions do not feature this standard range of tone. A black cat photographed at night is an unusually dark scene, while a sheep in snow is particularly bright. Left to its own devices, the camera will render the snow as middle grey. By using P mode (and accessing exposure compensation) the photographer can intentionally overexpose the scene by letting more light in than the camera recommends (by adding + numbers to the exposure compensation). The effect of this overexposure is that the picture will be brighter than recommended; some light greys will become pure white, but that is fine, as snow is supposed to be bright! The left-hand image (Fig 77) illustrates the effect of a +2 value of exposure compensation.

▲ Fig 78
The image on the left is as metered. The right-hand image has received -2 exposure compensation, darkening the entire image and keeping the cat black.

When exposure compensation is activated, the photographer is required to specify the 'type' of compensation (over- or underexposure) and the 'amount' of compensation required. The values offered are measured in units called EV (exposure values), and it is helpful to think of these as units of light. Typically, a camera will offer the capacity to adjust exposure in increments of thirds. If +1EV is selected, the camera will overexpose (let more light in) by one EV. This is equivalent to doubling the shutter speed, or opening the aperture by one full increment. The effect of positive values is that more light is admitted and the image becomes brighter (as with the sheep in snow). Conversely, some subjects need to be kept darker than middle grey. A black cat photographed at night, for example, will fool the camera's meter in the opposite direction. Left uncorrected, the cat would render to a mid-grey, but dialling in a value of -2 EV means that the cat stays black (Fig 78).

In addition to dark or bright subjects some high-contrast scenes contain detail visible to the human eye, but impossible for the camera to record. Even for the human eye, simultaneous perception of detail in both shadow and highlight is problematic and this is why the eyes need a moment to adjust when moving from a light room into darkness. The breadth of tone that can be recorded in a single frame is known as the 'dynamic range' (*see* Chapter 14). When an image is exposed as metered (middle, Fig 79), the result contains neither the shadow detail of the wooden panelling or the highlight detail beyond the window. Using exposure compensation the photographer can easily specify over- or underexposure in order to record the detail of the scene.

▲ Fig 79
Exposure compensation may be used to capture detail in either the shadows or the highlights.

◀ Fig 80
Combining exposure compensation with fill flash provides a high key image with the highlights burnt out and a catch light in the model's eyes.

In the overexposed image (right, Fig 79) (+2), the shadow detail of the statues and wooden panelling are visible, while the gardens outside the window have been burned out to pure white. In the underexposed image (left, Fig 79) (-2) the shadows are crushed to black but the highlight detail of the trees outside the window is visible.

Exposure compensation and fill flash can also be combined in P mode. In Fig 80, +2 exposure compensation was added to lift the shadows present in the room and give an airy feel while also intentionally blowing out the highlights in the window. At the same time the camera's flash was force-fired to fill shadows on the face and provide a catch light in the model's eyes. This image would

have been impossible to record in this way using automatic mode.

Exposure compensation is a useful tool and is available in the other semi-manual exposure modes (such as A and S). For a fast way of dealing with tricky metering conditions, or subjects featuring tone at the extremes of light and dark, it is an effective tool. However, care must be taken, as exposure compensation is a 'sticky' setting. This means that, when a value has been specified (for example, -2EV for the black cat), the camera will continue to underexpose all future shots until told otherwise (even if the camera is switched off and on again). When using an electronic viewfinder the effects of exposure compensation can be seen

prior to taking the photograph, while for optical viewfinders the effect needs to be judged in playback mode after capture on the camera's LCD screen.

Program Shift or Flexible Program

When set to P mode the camera selects what it considers to be an optimal exposure but allows the photographer to 'shift the exposure'. This option is called 'program shift' (or 'flexible program', depending on manufacturer). This allows the photographer to change the automatic exposure settings while maintaining the overall amount of light that enters the camera. In practical use, when the shutter release button is half-depressed the camera will select a combination of aperture and shutter speed. With the shutter release held at the halfway point the photographer can simply rotate the main command dial to select an alternative combination of these values that will produce the same exposure. For example, if the camera suggests an exposure of ƒ5.6 at 1/60th of a second, one EV shift could reduce light entering the camera by narrowing the aperture while lengthening the shutter speed to compensate. Both settings let in the same amount of light, but in a different way. (For more on this, *see* later chapters.) Once a shift has been applied to the camera's recommendation the P icon changes to feature an asterisk (Fig 81).

▲ **Fig 81**
A 'shifted' program exposure icon.

Further Variables of P Mode

Camera manufacturers provide differing levels of control when the camera is set to P mode. Menus that were previously unavailable in automatic mode are now unlocked. As well as flash control, exposure compensation and program shift, there are further advantages to shooting in P mode, including ISO settings (*see* Chapter 10), flash power and shooting mode (Chapter 12), exposure bracketing and picture styles (Chapter 15) and, perhaps most importantly, the creation of raw files instead of JPEGS (Chapter 18).

SUMMARY

The camera controls all exposure variables while operating in automatic mode. P mode was introduced as a way for the photographer to gain an element of control over how much light enters the camera and whether or not ambient light is supplemented with flash. P mode is a significant step forward from fully automatic. P mode enables the photographer to influence the 'amount' of light that enters the camera (via flash and exposure compensation), but there are also various scene modes that can control 'how' the light enters the camera and the way in which it processes the resulting image data.

Chapter 7

Understanding Scene Modes

- What is a scene mode?
- How do scene modes work?
- Commonly used scene modes.
- Less popular scene modes.
- Should the scene mode always match the subject?
- Limitations of scene modes.

▲ Fig 83
Icons representing commonly used scene mode settings (portrait, landscape, sports and night portrait).

▶ Fig 84
Scene modes on the mode dial.

While both automatic and P mode are expedient and convenient options, they are limited. In automatic mode the camera makes all of the technical decisions, while program mode provides the photographer with some influence upon how much light enters the camera (via exposure compensation). With a basic understanding of exposure, it is possible to take more of the exposure control away from the camera and place it in the hands of the photographer. One simple way of doing this is by using scene modes. These custom modes represent another significant step away from automatic while still enabling the photographer to work quickly and without the requirement to define precise manual settings.

WHAT IS A SCENE MODE?

A scene mode is a 'recipe' for creating a particular type of image – a shortcut to camera settings that are optimized for particular photographic subjects or situations. These modes are prepared by the camera manufacturers to give better results than automatic mode. They give the photographer a simple way to collaborate with the camera and influence some of the more technical variables such as aperture, shutter speeds and flash control. These settings are accessed through their icons, which may be visible within the camera's menus or located within the mode dial (Fig 84).

◀ Fig 82
Scene modes provide appropriate camera settings for particular shooting scenarios.

Understanding what scene modes do and, more importantly, how they work is a great launch pad for tackling semi-manual modes (*see* later chapters). The following pages introduce the most commonly used scene modes and describe the decisions that they instruct the camera to make on the photographer's behalf. Typically, these settings are a way of changing the flash, shutter speed, aperture and colour settings without having to specify details such as exposure, metering, colour profiles or flash control.

HOW DO SCENE MODES WORK?

Once selected, a scene mode notifies the camera of the photographer's intent for how to treat the subject. This intent is acted upon by modifying two separate processes in camera. The first influences the exposure process (aperture values, shutter speeds, ISO settings, metering patterns, flash mode and the behaviour of the auto-focus). The second variable is concerned with the cameras processing of the image data such as white balance, colour settings and sharpening. Each of these subjects is described in far greater detail in later chapters but for now, be aware that by choosing a particular scene mode the camera will prioritize different settings based upon the subject. Arguably, the most useful thing about scene modes options are that the photographer remains undistracted to concentrate on the non-technical aspects of photography such as composing, framing, interacting with the subject and timing the shot.

▶ **Fig 86**
Portrait mode prioritizes a shallow depth of field (soft blurred background).

COMMONLY USED SCENE MODES

The most popular scene modes are portrait, landscape, sports and night portrait. These settings are usually accessible via the camera's mode dial while the less frequently used settings are accessed via custom settings or camera menus.

▲ Fig 85
Portrait mode icon.

Portrait mode

Use it for: subjects in the foreground isolated from the background using a shallow depth of field. This works by keeping the person in the portrait sharp while allowing the background to become blurred.

How it works: the camera selects a large aperture value (consequently a fast shutter speed is also likely to be selected). Some cameras also engage face detection to assist with focusing. The camera manages white balance values (how warm or cool the tone is) when processing the image data, to produce natural and soft skin tones.

▲ Fig 87
Landscape
mode icon.

Landscape mode

Use it for: landscapes, seascapes or any scenes requiring subjects both in the foreground and background to be in sharp focus.

How it works: the camera seeks to maximize depth of field. To achieve this it selects the smallest aperture available while keeping shutter speeds fast enough to hand-hold. The built-in flash is usually disabled. When processing the file the camera will aim to intensify colours through greater saturation.

▲ Fig 89
Sports mode
icon.

Sports mode

Use it for: freezing fast-moving subjects.

How it works: when sports mode is selected the camera prioritizes a fast shutter speed in order to freeze movement. The camera may also activate 'continuous focus' (*see* Chapter 14), which identifies and tracks fast-moving subjects. The camera will also engage the motor drive (known as continuous shooting), which is useful for recording sequences of images and capturing rapidly evolving action. The camera also prioritizes shutter release above confirming focus. The flash is disabled (most cameras cannot fire the flash at shutter speeds above 250th second anyway).

▲ Fig 91
Night portrait
mode icon.

Night portrait mode

Use it for: photographs of people or objects in low light conditions.

How it works: night portrait is a very effective scene mode, arguably the most useful of all. When set to automatic mode in dark conditions the camera is accustomed to firing the flash with sufficient power to light the subject at the required distance. This produces an exposure by lighting the foreground but does not capture detail outside of the range of the flash. When night portrait is selected,

▲ Fig 88
Landscape mode prioritizes a deeper depth of field (front to back sharpness).

▲ Fig 90
Sports mode prioritizes a fast shutter speed to freeze moving subjects.

▲ Fig 92
Automatic mode (left) records only the light output from the camera's flash, compared with night portrait mode (right), which combines the flash exposure with ambient light.

the built-in flash is activated as normal, but the fundamental difference is that night portrait mode combines the flash with a slightly longer shutter

speed. The longer exposure allows subtle colours and detail present in the background to be recorded and balanced with the flash exposure. The longer shutter speed makes night portrait mode more susceptible to camera shake so the camera must remain still. In many cameras, night portrait mode also activates the camera's red-eye reduction function.

While compact cameras may offer a wide range of modes and wizardry, aimed at extending the capability of the automatic modes, the limited specification of the low-end versions means that there are times when they are unable to deliver the promised results. This is particularly the case when using the portrait and landscape scene modes. Cheaper cameras only offer a small variation between apertures (in some cases between *f*4 and *f*8). With such small differences the promised shallow depth of field (portrait) and deep depth of field (landscape) deliver frustratingly similar results. If this is the case, more manual options may provide access to a wider range of settings. Otherwise, it may be time to purchase a new camera, with a broader range of apertures and shutter speeds.

Macro (or close-up) mode

Use it for: close-up photographs of small subjects.

▲ Fig 93
Macro mode icon.

How it works: functionality differs depending on the manufacturer. Generally, the camera will attempt to select a shutter speed that is fast enough to prevent shake while giving a medium aperture (macro photography results in very shallow depth of field). The camera engages single point auto-focus (usually in the centre of the frame to aid accuracy). Some limited flash control is also enabled.

Macro photography is a specialized field and selecting the macro mode on a camera does not change the minimum focus distance of the lens. Macro mode is usually an inaccurate title for the scene mode. The true definition of 'macro' is when an object is reproduced at its actual size (or larger) on the camera's sensor, and this usually requires a specialist lens. In most cases, macro would be more correctly referred to as 'close-up' mode.

LESS POPULAR SCENE MODES

Some of the entry-level cameras (particularly compacts) provide a plethora of scene mode options. Some are more useful than others. In addition, each manufacturer interprets a scene mode in a different way and develops its exposure settings and processing algorithms differently. For example, the 'party mode' offered by Nikon, Canon and Sony cameras may yield quite different results. However, as a guide, the less popular scene modes are described below.

▲ Fig 94
Macro photography allows an object to be recorded on the camera's sensor larger than life-size.

Movie mode

Use it for: recording movies.

How it works: the camera changes from being a stills camera to recording videos. One immediate effect is that the camera reduces the pixel dimension of the pictures being recorded (usually to 1080 or 720). The camera also activates the built-in microphone, if there is one. Stills can also be extracted from movie frames, although resolution and quality are greatly reduced compared with the camera's performance in a photographic mode.

ADep (Automatic Depth of Field)

Use it for: this mode attempts to detect both the subjects closest to the camera and those furthest away. The camera then applies settings to ensure that depth of field is sufficient to keep both in sharp focus.

How it works: the camera analyses all of the focus points in the frame to identify the nearest and furthest subjects. Once known, the camera selects an aperture, which, based on the distances between the focus points and lens, should be capable of giving sufficient depth of field to keep both subjects in focus.

▲ Fig 96
Snow mode ensures that bright white snow stays white rather than being rendered grey/blue.

Snow mode

Use it for: snowscapes.

How it works: in automatic mode, snow is likely to be rendered blue or grey rather than white. Snow is challenging to photograph because it is very bright and reflects light. As an alternative to using exposure compensation (when set to P mode), snow mode tells the camera to increase the exposure while also adjusting white balance to keep the snow white.

▲ Fig 95
ADep mode calculates how much depth of field is required to keep both the closest and farthest subject in focus.

▲ Fig 97
Sunrise/sunset mode.

▲ Fig 98
Night mode records ambient light using slow shutter speeds.

Sunset/sunrise mode

Use it for: sunset or sunrise.

How it works: the camera adjusts metering to compensate for the high level of contrast associated with keeping the sun in the frame. When processing the image data the camera maintains warm golden tones and accentuates the vibrant hues present in a sunset scene.

Night scene mode

Use it for: landscapes in low light conditions.

How it works: the camera prioritizes a slow shutter speed that allows enough ambient light to enter the camera without firing the flash. Some compact cameras take more than one image at slightly different exposures and combine them, to preserve a wider range of detail. A tripod or similar camera support is needed to avoid camera shake.

Party mode

Use it for: busy low-light colourful scenes featuring people.

How it works: similar to night portrait mode, the camera seeks to capture the subtle lighting, atmosphere and general bustle of a scene rather than simply drench the subjects with flash. The camera selects a slow shutter speed to record the ambient light combined with a subtle burst of flash to pick

▲ Fig 99
Party mode is useful for vibrant scenes lit by warm light sources
such as tungsten bulbs.

▲ Fig 100
Kid mode freezes action and saturates colour.

out people and detail (flash control is available,
including anti-red-eye). While processing, warm
colour casts caused by tungsten lighting are cor-
rected and primary colours are saturated.

Kid and pet mode

Use it for: fast-moving, brightly coloured subjects.
How it works: when set to kid mode the camera
selects a faster shutter speed than portrait mode
(subject to the brightness of the scene). Some cam-
eras also have or use 'continuous focus and subject
tracking' modes. The camera may also activate
continuous shooting drive mode to enable fast se-
quences to be captured and engage release priority
to reduce shutter lag (the time between pressing the
button and the photograph being taken). When in
kid mode some cameras fire a weaker than normal
flash to gently fill shadows and place a catch light in
the eyes of the subject. When processing the file the
camera attempts to soften skin tones and seeks to
saturate the most vibrant colours.

Pet mode is almost identical to kid mode. The
key difference is that pet mode uses face-detection
technology with algorithms developed specifically
for cats and dogs.

▲ Fig 101
Pet mode uses animal facial recognition.

▲ Fig 102
Firework mode selects a longer shutter speed to record the movement of the firework.

▲ Fig 103
Beach mode manages bright subjects in bright conditions.

Fireworks mode

Use it for: shooting fireworks at night.

How it works: the camera sets the focus distance to infinity (to prevent it from unsuccessfully attempting to focus on an empty dark sky). The built-in flash will be disabled and the camera will select a long shutter speed (typically between two and five seconds). In post-processing, the camera will boost the contrast between dark night skies and the bright fireworks. When processing colour the vibrant hues are saturated.

Beach mode

Use it for: beach scenes in sunny conditions.

How it works: like snow, sand reflects light and can fool the camera into underexposing the whole scene. Left in automatic mode, golden sandy beaches can easily be rendered as a murky dark brown. To cope with these conditions the camera increases the exposure to accept the exaggerated brightness. During processing the camera recovers the lightest areas of tone to prevent the highlights from burning out to white, while also adjusting the white balance settings to compensate for the yellow hue of a sandy beach and deepening the blues and greens of the sea.

▲ Fig 104
Foliage mode increases the colour of flora.

▲ Fig 105
Suppressing the flash prevents the camera basing exposure
decisions on subjects that are too far away to be lit by flash light.

Underwater mode

Use it for: taking photographs under water (in
combination with a waterproof casing). It is suited to
photography that takes place deep underwater such
as when diving in the sea.

How it works: underwater lighting is very different
to that found in normal shooting conditions – the
deeper the water, the more reliant the exposure is
upon the camera's flash. The goal of underwater
mode is to select a fast enough shutter speed to
capture the movement of fish and sea creatures by
increasing ISO and varying the aperture. The cam-
era also engages the continuous shooting mode to
avoid missing anything. During processing, warmer
tones are applied to mitigate the blue/green hues
found in water.

Some cameras also feature the option to deepen
the rich blues found in tropical seas.

Foliage mode

Use it for: gardens and flowers.

How it works: foliage mode disables the built-in
flash and selects a white balance value appropriate
for daylight values. The camera processes the file by
boosting colour saturation levels, resulting in bright
vivid colours.

Suppress the flash

Use it for: dimly lit shooting conditions that do not
require the camera flash. Examples include shooting
through glass or a landscape at night.

How it works: in fully automatic mode, when
the camera detects low ambient light levels it will
instinctively fire the flash. When flash suppression
is engaged, the flash will not pop up or fire. Instead,
the camera will select a long enough shutter speed
to create the exposure using ambient light alone.
This will require a steady hand or tripod.

Museum or gallery mode

Use it for: galleries or museums where use of the
flash is not permitted.

How it works: the camera opens the lens aperture to
the widest possible setting and increases the cam-
era's ISO sensitivity. These two variables combine
to allow the camera to be hand-held without the
use of a tripod. One disadvantage of gallery mode
is that when the ISO value is raised the resulting
photographs appear grainy and demonstrate exces-
sive 'noise' (*see* Chapter 10).

Silhouette mode

Use it for: strongly backlit subjects.

How it works: the camera exposes for the backlighting and suppresses the built-in flash. The camera's processor allows the foreground shadow details and dark greys to reduce in brightness to black.

▲ **Fig 106**
Silhouette mode in use (right).

▲ **Fig 107**
Backlighting is a challenging scenario for the camera's meter.

Backlighting (avoiding silhouettes)

Use it for: when the subject is being lit strongly from behind.

How it works: the camera's meter will normally be fooled by strong light sources. When backlighting mode is selected the camera will make exposure adjustments to expose faces or details in the foreground (at the expense of losing detail in the bright highlights). The camera may also choose to fire the flash. While processing image data the camera seeks to boost the darker tones, ensuring that subtle shadow detail is preserved.

Panoramic assist (stitching mode)

Use it for: taking a sequence of images to create a panoramic photograph.

How it works: the photographer takes an image, then moves the camera slightly to the side before taking another and so on. The camera will sometimes provide a 'ghost' of the previous image in the viewfinder to assist with overlapping the edges. For cameras with built-in image-stitching software, the camera's processor analyses edge detail, colours and brightness levels of the frames and blends them together to create a single seamless photograph. For cameras without built-in stitching the merging together of the edges is a simple image alignment modification easily completed in Adobe Photoshop (*see* Figs 108 and 109).

Group mode

Use it for: groups of people.

How it works: this mode uses face recognition to identify the closest and furthest people in the group. The camera attempts to create sufficient depth of field to keep everyone in focus. Additionally, some cameras will notify the photographer if any of the subjects blinked during the exposure.

▲ Fig 108
Seven frames captured to make a panorama.

▲ Fig 109
A panoramic image created by photographing a sequence of shots
and stitching them together in Adobe Photoshop.

▲ Fig 110
Group mode is ideal for ensuring that no one blinked when the
photograph was taken.

SHOULD THE SCENE MODE ALWAYS MATCH THE SUBJECT?

Scene modes are a great way of influencing how the camera admits light to create an exposure. However, just because a person happens to be the subject of a photograph, it does not mean that portrait mode should automatically be selected. To use scene modes effectively it is important to understand how the modes are telling the camera to behave. For example, sports mode could be useful when the photographer is moving (such as when taking pictures from a moving train), a white kitten on a white rug would benefit from snow scene mode, and fireworks mode could be a perfect option for shooting traffic-light trails. The point of scene modes is to appreciate how they are instructing the camera to operate and to understand which variables they affect.

INTELLIGENT AUTO

Some cameras have an iA setting (Intelligent Auto). This mode is sometimes given an alternative name such as Smart Capture, Easy Auto mode, Scene Auto, iAuto, Creative Auto, Auto picture or iSCN (Intelligent Scene Recognition).

This setting is most frequently found in compact cameras and works by analysing the scene that is about to be photographed and then selecting what the camera believes is the most appropriate scene mode. For example, if the camera detects a person in the foreground (using face detection), it will prioritize portrait mode. While this is not a mode experienced photographers are likely to select, it is an option that can enhance the experience of a novice photographer seeking fast results from a point-and-shoot camera.

◀ **Fig 111**
Intelligent Auto mode (selects what the camera considers to be the most appropriate scene mode).

LIMITATIONS OF SCENE MODES

Do scene modes contain everything that could ever be required to create fantastic pictures in most situations? Perhaps, for some photographers, the answer is 'yes'. However, if scene modes were as good as manufacturers claim, all photographers would use them all of the time. It is important to note that scene modes do not act as a photographic magic wand. They are settings governed by the same principles of physics as the camera's other exposure modes. For example, selecting portrait mode will prioritize a wide aperture but this alone will not create an image with shallow depth of field if combined with a wide-angle lens, or if the subject is too far away.

Scene modes are significantly more sophisticated than automatic mode and can provide helpful step-ping-stones when learning photography. However they can be frustratingly restrictive. As camera understanding increases, most photographers will seek to refine the way scene modes render the image, but, because scene modes are still automated functions (guided by pre-defined recipes), they cannot be significantly modified. Another restriction is that these modes usually only produce JPEGs, not raw files. Some cameras produce both raw and JPEG in scene modes but the image processing will be ap-plied to the JPEG copy only. Some camera controls are also disabled in scene modes, for example, exposure compensation cannot always be accessed and use of the flash is a decision of the camera rather than of the photographer.

SUMMARY

Scene modes are a quick and easy way of gaining a degree of influence over the camera's exposure variables and subsequent image processing. They can help less experienced photographers achieve better results quickly. For example, the photographer can specify whether the subject should be recorded with shallow or deep depth of field, or with a fast or slow shutter speed, without having to deal in specifics. Understanding what a scene mode does is more important than selecting a mode that corresponds with the subject.

There are limitations when using scene modes. They tend to be most restrictive in consumer compact cameras (which feature the largest choice of scene modes but the least amount of specification to achieve them). When activated, scene modes restrict access to a variety of other camera settings, such as metering modes, exposure compensation and colour settings. While preset modes 'influence' exposure, 'controlling' gives far greater creative potential. For this reason, there are also a number of semi-manual modes.

Chapter 8

Understanding Aperture

- What is aperture?
- What is aperture priority mode and how does it work?
- What are *f*-stop numbers and how do they relate to aperture settings?
- Introducing depth of field.
- Shallow DOF (working with wide apertures).
- Deep DOF (working with narrow apertures).
- Why not just use scene modes to control depth of field?
- Other factors affecting depth of field.

Scene modes serve as expedient shortcuts in a wide variety of situations. Certainly when compared with automatic mode they provide the photographer with significant authority upon how the camera captures movement, renders depth of field and other key variables. The photographer can increase his or her contribution to the picture-making process by assuming control over the first of the semi-manual exposure modes: aperture priority.

WHAT IS APERTURE?

Inside a lens there is a series of overlapping leaves, which move apart to modify the size of the hole through which light can travel. This mechanism is called the iris. The iris can be made larger or smaller to adjust the amount of light that enters the camera. The hole created by the position of the iris is called the aperture. Camera lenses offer a variety of apertures enabling a lens to use an open aperture (large hole), or a closed-down aperture (small hole).

A simple metaphor to demonstrate the purpose of the aperture is offered by the human eye. In dark conditions the pupil expands so that as much light as possible can enter. If conditions become brighter the brain tells the pupil to reduce in size to reduce the volume of light admitted. This fluctuation ensures that the light entering the eye is regulated appropriately to enable vision (Fig 114).

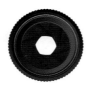

← large hole

small hole →

▲ Fig 113
The camera aperture (the hole in the lens through which light enters the camera).

◀ Fig 112
Aperture controls depth of field.

▶ Fig 114
The aperture of the human eye (pupil) in varying lighting conditions.

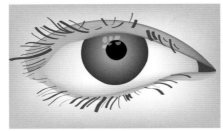

The human response to fluctuating light is similar to the way in which the camera regulates the aperture value when set to automatic mode. A key difference between the mechanics of the camera and the biology of the eye is that human vision is reliant solely on aperture for brightness control. The human eye, although having dark adaptation at night, which increases the ability to see (in black and white) in low brightness, has no mechanism such as shutter or ISO setting for colour vision. The camera's exposure, on the other hand, is a balance of all three.

Aperture is the first of the three corners of the exposure triangle (*see* Chapter 6) to be explored in detail (Fig 115). Not only does aperture control the amount of light that enters the camera, it also impacts upon depth of field.

Aperture

Depth of field

Movement

Noise

Shutter

ISO

▲ Fig 115
Aperture as a variable of the exposure triangle.

WHAT IS APERTURE PRIORITY MODE AND HOW DOES IT WORK?

◀ Fig 116
The mode dial set to A (aperture priority).

Aperture priority is activated by switching the mode dial to the A position ('Av' on Canon cameras, which stands for aperture value and does the same thing).

When aperture priority is selected the camera provides access to the lens's entire range of aperture settings. Whichever aperture value is chosen, the camera balances the exposure by measuring ambient light and modifying the shutter speed (and possibly ISO) to ensure sufficient light is admitted to the camera. If the photographer selects a large aperture (big hole) the camera will specify a shorter shutter speed. If a smaller aperture (small hole) is chosen, a longer speed will be required to balance the exposure. Importantly, in addition to increasing or reducing the amount of light that enters the camera, the aperture value (known as an f-stop) impacts upon depth of field.

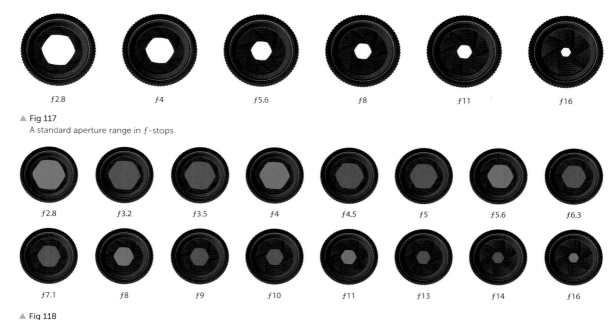

▲ **Fig 117**
A standard aperture range in ƒ-stops.

▲ **Fig 118**
The aperture scale – each full (green) aperture setting represents one full ƒ-stop while the red shaded settings represent thirds of stops.

WHAT ARE ƒ-STOP NUMBERS AND HOW DO THEY RELATE TO APERTURE SETTINGS?

When communicating aperture settings, a level of precision is required. Using the terms 'large hole' and 'small hole' may be satisfactory to describe general principles but when defining the detail of an exposure the exact size needs to be made clear. The photographic term for an aperture setting is 'ƒ-stop' – f for 'focal', and 'stop' representing a setting or value. An ƒ-stop refers to one unit of exposure measurement and, in the case of aperture, specifi-cally the size of the hole.

Aperture numbers can appear counter-intuitive when learning photography, as smaller f-numbers such as ƒ2.8 refer to a larger lens opening, while larger numbers such as ƒ16 relate to a smaller hole. In the majority of cameras the aperture range is also available in thirds of ƒ-stops (Fig 118). Knowing that the red shaded values are fractions of stops is

relevant because the settings are logarithmic. This means that when the aperture is opened one full ƒ-stop (for example, from ƒ5.6 to ƒ4), double the amount of light is admitted compared with the pre-vious setting. Conversely, for every ƒ-stop that the aperture is reduced (for example, from ƒ8 to ƒ11), half the amount of light enters the camera. Increasing or decreasing the aperture value physically changes the size of the iris, which in turn regulates the amount of light entering through the lens.

The ƒ-number sequence (ƒ2.8, ƒ4, ƒ5.6, ƒ11, ƒ16...) follows a mathematical pattern, with each number differing by a factor of the square root of two. This is because the aperture relates to the area of a circle. Geometry dictates that, in order to double the area of a circle, the diameter must be multiplied by the square root of two. So while the aperture numbers can appear non-intuitive at first, an f-number is a simple way of describing the size of the hole inside the lens through which light passes en route to the sensor. The numbers may be a bit of a mouthful, but they are easier to remember than the size of

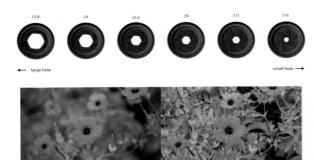

▲ Fig 119
The *f*2.8 setting gives a shallow depth of field (top), while *f*16 (bottom) results in a deeper focus.

the circle in geometric terms. Cementing the small number/big hole mantra in the mind is the first stage to being able to quickly define exposure settings and being able to influence depth of field.

INTRODUCING DEPTH OF FIELD

The term 'depth of field' refers to the distance in front or behind the focal plane (or subject) that is in acceptable focus. Changing depth of field is an important way of exercising control over the detail contained within the photograph. Using a large aperture gives a shallow depth of field whereas a smaller aperture will provide a deeper depth of field.

Altering the depth of field is an effective way of controlling the viewer's eye within the composition. For example, blurring non-critical elements of the composition can draw the attention of the viewer to the area of the photographer's focus.

It is helpful to know how to change the depth of field, but it is also important to know when to do it. In addition to directing the viewer's eye, a shallow depth of field is also useful for simplifying a scene and removing distracting backgrounds. It can also be used to isolate a detail, for example, to pick out a face in a crowd. Fig 121 is a good example of this. The model was photographed at a busy festival and

▲ Fig 120
Using depth of field can direct the viewer's eye.

▲ Fig 121
Using a wide aperture (*f*2.8) to soften and blur the background.

the distracting background was rendered to a soft blur by using a large aperture (*f*2.8).

Conversely, the photographer may want to keep the entire scene in sharp focus. In Fig 122, a small aperture (*f*16) was chosen, which enabled the detail both in the foreground and on the horizon to remain sharp.

▲ Fig 122
Using a narrow aperture (ƒ16) to maintain sharp detail in both the foreground and background.

▲ Fig 123
Shallow depth of field (such as this) can be unattainable if using a standard kit lens because the maximum aperture (largest hole) may be ƒ5.6.

SHALLOW DOF (WORKING WITH WIDE APERTURES)

A larger aperture will generate the shallowest depth of field. Typically, the maximum aperture of a lens will vary between ƒ1 and ƒ5.6. Photographers with inexpensive zoom lenses may notice that the maximum aperture varies at different focal lengths. Those who require a very shallow depth of field should use lenses with maximum apertures of ƒ1.4, ƒ1.8, ƒ2 or ƒ2.8. These lenses do cost significantly more. Creating shallow depth of field (as featured in Fig 123) requires an aperture of ƒ2.8 or larger, which would be impossible to achieve using a standard kit lens such as 24mm–55mm ƒ3.5–ƒ5.6.

When using large apertures to generate shallow depth of field, the area of the photograph that falls outside of focus is known as 'bokeh'. Pronounced 'bo-ka', this term comes from the Japanese word *boke*, which means 'to blur'. The appearance of bokeh varies on a lens-by-lens basis. This variation stems from the shape and construction of the aperture's diaphragm. The effect and shape of the bokeh is most visible in the brighter areas; note the hexagonal highlights at the top of the frame and magnified area in Fig 124.

▲ Fig 124
Bokeh (circular or hexagonal shapes visible in the areas that fall outside the areas of acceptable focus).

DEEP DOF (WORKING WITH NARROW APERTURES)

At the other end of the spectrum there are certain subjects that demand maximum depth of field. This is particularly useful for landscapes or situations where both the foreground and background are required to be in sharp focus. It is a common misconception that selecting the smallest possible aperture will provide the sharpest possible image. In fact, when really small apertures are used, the image quality begins to degrade because the hole becomes too small for light to pass through easily. Light rays begin to converge with each other and create interference. Photographically this is known as lens diffraction. As a general rule of thumb, for maximum clarity an aperture of around ƒ16 provides the greatest sharpness through extended depth of field without introducing diffraction artefacts.

Using a deep depth of field is helpful when everything in the scene needs to be sharp. From a creative point of view, having the entire scene in focus enables the photographer to channel the viewer's eye along a path. While shallow apertures are used to draw the eye away towards areas of contrast, deeper depth of field (with front to back sharpness) may be used to provide signposts for the viewer's eye to follow through the composition. In Fig 125, the eye is drawn to the bright foreground before zigzagging along the railing within the composition.

DEPTH OF FIELD PREVIEW BUTTON

Film SLR cameras are equipped with a depth of field preview button. When pressed, this button closes down the lens diaphragm to the selected aperture. This has the effect of darkening the viewfinder while providing a preview of how the selected aperture will affect depth of field.

Many DSLRs retain this button; however, when shooting digitally it is simple to take a photograph at the selected aperture and judge the depth of field from the resulting image (which is brighter and easier to view). Many photographers choose to reassign the purpose of the DOF preview button in the camera's custom menu to act as a shortcut to something that is used more frequently.

▲ Fig 125
Extended depth of field used to guide the viewer's eye along a path.

WHY NOT JUST USE SCENE MODES TO CONTROL DEPTH OF FIELD?

Novice photographers often wonder why they should not just use the portrait and landscape scene modes to control depth of field? There are a number of reasons. First, these modes rarely use the extremes of the options available. For example, in automated modes most cameras tend to work between *f*4 and *f*11 without using the full range. Also, scene modes manage other settings such as ISO, white balance, metering and colour, which may not be appropriate to all subjects. Aperture priority mode gives the photographer far greater control of the parameters available within the camera and lens combination. In Fig 126 the photographer has focused upon the model's eyes and used an aperture of *f*5.6 to ensure that the hand in the foreground remains in focus while the background becomes soft.

OTHER FACTORS AFFECTING DEPTH OF FIELD

Aperture is the main variable that controls depth of field, but there are a number of other factors that have a significant influence. First, the distance between the camera and the subject is important (subjects closer to the camera provide a shallower depth of field). Second, the focal length of the lens makes a difference (telephoto lenses provide a much shallower depth of field when compared with wide-angle). Finally, the size of the camera's sensor affects the depth of field, with a larger sensor providing a shallow depth of field. With this in mind, in order to achieve the shallowest possible depth of field, the photographer should select a camera with a

▲ Fig 126
Retaining elements of detail in the background by using a mid-range aperture value (*f*5.6).

▲ Fig 127
Shallow depth of field: Nikon D800, 105mm lens, *f*1.4, focused at a distance of one metre.

large (full-frame) sensor, fitted with a long lens (over 100mm), using the widest possible aperture (between *f*1.4 and *f*2.8), and ensure that the subject in focus is within one metre of the camera. When these variables combine, the depth of field is as shallow as possible. In Fig 127 the cat's eyes are sharp but the tip of the nose is already outside of acceptable focus. The front paw, while only around six inches closer to the camera than the eyes, is totally out of focus.

▲ **Fig 128**
Deep depth of field: Canon GX1, 50mm lens, ƒ16, focused at a distance of around ten metres.

The photographer seeking maximum depth of field should use the opposite settings – a camera with a smaller cropped sensor fitted with a wide-angle lens, set to use the smallest aperture (ƒ16), while focusing on a subject on or near the horizon.

To understand why these variables combine with aperture to affect depth of field so significantly, it is helpful to break down what is actually happening in terms of the physics. The starting point is 'the field'. In Fig 129, the white knight is sharp while the black pieces in front and behind are both out of focus and soft. This is because the camera is focused upon the knight. The knight, along with a few millimetres

◀ Fig 129
Shallow depth of field.

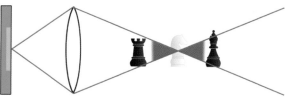

◀ Fig 130
'The field'.

◀ Fig 131
Extended depth of field puts all three pieces in acceptable focus.

either side, is sharp. This area in focus is known as 'the field'.

The field is illustrated by the purple shaded area in Fig 130. When using a wide aperture the path of light travels from the white knight through the lens before being converged at the sensor. Neither the black rook nor the bishop are contained within the purple field.

The starting principle is that the field is limited, like a budget, and it is down to the photographer to choose how to 'spend' that budget. In Fig 129, it is spent quickly, with light spreading out widely. If the goal is to keep the black pieces within the field, it must be stretched thinner so that it extends deep enough to include those pieces. Three variables can be used to extend (or compress) the depth of the field: aperture, focal length and distance to subject. When stretched thinly the field is sufficiently deep to keep all three chess pieces in acceptable focus (Fig 131). This happens for a number of reasons:

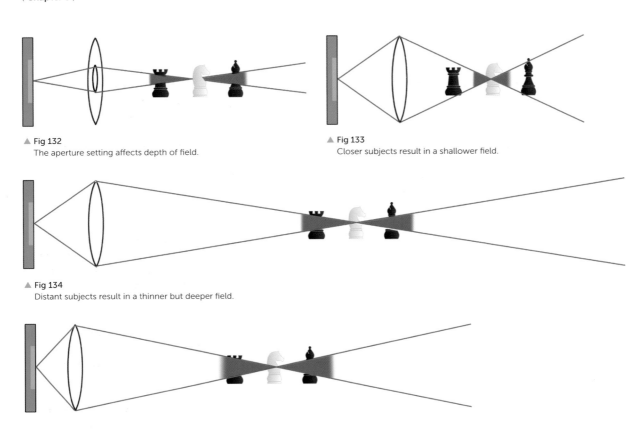

▲ Fig 132
The aperture setting affects depth of field.

▲ Fig 133
Closer subjects result in a shallower field.

▲ Fig 134
Distant subjects result in a thinner but deeper field.

▲ Fig 135
Wide-angle lenses extend the depth of field.

▲ Fig 136
A longer telephoto lens converges light much faster, narrowing the depth of field.

Aperture

A smaller hole stretches light and prevents it from spreading out. A small hole therefore provides a deeper depth of field, and the purple shaded area becomes longer and thinner (Fig 132).

Distance to subject

As the distance to subject increases, depth of field increases. The closer the subject is to the camera (Fig 133), the shallower the depth of field will be. This is noticeable when photographing very close-up subjects. On the other hand, when the camera is focused upon a subject on the horizon, depth of field extends much further (Fig 134).

FOCAL-PLANE MARKER

In specialist usage (such as macro photography), knowing the exact distance between subject and sensor can be critical. DSLR cameras have a focal-plane marker (Fig 137) etched on the top of the camera body. This etching marks the position of the camera's sensor and can be used as a reference from which to take measurements.

◀ **Fig 137**
The focal-plane marker etched into the camera body is used to mark the exact location of the camera's sensor.

Focal length

A telephoto lens provides a much shorter depth of field than a wide-angle lens. Super wide-angle and fisheye lenses provide huge depths of field. Figs 135 and 136 demonstrate how longer and shorter lenses affect the convergence of the field.

For photographers seeking the shallowest or deepest possible depth of field in any shooting situation, each of these variables must be managed to fully achieve the limits of the camera and lens combination.

SUMMARY

'Aperture' is the term given to the hole inside the lens through which light enters the camera. Varying the size of the aperture increases or decreases the amount of light that creates the photograph. Aperture settings are represented by using a number also known as an f-stop. Each full f-stop admits either half or double the amount of light in relation to its neighbour.

Although functionally the aperture controls the amount of light that enters the camera, the chosen value also impacts significantly upon 'depth of field'. The most important points to remember are:

- Low numbers (f2.8) = a large hole = shallow DOF
- High numbers (f22) = a small hole = deep DOF

Aperture priority is a way for the photographer to specify the precise f-number while the camera deals with the other exposure variables. With an understanding of the principles of aperture function, it is possible to use both shallow and deep depth of field for creative effects, including isolating detail and leading the eye within the frame.

Chapter 9

Understanding the Shutter

- What is the shutter and what is a shutter speed?
- How does the shutter work?
- What does shutter priority mode do and how does it work?
- Using fast shutter speeds.
- Using slow shutter speeds.
- Zooming and panning during the exposure.
- Painting with light.
- Best practice: long exposures.
- Long shutter speeds during daylight (ND filters).

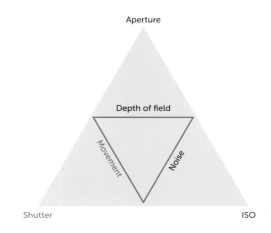

▲ Fig 139
Shutter speed located within the exposure triangle.

Aperture gives the photographer a way of controlling both the amount of light entering the camera and depth of field. The second of the semi-manual exposure modes is shutter priority (also known as time-value, or TV).

WHAT IS THE SHUTTER AND WHAT IS A SHUTTER SPEED?

The shutter is a mechanism located within the camera body that opens for a predetermined amount of time, allowing light to enter before it closes. The longer the shutter remains open, the more light enters. The unit of time used by cameras is one second. Faster shutter speeds are represented

as fractions of seconds, whereas longer speeds are quantities of seconds. A typical range of shutter speeds is:

Faster – 1/8000, 1/4000, 1/2000, 1/1000, 1/500, 1/250, 1/250, 1/125, 1/60, 1/30, 1/15, 1/8, 1/4, 1/2, 1, 2, 4, 8, 15, 30 – Slower.

Shutter speeds change the amount of light entering the camera incrementally by the same ratios as the aperture. This means that the next setting faster or slower doubles or halves the amount of light entering the camera. For example, a shutter speed of 1/30th of a second lets in double the amount of light compared with 1/60th. The shutter forms the second corner of the exposure triangle (Fig 139). Modifying the shutter speed also controls how the camera records movement and the passing of time.

◀ Fig 138
The shutter dictates the length of the exposure.

▲ Fig 141
The behaviour of the shutter curtains during slower exposures: green arrows mark the movement of the first curtain, red arrows mark the second curtain.

◀ Fig 142
The behaviour of the shutter curtains during fast exposures.

▲ Fig 140
A focal-plane shutter mechanism (from a Nikon D4 camera).

HOW DOES THE SHUTTER WORK?

There are some exceptions but most modern cameras use a focal-plane shutter. This type of shutter is located within the camera body (Fig 140) whereas the aperture is located within the lens. This means that, when the lens is changed, potentially the camera can benefit from a larger maximum aperture value. However, because the shutter is an integral part of the camera body, the shutter speed range is fixed.

The majority of shutter mechanisms comprise two curtains (Fig 141). The first curtain (marked with green arrows) opens the shutter before the second curtain (red arrows) closes it. For relatively slow exposures (less than around 125th of a second), the first curtain opens the shutter fully, exposing the entire sensor to light. Then, after the specified duration, the second curtain follows to close the exposure.

For faster shutter speeds, such as 1/2000th of a second, there is no single moment when the entire sensor is simultaneously exposed to light. This is because when the shutter is activated the first curtain opens the shutter and almost immediately the second curtain follows the first to finish the exposure. At no point is the shutter fully open; instead, photographs created with fast shutter speeds are exposed by a moving slit (the gap between the curtains).

WHAT DOES SHUTTER PRIORITY DO AND HOW DOES IT WORK?

When the mode dial is set to shutter priority (Fig 143), the photographer selects the shutter speed and the camera works out the aperture (and sometimes ISO).

◀ Fig 143
The mode dial set to shutter priority.

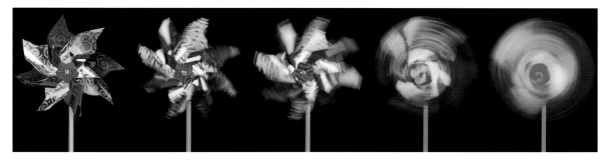

▲ Fig 144
The effect of different shutter speeds on movement in fractions of seconds, 1/500th, 1/60th, 1/15th, 1/2 and 1-second shutter speeds.

Shutter priority is an ideal mode when the most critical aspect of the photograph is rendering movement. The effect of either fast or slow speeds is dependent on the movement of either the subject or the camera. To freeze action a fast shutter speed should be selected. Alternatively, scenes featuring blurred trails to give a sense of movement would require slow shutter speeds. The same scene can be photographed with different speeds and appear very different (Fig 144).

The sports scene mode (*see* Chapter 7) is a way of prioritizing a fast shutter speed. One downside of this mode is that the photographer has no control over whether the camera selects 1/250th or 1/2000th of a second. 1/250th is fast, but it would not stop a speeding bullet. Sports mode also rarely utilizes the full range of shutter speeds available. If the subject demands a truly fast shutter speed, such as 1/8000th of a second, even in very bright conditions it is likely that the ISO setting will have to be changed to prevent underexposure. (For more on ISO, *see* Chapter 10.)

USING FAST SHUTTER SPEEDS

Fast shutter speeds can reveal scenes and situations that are normally too fast for human perception. Before considering practicalities, it is helpful to define what makes a shutter speed 'fast'? Under normal conditions, it is standard practice to consider anything above 1/60th of a second fast, but the focal length of the lens being used is significant too. For example, when using a 200mm lens, anything faster than 1/200th of a second is considered fast. The variation occurs because a lens with a longer focal length is harder to hold steady – any small movement is magnified – so longer lenses need faster speeds in normal conditions to avoid camera shake.

When choosing to use a fast shutter speed the photographer is usually prioritizing the act of freezing motion above other exposure variables such as depth of field. In Fig 145 a shutter speed of 1/1000th of a second was used to freeze the truck in

▲ Fig 145
A truck frozen in mid-air using a shutter speed of 1/1000th of a second.

mid-air and capture the debris flying from the cars underneath. Slower speeds would have resulted in a soft-edged blur.

Fast shutter speeds are frequently used to freeze action, while slow speeds provide an alternative way of communicating movement (Figs 146 and 147).

There are situations when the camera will not allow the fastest speeds to be selected. For example, in dark conditions the camera is unlikely to allow an exposure of 1/4000th of a second. This is because even with the aperture wide open insufficient light is able to enter the camera in such a brief amount of time to make an exposure. The camera is likely to display 'Lo' in the viewfinder (or the maximum aperture value of the lens may flash), indicating that light levels are too low to use the selected shutter speed.

USING SLOW SHUTTER SPEEDS

'Slow' usually refers to a shutter speed that makes it difficult to hand-hold the camera really steady, without experiencing camera shake. Modern anti-shake lenses compensate for any trembling of the human hand, and image-stabilization technologies make it easier to hand-hold the camera even at slower speeds (see Chapter 2). Even with the steadiest of hands, exposures longer than around 1/15th require the camera to be kept static on a firm surface or tripod.

Slow shutter speeds allow the photographer to record movement by recording the passing of time through smearing movement and leaving trails. Fig 148 represents a challenging shooting situation. The shooting conditions in the fairground were dark but, with a shutter speed of six seconds, movement is blurred while the rest of the scene remains sharp.

When selecting a slow shutter speed (assuming an overall blur is not part of the desired aesthetic), the camera needs to remain motionless while the shutter is open. A tripod is ideal, although any sturdy surface will do. If the camera remains still, only the movements of the subject will leave trails. If the camera moves (camera shake), the entire image will become blurred. In Fig 149, the photograph suffered from being taken from a moving helicopter in dark conditions. The camera was unable to select a sufficiently fast shutter speed to compensate for the moving shooting position.

There are exceptions, and certain subjects do require a moving camera. In Fig 150 the camera was fixed to the car, so it was moving, but at the same speed as the rest of the car. The shutter speed was set at two seconds and, although both the camera and the car were moving, the interior of the car remained within acceptable focus. The streetlights and surroundings passing on either side of the moving car were blurred because they had moved in relation to the camera's position.

▶ **Fig 146**
Speeding cyclists in the Tour
of Britain are frozen in time
by using a shutter speed of
1/4000th of a second.

▶ **Fig 147**
Cyclists captured with a
slower shutter speed of
1/20th second are rendered
as a blur.

▲ Fig 148
A fairground ride photographed using a shutter speed of 6 seconds.

▲ Fig 149
Camera shake caused by slow shutter speeds combined with an unsteady hand (in a helicopter, at night, over Las Vegas).

▲ Fig 150
Using a slow shutter speed while the camera moves at the same speed as the subject.

▲ Fig 151
Slow shutter speeds can be useful for dark urban cityscapes

Blurring movement is a good reason to select a slow shutter speed, though there are situations when a slow speed is a necessity simply to admit enough light into camera. In Fig 151 an exposure of two seconds was required to expose the dark flooded car park; if flash had been used, only the foreground would have been illuminated and the reflections from the overhead lights would have been lost.

ZOOMING AND PANNING DURING THE EXPOSURE

Moving the camera or lens during the exposure can change the appearance of the photograph. Two examples of camera movements are zooming and panning.

Zooming

'Zooming' refers to changing the focal length of the lens mid-exposure. This technique produces trails from highlights leading from the centre of the frame to the edge. In Fig 152 the model was photographed

▶ Fig 152
During the 1/3rd second exposure the lens was zoomed between 18mm and 200mm and a burst of flash was fired.

on a beach in near-dark conditions. A shutter speed of a third of a second was selected. When the shutter was activated, the camera fired the flash (which lit the model and the sand in the foreground). During the remaining time that the shutter open, the zoom ring of the lens was rotated from 200mm to 18mm. The change in focal length can be seen through the movement of the coloured lights in the background (which moved in relation to their position within the frame). The model in the foreground remained static because she was lit by a brief burst of flash.

Panning

Panning involves lateral movement along a horizontal axis, following the path of the subject as it moves. Visually, its effect is similar to Fig 150 because the camera stays still in relation to the subject. Panning is used to communicate a sense of speed while keeping the important parts of the composition sharp. The technique is popular with motorsports photographers – a photograph of a car travelling

▲ Fig 153
Panning at 1/40th second keeps the car relatively sharp but blurs the background.

at 200mph is much more impressive if it gives a sense of its movement. In Fig 153, a shutter speed of 1/40th was used. The car remains sharp because the camera was moved to keep the car in the centre of the frame throughout the exposure.

▲ Fig 155
Slow shutter speeds can be used in dark conditions to draw patterns with light.

▲ Fig 154
Using torches to paint light during a long exposure (30 seconds).

▲ Fig 156
Steel wool photography in a night landscape.

PAINTING WITH LIGHT

As an alternative to recording ambient light, it is possible to introduce supplementary light sources while the shutter is open. In Fig 154 the scene was completely dark; the camera was placed on a tripod and the shutter speed set to 30 seconds. During the exposure the photographer and assistants shone torches on to the columns to 'paint in' areas of detail.

To produce a variation of this effect an artificial light source may be introduced in a different way. In Fig 155, the camera was mounted on a tripod with a shutter speed of 15 seconds and the photographer used moving LED lights to draw patterns within the night landscape. Because the photographer was continually moving, the presence cannot be seen in the final photograph.

Another popular and relatively easy technique is

to write or draw symbols using sparklers. Because the sparks are so bright, the movement of the sparkler will be recorded simply by setting the camera to S mode and selecting a long exposure. For photographers interested in this technique, there is a more advanced version, known as 'steel wool photography' (Figs 138 and 156). This effect is achieved though long shutter speeds and moving burning steel wool that disintegrates as it burns. Search online for 'steel wool photography' for further examples and tutorials.

BEST PRACTICE: LONG EXPOSURES

Camera shake can continue to be a problem even when a tripod is used. To avoid vibration when the shutter release is activated by hand, care should be taken to gently squeeze the shutter release rather than actually pressing it. Better practice is to use the camera's self-timer or a remote control to avoid touching the camera. The photographer should stay quite still during the exposure because any vibrations from his or her movement can travel through the ground and affect the tripod. Another source of vibration is introduced by the camera's own internal movements. To combat this most DSLRs have a mirror lock-up setting (Mup) (Fig 157).

When set to mirror lock-up mode the mirror flicks up out of the way when the shutter is pressed for the first time. This means that when the photograph is taken for real (when the shutter is pressed for the second time), the mirror is already in place and internal vibrations are reduced.

▶ **Fig 157**
Mirror lock-up setting, which causes the mirror to move before the photograph is taken, to reduce vibration.

▲ **Figs 158 and 159**
The same scene takes on a different feeling when photographed at night.

LONG SHUTTER SPEEDS DURING DAYLIGHT (ND FILTERS)

Slow shutter speeds are usually associated with low-light or dark conditions and scenes that appear uninspiring during the day can change dramatically when captured using longer exposures at night.

▲ Fig 160
A neutral density (ND) filter fits over the lens and reduces the amount of light entering the lens.

▲ Figs 161 and 162
The same scene photographed at 12 seconds and 1/60th second. The slower shutter speed records the movement of the water as a soft blur.

For landscape photographers the time of day (or time of year) can provide an alternative aesthetic. Dawn, dusk and night-time can offer rich shooting opportunities, with warmer lighting and longer shadows. The view of Tokyo was first photographed in daylight (Fig 158), and then captured later at night using a shutter speed of six seconds (Fig 159).

In Fig 151 the dark conditions made the long exposure easy to achieve, but in daylight conditions such slow shutter speeds are much harder to achieve. If attempted, the camera will display an error message (which may be 'Hi' appearing in the viewfinder). This is a warning to the photographer that the settings will result in significant over-exposure. Even with the aperture closed to the smallest setting, a six-second exposure will still let in too much light. Photographers using slow speeds in daylight require a neutral density filter (also known as an ND), which attaches to the lens. These filters reduce brightness without altering colour.

ND filters are sold in a range of varying densities that reduce the light entering the camera in 'stops'. For example, if the slowest shutter speed available in daylight is two seconds, fitting a ND filter with a density of one stop would mean that the photographer could use an exposure of four seconds without risking overexposure. Although listed as *f*-stop reduction, using the concept of photographic reciprocity (the doubling or halving of light in both aperture and shutter speed values), the numbers

SHUTTER ACTUATIONS

Similar to the mileometer of a car, a digital camera records the number of shutter actuations that occur. This figure is also used by manufacturers as a guarantee of shutter reliability. When viewing second-hand cameras, sellers will often specify the actuations of a camera to illustrate the level of usage.

The shutter actuation of any camera is embedded into the photographs it produces. It is possible to find out the actuation count of a camera by using software that reads the file metadata or simply uploading a photograph to: myshuttercount.com

refer to a single unit of exposure that may be used to extend aperture, shutter speed or ISO. Used in a shooting scenario, if the metered scene gave an aperture value of ƒ8 at 1/60th second and a five-stop ND filter was used. Knowing that the difference between 1/60th of a second and 1/30th second is one stop, 1/15th would be two stops, 1/8th three stops, 1/4 would be four stops, 1/2 would be the final exposure with the ND filter in place.

ND filters enable movement to be blurred in a way that would be impossible to achieve in daylight conditions. In Fig 161 moving water was photographed in daylight (1/60th), then shot again with an ND filter. The density extended the shutter speed to 12 seconds. The water appears softer rather than having a sharp and frothy surface (Figs 161 and 162).

SUMMARY

It is important to have an understanding of the construction, function and effect of the camera's shutter. 'Shutter speed' refers to the length of time the shutter remains open to allow light to enter the camera, so varying the shutter speed increases or decreases the amount of light that makes the photograph. The selected speed also has a significant impact on the way movement is recorded.

Shutter speed values exist in a range where each setting halves (faster) or doubles (slower) the amount of light entering the camera compared with its neighbour. Shutter priority mode enables the photographer to specify the exact speed required from the range while the camera modifies other parameters in order to balance the exposure.

A speed faster than the focal length of the lens (in mm) is considered a fast shutter speed. Fast speeds reduce the risk of camera shake and can freeze subjects that are too quick for the eye. Slower shutter speeds can be used to smear movement or leave trails, or reveal colour and detail in low light. During long exposures, camera movements such as panning and zooming can be engaged for creative effect. Slow shutter speeds are problematic in daylight but may be facilitated using an ND filter.

Chapter 10

Understanding ISO

- What is ISO?
- Accessing camera ISO settings.
- What effect does altering ISO have on the image?
- What is 'noise'?
- Factors that mitigate the effects of noise.
- What is Auto ISO and how does it work?
- Why change the ISO setting?
- Noise reduction options.

The three corners of the exposure triangle affect the aesthetic of the image. The first two variables, aperture and shutter speed, dictate the amount of light entering the camera; the final corner (ISO) is a little different, in that it increases or decreases the sensitivity of the sensor to light.

WHAT IS ISO?

The term ISO is an abbreviation that stands for International Standards Organization. In photographic terms, 'ISO' indicates the numeric measurement of the camera sensor's sensitivity to light. Whereas aperture and shutter speed define 'how' the required amount of light enters the camera, ISO defines the 'amount' of light required. ISO value forms the final corner of the exposure triangle (Fig 164).

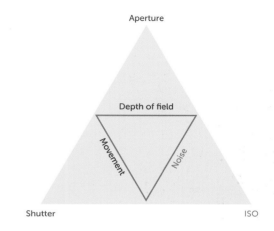

▲ Fig 164
ISO in the exposure triangle.

ACCESSING CAMERA ISO SETTINGS

Cameras provide various methods by which their ISO setting may be changed. Some models offer ISO as a button that, when pressed, enables a command dial to select a value (Fig 165). Other manufacturers offer ISO as a menu item on the camera (Fig 166). Either can work well, although when shooting it is useful to be able to change the ISO without having to take the eye away from the viewfinder. For this reason, many photographers find a dedicated button preferable to a menu that needs to be navigated.

The ISO options available in most digital cameras are the 'stops' of 50, 100, 200, 400, 800, 1600, 3200, 6400, 12,800 and 25,600. Some cameras offer an even higher range of numbers (settings that go beyond these extremes values are sometimes listed as Low1, or Hi+1, Hi+2, and so on). To increase precision and flexibility, most cameras also offer

◀ Fig 163
Visible noise at 800 ISO.

▲ Figs 165 and 166
ISO control on a Nikon camera and as a menu option on a Canon.

▲ Fig 167
Film grain is visible at ISO 3200 (circled area magnified).

these increments in halves or thirds of stops. Just like aperture and shutter speed, each full stop value requires exactly half or double the amount of light of its neighbour. For example, ISO 100 requires half the amount of light to create an exposure compared with ISO 50 but double the amount of light compared with ISO 200.

For early photographers ISO was not such a flexible and convenient variable. Film has a fixed ISO speed and if the photographer wished to change ISO it meant removing the roll of film and loading another with a different ISO speed.

Film is made up of a gelatin base covered in tiny silver halide (light-sensitive) crystals. Slower films (ISO 50, 100, 200) have a finer density of crystals that provide a finer, smoother image with less grain. Slow films require a greater amount of light to produce an exposure than a more sensitive film. Films that are more sensitive to light are known as 'fast' films (ISO 400, 1000, 3200 and beyond). Fast films contain larger crystals that do not require as much light to expose and introduce coarse graining within the image. Fig 167 shows an enlargement of film grain.

When considering ISO in relation to film, cause and effect are simple to grasp: the faster the film, the higher the sensitivity and the grainier the

image will be. For digital cameras, the sensor is not interchangeable so the actual physical sensitivity to light remains constant. Each sensor has a native ISO speed (the speed at which the sensor was designed to provide optimum performance); this is usually either 100 or 200 ISO.

Without being able to change film, digital cameras rely on the process of electrical amplification to boost ISO speed. When a higher (than native) ISO setting is selected, the camera uses amplification to boost the smaller than optimum amount of light into a sufficient quantity to create an acceptable exposure. For example, if a sensor has a native ISO speed of 100, and the photographer sets a value of 200 ISO, the camera receives half of the light that the sensor requires to make a photograph. The camera processor then 'amplifies' the signal until the quantity of light is sufficient. This means that, when describing ISO digitally, the higher the ISO rating, the greater the amount of amplification that is applied to the light admitted to the camera.

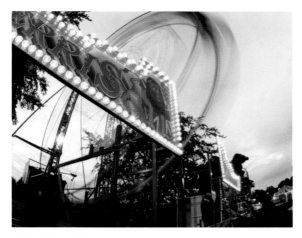 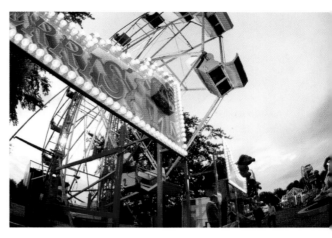

▲ Figs 168 and 169
ISO settings of 50 (left) and 26,5000 (right) were used to create these files of a moving subject in low light.

WHAT EFFECT DOES ALTERING ISO HAVE ON THE IMAGE?

ISO has a powerful influence on exposure decisions because its value directly informs the shutter and aperture settings available. The flexibility provided by high ISO settings comes at a cost. Amplification introduces interference and visible noise and, the higher the level of amplification, the more obvious these undesirable traits become in the resulting photograph. A good analogy is to compare the amplification of light with the more familiar over-amplification of sound. Consider how the spoken word sounds when recorded by a microphone. If the voice is close to the microphone the signal is strong and clear. However, if the voice is farther from the microphone, the sound signal is weaker and must be amplified to achieve the same volume of speech. The process of amplification degrades and distorts the weaker sound signal, introduc-ing hiss and interference. The same is true of the amplification of light, except the background 'noise' is experienced visually rather than aurally. The scene of a big wheel (Figs 168 and 169) was photographed at the extremes of slow and fast ISO speeds. At small

▲ Fig 170
The image on the right was shot at ISO 25,600. The increased graining and lack of detail are referred to as visual 'noise'.

sizes the differences in quality appear negligible but, after enlargement (Fig 170), the effects of high ISO become more obvious.

WHAT IS 'NOISE'?

Film grain can be aesthetically appealing whereas digital 'noise' is almost always considered ugly. Noise makes pictures appear pixelated, lacking in colour and speckled with a pattern of unwanted random sludge. The traditional tonal prevalence of

grain is reversed in digital photography. Film grain is most obvious in the midtones and highlights; digitally, the opposite is the case. Noise manifests itself most significantly in the blacks and shadow regions of the photograph. This is because brighter areas of the image receive more light, which by definition means they require less amplification. The images in Fig 171 were photographed at 50 ISO (left) and 25,600 ISO (right).

▲ Fig 171
Noise is more noticeable within the darker areas of a high-ISO image.

FACTORS THAT MITIGATE THE EFFECTS OF NOISE

Noise management is an area of digital photography that has improved significantly in recent years. Modern cameras deal better with noise through a combination of improved sensor technologies and increasingly sophisti-cated noise-reduction algorithms. At the same time, sensors have increased in size and a larger sensor naturally produces less noise at higher ISO settings than a smaller equivalent.

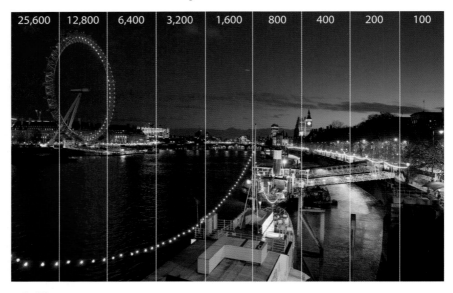

▲ Fig 172
ISO settings compared on a low-light landscape. At 25,600 the noise is most obvious.

This is because the greater the area of the sensor the better it is at gathering light (resulting in a stronger signal). For this reason, DSLR cameras usually produce less noise than compact cameras. Photographers seeking the highest-quality results use cameras equipped with full-frame image sensors. Higher-specification DLSRs can provide acceptable noise handling at speeds of up to around 3200. To test a camera, shoot the same scene at different ISO settings in low light and compare the results (Fig 172)

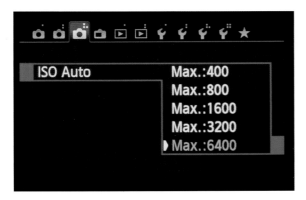

▲ Fig 173
A Canon menu limiting the scope of Auto ISO.

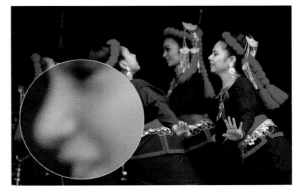

▲ Fig 174
A high-ISO concert/performance image, shot at 1600 ISO to enable a shutter speed of 1/60th.

WHAT IS AUTO ISO AND HOW DOES IT WORK?

Auto ISO grants the camera permission to dynamically alter the ISO on an image-by-image basis. This can be convenient in changing conditions. For example, if a photographer is shooting in aperture priority mode and has selected *f*22 (for maximum depth of field), and the light level reduces (perhaps a cloud passes in front of the sun), the camera may have to resort to using long shutter speeds (which would blur any movement of the subject or introduce camera shake). Auto ISO may boost the ISO so that the small aperture can still be used with a fast speed.

One significant disadvantage of relying on Auto ISO is that a camera is far more inclined to accept the negative visual side effects of using high ISO speeds than a photographer. Auto ISO has a tendency to select a higher ISO value when another combination of settings might have created the same exposure with less noise. In response, many cameras offer the option to specify an upper limit on the fastest ISO that the camera will select when set to Auto ISO (Fig 173). This can be useful if a camera is known to exceed acceptable noise at a particular ISO value.

WHY CHANGE THE ISO SETTING?

Balancing any corner of the exposure triangle is a question of compromise. In the case of ISO, the choice involves weighing up the importance of higher-quality images obtained using slow ISO speeds against the benefits of using the faster shutter speeds and narrower apertures that are associated with fast ISO settings. Wherever possible, it is best practice to select the lowest ISO value that the lighting conditions allow. In dark conditions where the flash cannot be used, if the aperture is already wide open and the shutter speed cannot be reduced due to movement, high ISO values are the only option left. Scenes and subjects that call for these decisions vary, although they often combine low light conditions with moving subjects. Examples may include concerts, church services and indoor sports.

Concerts

In dim conditions, with a performer moving around on stage, the photographer cannot always rely on flash. The stage could be too far away, or the flash may dominate the subtle ambient lighting – neither are desirable outcomes. If the metered scene suggests that the aperture is wide open at *f*2.8, and with an ISO of 200 the camera requires a shutter speed

▲ Fig 175
A high-ISO church image photographed at 800 ISO.

of 1/8th second, the photographer has a problem. The likely outcome is camera shake, combined with a blurring of the performer. If the photographer decides that the required shutter speed should be 1/60th second, then the shutter speed is removing three stops of light from the exposure (which would result in severe underexposure). In order to balance the exposure, three stops would need to be added to the ISO value (giving a value of 1600 ISO). This choice of exposure was used in Fig 174; notice the enlarged area detailing noise.

Church services

Professional photographers are frequently required to record official ceremonies in a dimly lit environment such as a church. Camera flash can be obtrusive during events such as weddings – indeed, many officials forbid its use – and church interiors are often high-contrast environments combining dark corners with bright stained-glass windows. Although camera shake is less of an issue, the camera will need to use a reasonably fast shutter speed (around 1/60th) combined with a mid-range aperture (f8), allowing sufficient depth of field for the participants to be in focus. With both variables fixed, the photographer would then increase the ISO value until the exposure balanced to create a sufficient exposure.

Indoor sports

Most sports involve action and speed. For a viewer to comprehend a sports photograph, the scene usually needs to be 'frozen'. Imagine a picture of a table tennis match where the ball was not visible, or a high diver photographed mid-somersault using a slow shutter speed. The starting principle for selecting the most appropriate exposure parameters would be to aim for the fastest possible shutter speed that conditions will allow. If the metered exposure given by the camera is f4, 1/8th second at 100 ISO, the photographer could choose to increase the ISO rating to the maximum possible value, and from this value work out the fastest shutter speed available for the conditions. As an example, if the fastest ISO value available on the camera is hi+2 (which represents an increase of ten stops from 100 ISO), the approximate ISO value is 102,400 ISO. This extreme setting would enable the photographer to increase the shutter speed by ten stops. This would mean that the maximum shutter speed in these conditions could be up to 1/8000th second. The image would be very low in quality, crammed with noise, artefacts and defects.

Camera flash may be permitted at other sports events, although high ISO can still play an important role. If the ISO value is set high – for example, at 400, 800, 1600 – the flash does not have to provide as much output and can also act as a fill to the ambient light. A related advantage of using high ISO with flash is that, because the flash does not need to work so hard, it can recycle faster. This can be particularly important in sports photography where timing is often crucial.

NOISE-REDUCTION OPTIONS

There are situations when the only option available is to increase the ISO speed beyond ideal limits. When this is the case, it is possible to mitigate the

▶ Fig 176
A standard noise-reduction options menu.

▶ Fig 177
Three different noise-reduction settings applied in Adobe Lightroom.

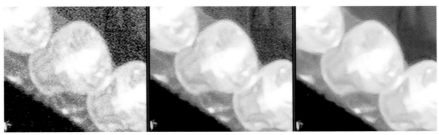

effect of the noise on the image. The first option is to reduce noise using the camera's built-in noise reduction algorithms (Fig 176). These are activated through the camera's internal menus and usually offered in a variety of strengths. The advantage of using these menu options is that they are convenient, applied in equal measure for each shot and require no input from the photographer.

The disadvantage of using camera processing is the lack of control over how the effect is applied. Camera presets can often appear to soften an image and lose detail. The increments of noise reduction often occur in big jumps when a more subtle approach may be preferred. A better alternative is to use software such as Adobe Lightroom so that 'pixel-critical' noise-reduction decisions can be compared and manipulated in minute detail according to taste. (Fig 177 shows a close-up area of Fig 170.)

Noise reduction is a delicate balance between softening the particles of noise while maintaining edge detail in the image. This process should be applied with care as overuse can result in soft and unnatural images.

SUMMARY

A number of changes take place inside the camera when the ISO value is changed. Low ISO settings provide finer image quality although require more light to expose than high numbers. High ISO values introduce 'noise' to the photograph, which is most obvious in the shadows.

Auto ISO can be an effective setting, but performs better when it is limited, so that ISO values do not exceed around 800 ISO. There are occasions when noise is a price worth paying to use faster shutter speeds or smaller apertures. When this is the case there are strategies for reducing the effect in both the camera processing stage and software solutions.

Once you have an understanding of all three corners of the exposure triangle, it is time to move on to the fully manual exposure mode.

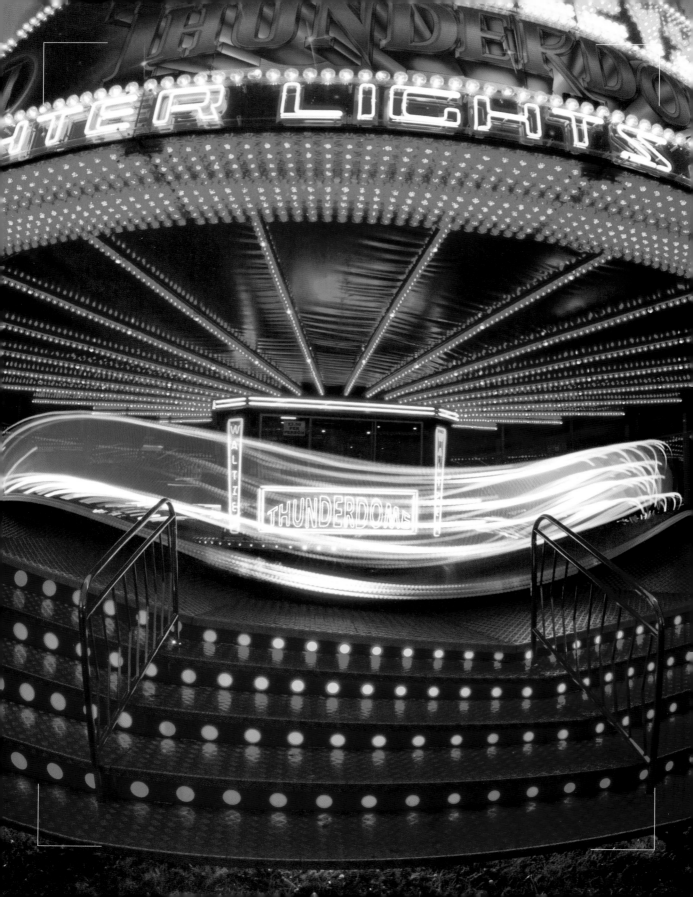

Chapter 11

Understanding Manual Exposure Mode

- What is M mode?
- Advantages and disadvantages of using M.
- Where to start with manual exposure mode.
- Reading and controlling the camera's meter.
- Disadvantages and advantages of using M.
- What is bulb mode and why use it?
- When to use M mode: low light; balancing ambient light with flash; slow shutter speeds with flash.

There are a number of advantages and challenges involved in using the manual exposure mode to gain full control over the exposure parameters. When set to M mode, the shutter, aperture and ISO may be changed independently of the other variables.

WHAT IS M MODE?

To avoid confusion, manual mode (as illustrated by the position of the mode dial in Fig 179) refers to the manual function of exposure only (aperture, shutter speed and ISO). The camera can still use auto-focus, auto white balance and use automatic flash functionality while set to M (these can be switched off in the menus if not required).

In automatic modes, the camera retains control of at least one corner of the exposure triangle. Even with just one corner within its grasp the camera will generally be able to prevent exposure catastrophes. In manual mode, this is no longer the case, and it is perfectly possible while shooting manual to create

◀ Fig 178
M Mode provides independent control of the exposure parameters.

▶ Fig 179
The mode dial set to manual exposure mode.

▲ Fig 180
All three corners of the exposure triangle are the responsibility of the photographer to manage in M mode.

images so underexposed that they are pure black or so overexposed that they emerge pure white.

Manual mode may appear unnecessary and over-complex. Why should a photographer bother to use it when cameras today employ such sophisticated technologies and scene recognition modes? The answer is that the camera's interpretation of a correct exposure does not always match that of the photographer. For example, the camera will prize a sharp and bright image, whereas the photographer may sometimes wish for the scene to be rendered dark and blurred.

From using S mode and A mode it is already apparent that there are many different combinations of settings that will result in the same amount of light entering the camera. For example, in aperture priority, if the photographer opens the aperture from ƒ8 to ƒ5.6 the camera may change the duration of the exposure from, say, 1/60th to 1/125th of a second, to maintain the overall exposure value. If set to Auto ISO, the camera may reduce the ISO from 200 to 100 to achieve the same effect. In manual mode the decision of how to balance the exposure rests with the photographer; if it is not balanced, the resulting exposure will suffer either over- or underexposure.

WHERE TO START WITH MANUAL EXPOSURE MODE

First, consider whether manual is necessary. If the camera's automatic setting suggests an exposure of ƒ8, 1/125th of a second at 200 ISO, the photographer needs to consider why this setting may not be suitable and why it should be changed. Likely reasons to change the setting would be to affect depth of field or movement – could either of these be achieved using either S or A modes? If so, most photographers find these modes an expedient way of adjusting the exposure while avoiding the necessity of manually balancing it.

When the camera is set to M, the first variable most frequently set is ISO. In situations where lighting is sufficient, a value of anything up to around 800 is acceptable (with lower values giving better quality). Once one variable is defined, it is much easier to balance exposure on the fly using just aperture and shutter speed. If the ISO value is static and the shutter speed changes, aperture must be compensated, and vice versa. Understanding the changes that need to be made is indicated by the camera's exposure meter.

READING AND CONTROLLING THE CAMERA'S METER

In manual mode the camera's meter becomes visible to the photographer, while in automatic modes only the camera's chosen settings are displayed. The meter will be displayed both in the viewfinder and, usually, the camera's LCD screen (Fig 181). This acts as a visual guide, notifying the photographer whether the camera believes the image is over- or underexposed.

Assuming that the subject contains a full range of tone (in other words, the photograph is not of a black cat at night), the goal, as far as creating a technically correct exposure is concerned, is to modify either the shutter speed and/or aperture to obtain a balance. This is achieved by varying the amount of light entering the camera until the bars either side of the central zero marker disappear. If the shot remains either over- or underexposed with the desired settings, then the ISO value can be adjusted to give additional exposure flexibility.

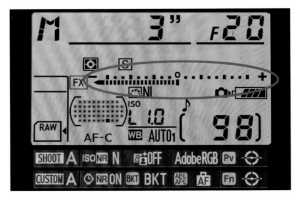

▲ Fig 181
The info on the camera's LCD screen showing the exposure level (circled); in this instance the meter is showing that the scene is underexposed.

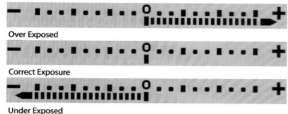

Over Exposed

Correct Exposure

Under Exposed

▲ Fig 182
Viewfinder and LCD display of the meter information.

◀ Fig 183
AV button (and exposure compensation), when pressed, changes the action of the command dial to vary the aperture.

To change the position of the light meter both shutter speed and aperture may need to be changed. Most DSLR cameras have a single command dial located for easy access by the photographer's right thumb; when this dial is turned, the shutter speed will adjust. When the same command dial is turned while the AV button (Fig 183) is depressed, the aperture value will change. This should be practised until both aperture and shutter speed can be altered without needing to remove the camera from the eye.

Higher-specification cameras have two command dials: a main dial located for ease of access by the right thumb and a secondary sub-command dial in front of the shutter release (accessed by the right index finger). The main dial is used to change shutter speed whereas the sub-dial adjusts the aperture. Some photographers find two dials easier to use rather than pressing and holding buttons on the back of the camera while shooting.

▲ Figs 184 and 185
Command dial and sub-command dial, both used for varying the exposure parameters and navigating menus.

DISADVANTAGES AND ADVANTAGES OF USING M

The disadvantage of manual exposure mode is the extended time that it takes the photographer to work out, specify and compensate for the individual exposure parameters when compared with automatic modes.

Specific advantages of M will become apparent in the examples given later, but the most significant

▲ Fig 186
High-contrast scenes present metering challenges that may exceed the exposure compensation options available.

▲ Fig 187
A panorama landscape collage photographed in automatic mode.

is the complete control that the photographer has over the exposure parameters. For example, cameras offer a limited amount of exposure compensation (usually +/-3 stops). In high-contrast lighting scenes, such as Fig 186, it is possible that the camera's automatic exposure will be out by more than three stops. Manual mode allows access to a much larger range of exposures than those that are permitted in any other mode.

Manual mode is also helpful when a consistent exposure is required. This is less of an issue when shooting a single frame but, when shooting a series of images, consistency is important. A good example of this is when shooting a sequence of pictures that will be stitched together to create a panorama. In Fig 187, the panorama was shot using automatic mode (the effect would have been the same in either P, A or S modes). In each shot the camera evaluated the brightness differently and changed the exposure parameters accordingly – each image has a slightly different exposure and this affects the luminance of the scene (which is particularly noticeable in the saturation of the blue sky).

Shutter speeds become more flexible in manual mode. If a very long shutter speed is required – such as an hour, a week or even a year – manual mode is the only way to achieve this.

WHAT IS BULB MODE AND WHY USE IT?

If the photographer wishes to keep the shutter open in dark conditions for an extended period (for subjects such as lightning or fireworks), bulb mode (only available in M mode) is the most effective way of creating the exposure. Bulb mode is a setting that allows the shutter to remain open for as long as the photographer chooses. It originates from the earliest days of photography when film emulsions had a very low sensitivity to light. This meant that pictures would take minutes to expose rather than fractions of seconds. To activate the shutter the photographer would squeeze a pneumatic valve bulb, which would open the shutter. As long as the bulb remained compressed the shutter would stay open, and it would only close when the bulb was released. The exposure could last for as long as the photographer needed it to.

This bulb function remains in most modern cameras, usually only available in manual mode. While the name remains, rather than compress a pneumatic valve bulb the photographer today simply has to keep the shutter depressed to ensure the shutter stays open. To select bulb mode, engage M mode and scroll the command dial through the

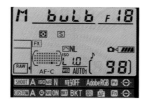

► Fig 188
Bulb mode keeps the shutter open while the release is depressed.

▲ Fig 189
A greater number of fireworks can be captured in a single frame when using bulb mode.

slower shutter speeds. After 30 seconds (shown as 30″), the camera will show the word 'Bulb' (or the letter 'B' on some cameras).

Bulb mode is particularly useful for creating long exposures at night (such as when photographing traffic-light trails). One major advantage is that, in really dark situations, the ISO can be kept low (reducing noise), because the shutter is able to remain open for an extended period.

Photographers using bulb mode do need to be aware of some common pitfalls. First, using long shutter speeds increases the likelihood of camera shake. This risk is heightened by the fact that the photographer needs to keep a finger on the shutter release button. Simple control measures that will assist greatly with creating sharp images are the combination of using a tripod (essential) and activating the shutter using a remote control or cable release (so that the photographer does not make physical contact with the camera during the exposure). Finally, many DSLRs come with a function called mirror lock-up (*see* Chapter 9). This mode reduces internal vibrations, which have the potential to contribute to soft-edged images.

The second pitfall of bulb mode is that, as long as the shutter remains open, the camera battery is being drained. This is unlikely to be an issue for most photographers but for those seeking exposures of multiple hours, alternative power strategies may be required.

In practical use, bulb mode lends itself to a variety of subjects; popular and particularly effective uses of extended shutter speeds include fireworks and star trails.

Case study: fireworks

A common issue with photographing fireworks is that the scene usually consists of black sky with one or two fireworks somewhere in the scene. Frequently, the spectacle of the display is lost. When using bulb mode, the photographer creates a cumulative image recording a much greater and vibrant image (Fig 189).

For a bulb exposure of fireworks the camera needs to remain motionless, ideally on a tripod. Auto-focus should be disabled (to avoid the camera hunting for focus in the night sky). The length of the ideal exposure is dependent on the conditions, the narrowest aperture of the lens and desired ISO. When the first firework is launched, the shutter can be opened. Then, between fireworks, a piece of black card is placed in the front of the lens (to avoid any unwanted light entering the camera). By the time the shutter closes, multiple fireworks can be recorded within a single frame, creating a photograph full of fireworks rather than recording a limited number captured by shorter speeds.

Case study: star trails

As the Earth rotates, the stars change their relative position in the sky. Using a tripod, remote release and bulb mode it is possible to capture the trails of

▲ Fig 190
Trails in the sky caused by the movement of stars.

stars as they move across the sky (Fig 190).

For photographers particularly interested in star trails, there are alternatives to using the 'single-shot' technique of using bulb mode. One simple method is to use the camera's time-lapse function to take a separate photograph every ten seconds for half an hour and then overlay the resulting images on top of each other using editing software. When this method of 'multiple shots' is used, the resulting frames can also be used to create a time-lapse movie of the stars moving across the night sky.

WHEN TO USE M MODE

In addition to bulb mode, manual exposure mode offers the photographer precise control of ISO, shutter speed and aperture in fine increments. While program, scene modes, aperture priority and shutter priority are helpful for influencing exposure parameters, manual mode provides accurate control. The choice to use manual exposure mode is normally made on the fly, and in relation to a particular circumstance where the photographer believes they are better informed to make exposure decisions than the camera.

Case study one: low light

In Chapter 9, slow shutter speeds were used to capture the movement of the fairground ride to achieve blurring of the moving parts. In the same low-light and high-contrast conditions two further images were produced for comparison using manual mode. In the first image (Fig 191), in order to blur movement the photographer mounted the camera on a tripod, suppressed the flash and exposed at three seconds at ƒ22 with ISO 50. The desired aesthetic

▶ **Fig 191**
Three seconds at *f*22 using ISO 50.

▶ **Fig 192**
1/2500th of a second at *f*22 using ISO 6400.

was for the movements of the carriages and internal lights to be blurred. Depth of field and noise were of little concern, although *f*22 and ISO 50 combined to enable the long speed and provide excellent noise handling.

The second of the images (Fig 192) was produced as an alternative, this time seeking to freeze the movement. The exposure was adjusted to 1/2500th of a second at *f*22 and ISO 6400. These decisions

combined to render the fast-moving carriages as static. The high ISO did introduce noise, but this was a calculated compromise enabling a fast shutter speed in dark conditions.

These extremes show why manual exposure mode might be suitable for certain situations. M provides the photographer with different ways of recording the same scene by modifying all three corners of the exposure triangle independently.

Case study two: Balancing ambient light with flash

In this series, subjects were immersed in a tank of sparkling mineral water (Fig 193) and milk (Fig 194). Photographic lights were used to illuminate the models, and the light emitted from them was mixed with ambient light from behind the tank. The photographer's intention was to use the slowest possible ISO to reduce noise, while using the aperture value to control the brightness of the flash, and provide sufficient shutter duration to capture the subtleties of the ambient light. The settings used in both images were ISO 100, 1/4 second at f10.

RESET THE CAMERA

Modern cameras have a vast range of settings, which vary in their complexity and stickiness (preferences such as exposure compensation remain specified even if the camera is switched off). If a camera is exhibiting unexpected behaviours or experimentation has resulted in an effect that cannot easily be switched off, a system reset may be helpful. Resetting the camera to factory defaults can be specified in the camera's shooting menu or in certain models (such as Nikon DSLRs), by pressing and holding the two buttons marked with green dots for five seconds (Fig 196).

▲ Fig 196
Pressing and holding reset buttons is a fast way to restore the camera's behaviour to the factory default.

Case study three: slow shutter speeds with flash

The flash can be used to simulate the effects of a fast shutter speed when combined with slow speeds or bulb settings. Fig 195 used a shutter speed of ten seconds, yet the photograph has captured the moment when the water balloon burst. This is because the photograph was taken in complete darkness.

To achieve this effect the camera was mounted on a tripod and the exposure set to be activated by the self-timer. The shutter was opened and the water balloon was burst using a needle. The noise of the balloon popping activated a sound-sensitive flash trigger. The flash duration was so short that the single flash of light was sufficient to freeze the moment.

▲ Fig 195
Slow shutter speeds combined with flash shot in total darkness give the illusion of a fast shutter speed because the duration of the flash is so brief.

SUMMARY
.

Manual exposure mode brings together the settings that were available in program, shutter priority and aperture priority modes and provides control of each variable independently of one another. The main drawback of using M mode is simply the time that it takes the photographer to consider, manage and balance the exposure in response to changes in subject and shooting conditions. The advantages are numerous, and include the ability to finely control variables while gaining access to the full range of exposure combinations (such as bulb mode). Managing the variables manually enables photographers to cope with high-contrast scenes, manage flash-lit exposures and produce consistent results.

Few photographers use fully manual settings for every shot, but it is helpful to be able to switch to M with confidence when automated settings do not provide the preferred aesthetic. Shooting manual may seem a slow process initially, but enthusiastic users quickly become accustomed to reading and reacting to changes in meter readings and compensating one of the three exposure parameters.

With a full understanding of the manipulation (either automatic or manual) of the exposure triangle, it is possible to build upon these three foundations and consider how introducing light to a scene via the camera's flash impacts upon exposure.

Chapter 12

Understanding the Built-In Camera Flash

- An introduction to the camera's built-in flash.
- Exposing for flash.
- Flash exposure compensation.
- Flash modes.

First, the photographer needs to focus upon exposure in relation to available light and the parameters of the exposure triangle. The next stage is to build upon these principles by introducing camera flash as a fourth variable. Flash is of such significance that its use is detailed over two chapters. This chapter explains how the built-in flash functions, its relationship with the camera and how to modify the output.

AN INTRODUCTION TO THE CAMERA'S BUILT-IN FLASH

Available light is usually the starting point for creating an exposure, but controlled use of flash can lift images in a range of lighting conditions. Flash is not just a convenient tool for lighting up subjects in dark conditions. Flash can be of even greater importance when shooting in daylight conditions. In Fig 198 the flash was fired to balance lighting the subject with the bright sunlight.

Using P mode (*see* Chapter 6) provides some control of the flash – forcing the flash to fire, or taking the opposite approach by suppressing it. Further flash functionality is also available, to enable the

▲ Fig 198
Flash is not just a tool for use in darkness. In this example it has been fired as the fill light (supplementary to daylight), to soften shadows and combat the strong backlighting.

photographer to control variables such as the power, timing and frequency of the output. These variations can determine whether the flash is the main source of light, is used as an accompaniment to ambient light or perhaps just softens the shadows.

Most photographers' first experience of flash is through firing the camera's built-in device (usually a pop-up on a DSLR). This flash is incredibly useful, not least because of its convenience (it is always connected to the camera and runs from the same battery). The built-in flash is designed for small-scale work. Its purpose is to lighten and fill shadows rather than to act as a main light for an entire scene.

◀ Fig 197
Flash may also be useful in daylight conditions.

▲ Fig 199
The pop-up flash of a DSLR.

The specification of the built-in flash varies considerably between cameras in respect of both power and functionality (for more powerful and sophisticated flash options, *see* Chapter 13).

EXPOSING FOR FLASH

The built-in flash amply demonstrates the key principles. First, flash works very well in automatic mode. It is perfectly possible to select semi-manual or manual exposure modes while leaving the flash output to look after itself. If the technical information relating to the flash is too challenging at first, it is not necessary to change flash modes. Instead, it is wise to assess and learn from the results and gradually make changes as knowledge develops through practice. Control of the flash takes a little learning, but the benefits of the techniques are clear in the resulting photographs.

To begin to consider the process of the flash exposure it is useful to break the sequence down. When the flash is enabled, the camera is effectively being asked to make two separate exposures. The first is for the light emitted from the flash; the second for the ambient light already present in the scene. Usually each of these exposures takes place simultaneously and the resulting photograph represents a combination of the two. To deconstruct this process further, if it is not modified by the photographer the flash will use the camera's meter to measure light. This is known as TTL, or 'through the lens', metering. In practice, when the shutter release is depressed the camera meters the scene and locks focus on the subject. Some flashes fire imperceptible pre-flashes to assist with determining ambient light levels. Using this information the camera can work out how powerfully the flash must fire to illuminate the subject at the specified distance.

Before getting into the detail of flash output it is important to understand how the three parameters of the exposure triangle deal with flash. To define these principles, and assuming that the flash power remains constant, the following statements are true:

1 Shutter speed does not affect the brightness of the flash. This is because the electronic flash is so brief that the same amount of flash light hits the subject whether the shutter is open for one second or one-hundredth of a second. While shutter speed does not affect the flash exposure, it does control the ambient light levels. A slower shutter speed brightens ambient light (in this instance the background), whereas faster shutter speeds darken the ambient light levels (Fig 200).
2 Aperture directly affects the brightness of the flash. A large aperture (*f*2.8) provides a brighter flash illumination than a smaller aperture (*f*16) (Fig 201).
3 ISO defines the brightness of the entire scene (through the sensitivity to light). Selecting a fast ISO such as 800 results in a much brighter scene than a lower value such as 100 (Fig 202).

With these principles in mind it is simple to compare this relationship with the effect provided by night portrait scene mode (*see* Chapter 7). Night portrait mode works by activating the flash (to expose the subject with flash), then allowing a longer shutter

▶ **Fig 200**
Changing the effect of
shutter speed for a flash
exposure maintains the
brightness of the subject but
varies the background.

▶ **Fig 201**
Changing the effect of
aperture for a flash exposure
affects the brightness of the
subject lit by flash.

▶ **Fig 202**
Changing ISO increases or
decreases the brightness of
the entire exposure.

speed to expose for the ambient light. The tech-
niques being described here use the same princi-
ples; the difference is that, because the length of the
shutter speed can be manually defined, using this
method provides far greater control.

▲ **Figs 203 and 204**
Flash exposure
compensation button/menu
used to change the output of
the flash.

Built-in flash settings	
Built-in flash	NormalFiring
Flash mode	E–TTL II
Shutter sync.	1st curtain
exp. comp.	⁻2..1..0..1.⁺2

FLASH EXPOSURE COMPENSATION

There are two kinds of exposure compensation. The
first (introduced in Chapter 6) works by adjusting
the overall exposure by brightening or darkening
the photograph based on the subject and shooting
conditions. The second kind of compensation is
flash exposure compensation. This setting has a
similar effect, although only affects the flash output.
Changing the flash compensation value makes the
flash fire brighter or weaker than the default value,
while ambient light levels remain unaffected. The
flash exposure compensation setting is usually
denoted via an icon on the camera's body (Fig 203).
Alternatively, some manufacturers feature flash

control in the shooting menu (Fig 204).

Before considering how to do it, is helpful to
consider the reasons why a photographer may wish
to vary the flash output. Controlling the power of
the flash is incredibly useful in a range of settings.
Often the best flash exposure is indicated by an
effect that is so subtle that the viewer is unable to tell
whether or not the flash has been used. Reducing
the intensity of the flash is the main aim of flash
exposure compensation. This is because cameras
tend to overdo fill flash (the term for supplementing
daylight with flash light).

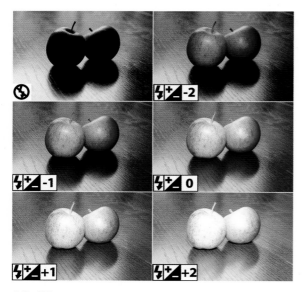

▲ Fig 205
Flash exposure compensation in use.

The units of measurement used in flash exposure compensation are the same as in overall exposure compensation. Thus, the output of the flash is increased or reduced by 'stops' that are also known as EVs (exposure values). To reduce the flash output, negative values must be set on the scale (-1 or -2), whereas increased values are represented by positive values (such as +1). Whichever value is set, it is important to note that, just like the overall exposure compensations settings, values specified for flash are 'sticky'. This means that if a compensation value of -2 is specified, the camera flash will continue to underexpose the flash output until the setting is changed back to 0. Be warned: it is not always obvious from the camera's LCD screen when the flash is underexposing!

One reason to reduce the power of the flash is because uncompensated flash can be too bright and dominate the exposure. Natural shadow and tone can be lost when the scene is blasted with flash. In Fig 205, the first image shows two apples lit entirely by daylight coming from behind. The subsequent photographs were each lit with a variety of flash outputs. The flash exposure compensation values used

were -2, -1, 0 (no compensation), +1 and +2. This sequence demonstrates the value of the controlled application of flash. The most natural and balanced image is the photograph with the weakest flash output (-2). This subtlety is easiest to observe in the shadows cast by the apples. A weaker flash softens the shadow and paints in foreground detail without dominating the exposure.

FLASH MODES

Flash modes provide the photographer with specific control over when and how the flash fires. Common options include standard, anti-red-eye, slow-sync flash, slow-sync with red-eye, and rear curtain (Fig 206).

Standard mode
Standard mode is the default setting of the camera flash. If no other mode is specified, the flash will behave by firing when activated by the photographer.

Anti-red-eye mode
Most cameras provide anti-red-eye as a flash mode. This feature is available in either P, A, S and M modes. Red-eye can appear in both human and animal subjects. It occurs when flash light travels directly into the subject's pupil before reflecting off the back of the eye and back out into the lens. Light absorbs the colour of surfaces from which it is reflected; in the case of the eye, the reflecting surface is comprised of rich blood vessels so the camera records the reflected light as 'red-eye' (Fig 207).

▲ Fig 206
A range of flash modes found on most cameras (standard, anti-red-eye, slow sync with anti-red-eye, slow sync and rear curtain slow sync).

Fig 207
Red-eye is caused by direct flash light entering the pupil and then reflecting from the back of the eye.

Darker conditions increase the risk of red-eye because the subject's pupils are more likely to be dilated (leading to greater potential for light to reflect). When anti-red-eye mode is activated, the camera fires pre-flashes that are designed to reduce the size of the pupil, which will contract in reaction to the bright light.

Most photographers agree that anti-red-eye flash has minimal effect and consumes an excessive amount of battery power. Another pitfall of this mode is that the subject may pose for the first flash (the anti-red-eye flash), and then look away before the actual shot is taken. Some cameras offer a post-production process that uses face recognition to detect eyes and remove the red cast digitally. Red-eye removal is also built into most image-editing programs and is a very simple fix to apply in post-production.

Fig 208
When the flash is combined with a faster than native shutter speed, only a small portion of the sensor is exposed to light.

Flash sync speeds

To understand slow and rear flash modes it is important to understand the role of the shutter during a flash exposure. The shutter does not comprise a single movement; instead, it is comprised of two parts, known as curtains (see Chapter 9). The first curtain moves at the start of the exposure to allow light to enter the camera; the second (known as the rear curtain) follows the first to close the shutter. When shooting at high shutter speeds, the first curtain opens the shutter and is almost immediately followed by the rear curtain. At no time is the entire sensor exposed. Instead, a moving slit allows light to enter the camera. At slower shutter speeds, the first curtain opens and the shutter remains fully open until the rear curtain moves across to close the exposure. This concept of front and rear curtain is important to grasp when using the flash.

This importance of this point is illustrated in high-speed flash photography. If the camera's maximum flash sync speed is exceeded, the flash will illuminate only the particular part of the image that is exposed by the gap between the front and the rear curtain (see Fig 208). This results in dark banding in the areas of the image that are not lit by flash.

It is therefore important to know a camera's flash sync speed – this is the fastest shutter speed the camera can use, where there is a point at which the front curtain has finished its journey but the rear curtain has yet to start. It will depend on the camera model but is likely to between 1/125th and 1/250th of a second. Certain models allow the sync speed to be increased. This is done by extending the duration of the flash output, to provide consistent light during

▲ Fig 210
Standard flash (left) versus slow sync flash (right); the slow sync setting has enabled the flames to appear.

▲ Fig 209
Slow sync flash lighting the subjects while the shutter remains open to allow ambient light to expose the background.

the time when the slit moves across, exposing the sensor.

Slow shutter speeds present different challenges. When slow speed flash is specified (usually combined with program mode), the flash fires at the beginning of the exposure (when the first curtain has fully opened the shutter) and remains open for the specified period, allowing the ambient light to expose. This balances flash with ambient light and works particularly well when shooting people in low light, or at parties or events where the intention is to give a flavour of the ambience. A secondary benefit of slow sync flash is that it gives a sense of movement. The image in Fig 209 was captured at twilight at a music festival using slow sync flash control.

The longer shutter speeds facilitated by slow speed flash also allow subtle colours to appear. In Fig 210 the image on the left was captured in automatic mode using the standard flash mode. The image on the right used P mode with slow sync flash. The slow sync flash has allowed the flames in the fire to become visible.

Rear curtain flash

A short explanation of rear curtain flash is that, instead of firing at the start of the exposure (when the first shutter curtain fires), the flash activates at the end of the exposure (when the second curtain fires). Why would rear curtain flash be preferred to standard flash behaviour? Consider the scenario of a photographer who has been commissioned to photograph a sprinter. The intention is to give a sense of the runner's movement. Without using rear curtain flash the image would be formed by selecting a slow-ish shutter speed (perhaps 1/2 second) combined with flash. However, this would not work well in practice. The starting pistol would fire, the shutter would open, the flash would activate and then 1/2 of a second later the shutter would close. Visually, the effect would be that of a sprinter 'frozen' in his blocks by the brief burst of flash, while the motion blur would lead forwards off down the track (Fig 211).

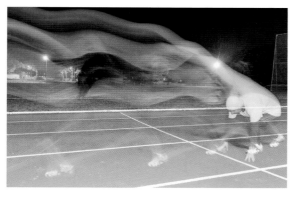

▲ Fig 211
Slow sync front curtain flash leaves a trail in front of the moving subject.

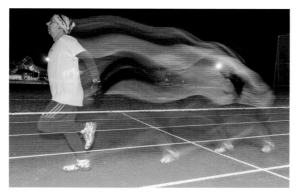

▲ Fig 212
Rear curtain flash sync leaves a trail behind the movement.

In this case, the result would be the opposite of that required. The movement blur would make the sprinter appear to be travelling backwards. Ideally, the sprinter would be frozen in full flight having left his blocks, with the motion blur leaving a trail behind him. This could be achieved by using rear curtain flash (Fig 212).

SUMMARY

The built-in flash is most commonly associated with dark conditions but careful application during daylight can lift an entire scene, balance backlighting and provide sparkle and contrast to a range of subjects. Flash has different relationships with the individual parameters of the exposure triangle. Varying the shutter speed has no effect on the flash brightness, although if the maximum sync speed is exceeded only a narrow part of the frame is lit. Aperture directly controls the brightness of the flash while ISO affects both flash and ambient light.

By default, most cameras use TTL metering to determine the required output from the flash. TTL equations are based upon the lighting conditions seen by the camera and the distance to the subject in focus. The TTL output can be modified using flash exposure compensation. Reducing the ratio of flash to available light enables the photographer to apply subtle and discreet amounts of supplementary lighting. Flash modes (anti-red-eye, slow sync, rear sync) provide additional options for adding flash output to the scene in different ways.

Although the built-in flash is a handy tool, there are times when it falls short of being able to provide the quality and type of illumination required for creative photography. An external flash unit will provide greater power, flexibility and control of flash light.

Chapter 13

Understanding External Camera Flash

- Why use an external flash?
- The hot shoe.
- Ten reasons why an external flash unit is better than the built-in.

While the built-in flash is a very convenient tool, it does have a number of shortcomings and there will be occasions when an external flash unit is a more appropriate tool. Some photographers are apprehensive about using an external flash unit, perceiving them to be complicated. This is not usually the case for those already familiar with using built-in flash. In fact, an external unit can provide a range of benefits without requiring a huge leap in technical knowledge.

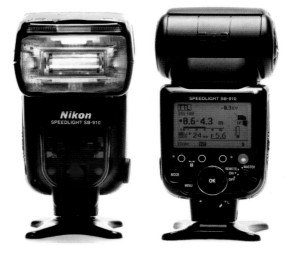

▲ Fig 214
A Nikon dedicated flash unit (SB-910).

WHY USE AN EXTERNAL FLASH?

The built-in flash is so convenient, why would anyone bother with the expense and weight of a bulky flash unit? Well, the built-in device has significant shortcomings. It is weak, inflexible, difficult to soften, casts harsh shadows and creates red-eye. Professional photographers – working at a press conference, taking paparazzi snaps, doing wedding or sports photography – will rarely be seen using the camera's built-in flash to light their subjects. These professionals make their living through photography and, if an external flash did not give better results, they would not use them.

There is considerable choice when considering which flash unit to purchase. Most camera manufacturers make dedicated flash units for their own cameras (Fig 214), while higher-specification models are available from makers such as Metz and Quantum. If you are unsure of the specification you need, buy the finest bespoke manufacturer's unit that your budget will allow.

◀ Fig 213
External flash provides advantages over the built in equivalent.

▲ Figs 215, 216 and 217
The hot shoe fitted with spirit level adapter and flash sync socket adapter (required for connecting external flash).

THE HOT SHOE

The 'hot shoe' provides the interface between the camera and an external flash (Fig 215). The size of the hot shoe is consistent across all camera models. In addition to activating the flash, the hot shoe also serves as a mount for accessories and adapters (Figs 216 and 217).

The hot shoe can also function as a mount for an LED lighting panel. These panels are most frequently used by filmmakers to provide a bright constant light source (Fig 218).

TEN REASONS WHY AN EXTERNAL FLASH UNIT IS BETTER THAN THE BUILT-IN

Power

Flash power is measured in units called 'Guide Numbers'. Understanding the concept of guide numbers involves some mathematics but the simple principle is that the higher the guide number, the brighter the flash output. Typically, the built-in flash on a compact or DSLR camera has a guide

TEN REASONS WHY AN EXTERNAL FLASH UNIT IS BETTER THAN THE BUILT-IN

There are ten major benefits to using external flash:

Feature	Built-in	External
1 Power	Low	High
2 Changing direction and bouncing light	No	Yes
3 Light modifiers	No	Yes
4 Ring flash	No	Yes
5 Combating red-eye	No	Yes
6 Strobes and special effects	Limited	Yes
7 Manual control of the flash	No	Yes
8 Zoom function	No	Yes
9 Using the flash 'off camera'	No	Yes
10 Using multiple flash and remote release	No	Yes

▲ Fig 218
Hot-shoe-mounted LED light panel made by Metz.

▲ Fig 219
Tilt and rotate action of an external flash unit.

▲ Fig 220
Bounced flash with a rotated camera softens the lighting but casts a soft shadow to the subject's left.

number of around 12, whereas a dedicated gun is more likely to have a number between 45 and 55. These numbers are important because they relate to the distance that flash light can travel to create an optimal exposure. A brighter flash means that the light can expose subjects further away. Therefore it is helpful to think of the guide number as an indicator of the distance that the light can travel.

However, it is not quite that simple, because there are several other variables at work in a creating flash exposure. Both aperture values and ISO settings have an impact upon flash brightness. When describing guide numbers the ISO is always assumed to be 100, and the formula for calculating guide numbers is as follows:

$$GN = distance\ (in\ metres) \times f\text{-number}$$

In practical terms, this means that, if you are photographing a person lit by flash at night, using a flash unit with a guide number of 12, at 100 ISO and with the lens aperture set to $f4$, the model can be up to three metres away. If the subject is more than three metres away, the light will not be bright enough to light the person and the image will be underexposed.

Changing direction and bouncing light

External flash units provide the photographer with many more options and greater flexibility in the way the light is delivered to the subject. One reason for this is because the head of the unit can be rotated and angled in all directions (Fig 219).

Modifying the direction of the flash enables light to be bounced from nearby walls or ceilings. The effect of bouncing light is that it converts a small light source (flash head) into a much larger light source (celling). Larger light sources provide a gentler form of diffused illumination. An issue arises when the camera is used in portrait orientation (on its side). Even when the flash is bounced, the light source is no longer central to the lens. In Fig 220, the flash was bounced off the ceiling (which softened the light) but, because the flash was positioned to the left of the lens, the image demonstrated a slight shadow on the model's left side.

Bouncing the flash does require some adjustments to be made to flash settings because light has further to travel. Flash exposure compensation is a way of modifying flash output (*see* Chapter 12). When bouncing flash the compensation should be increased. A second point to consider is that when light bounces it absorbs the colour of the surface from which it is reflected. Therefore, if a red wall is used to bounce the flash light, the subject will be lit by reflected red light. In normal circumstances, colour shifts caused by bouncing will not be so obvious. For example, an off-white or cream-coloured ceiling will introduce a slightly warm cast to the white-blue light emitted by the flash.

Light modifiers

Bouncing is one method of diffusion, although there are alternative ways to change the quality of light. Diffusion is important because a bare flash delivers a small (in relation to most subjects), harsh and direct light source. This type of lighting is predisposed to providing high contrast and somewhat brutal results.

One method of controlling the quality of light delivered by the flash is to use accessories that can be fitted to the flash (known as 'light modifiers' or 'shapers'). External flash units are usually supplied with a bespoke diffusion filter (Fig 222). The diffusion filter fits over the flash head and softens light by spreading it around. This works by bouncing the light internally, so that the resulting light appears to originate from a source that is larger than a bare flash head. Diffusion filters are used frequently in portraiture because harsh light sources and associated shadows are rarely flattering for the subject.

One scenario where using a diffusion filter would be appropriate is when using powerful direct flash. In Fig 223, the flash was competing with very bright ambient light levels (shooting into the setting sun). Without flash, the model would have appeared as a silhouette. The flash was set to fire with positive exposure compensation to provide sufficient light through the diffuser. If undiffused the powerful flash

USING A BOUNCE CARD

Some flash units have built-in bounce cards. These are small white plastic tabs that extend from the flash head (Fig 221). Bounce cards are useful in situations where there are no subjects or surfaces from which to bounce the light, such as outdoors or in spaces with high ceilings. The bounce card causes the light to be reflected and scattered, providing a larger and more diffused light source.

◀ Fig 221
Flash unit used with a built-in bounce card.

◀ Fig 222
A flash diffuser supplied with most external flashes provides omnidirectional diffused light.

light would have created hot spots on the subject's wet skin.

Other light modifiers are available cheaply. Two popular low-cost flash accessories are the diffusion dome and the beauty dish (Fig 224). These larger modifiers are a step up in terms of softened light when compared with the diffusion filter, albeit less portable or convenient. Both modifiers provide a variation on the quality of diffusion. The diffusion dome works in a similar way to the flash diffuser. Light spreads out, lighting a wider area and providing a soft gentle effect on the subject. The beauty dish works by bouncing the light internally within itself before spreading out en route to the subject. Both are worthwhile accessories for event or portrait photographers.

▶ Fig 224
Diffusion dome and beauty dish modifiers can be fitted to flash units to change the quality of the light.

▶ Fig 226
Ray Flash ring flash adapter connects to a standard flash.

▲ Fig 223
The use of a flash diffusion filter softens the light landing on the subject.

▶ Fig 225
Photographs shot with various devices: 1 the camera's built-in pop-up flash; 2 external flash (raw); 3 external flash fitted with a flash diffuser; 4 beauty dish; 5 diffusion dome; 6 ring flash. Light modifiers change the ways in which flash lights the subject and alter the appearance and harshness of shadows.

◀ **Fig 227**
Ring flash generates directionless light, avoiding facial shadows.

▼ **Fig 228**
The distinctive circular catch light associated with ring flash is visible in the pupil.

Ring flash

The ring flash was originally developed by dental photographers to be used as a light source capable of providing shadow-less illustrations inside the mouth. The lack of shadows is achieved because the illumination is emitted from around the entire circumference of the lens. A professional ring flash is usually large and expensive and needs to be plugged in to a dedicated power pack in a studio. Alternatively, non-professionals may like to consider an inexpensive ring flash adapter, which simply fits over the top of an external flashgun and redistributes the flash light (Fig 226). It will lack some of the power and finesse of the professional tool, but will offer an effective introduction to the ring-flash technique.

In addition to the unilateral direction of light, there are two further unique characteristics associated with ring flash. The first is the tell-tale white circular catch light in the subject's eyes (Fig 228). The second is the shadow that falls around the edge of the subject in all directions as the light spreads out. This can show as a dark halo of shadow that falls upon the background. The shadow is also exaggerated when the ring flash is used with a wide-angle lens and when the subject is very close to the camera (Fig 230).

Fashion and portraiture photographers have adopted the ring flash because the lighting characteristics are well suited to glamour and beauty. The light provides exceptionally even levels of illumination, which removes facial shadows (Fig 227).

Ring flash is also used by photographers who specialize in close-up photography. The even lighting is ideal for recording tiny details that could otherwise be lost in the shadows. Specialist macro photographers are more likely to use smaller dedicated macro flash guns instead of using the adapter. Metz is one manufacturer that produces a lens-mounted macro flash (Fig 231).

▲ Fig 229
Shadow appears as a dark halo on the background.

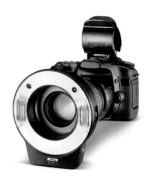

◀ Fig 231
The Metz lens-mounted ring flash provides even illumination for macro and close-up photography.

▲ Fig 230
A wide-angle (18mm) lens combined with ring flash exaggerates the surrounding shadow.

◀ Fig 232
Metz flash with hammer grip.

Combating red-eye

Techniques employed by the camera to combat red-eye are generally unsatisfactory. Red-eye occurs when the flash is fired directly into the model's eye and light reflects back on the same axis. If defeating red-eye is a priority, a flash bracket or grip can be used to increase the distance between the flash and the lens. This reduces the risk of red-eye occurring because, if light does reflect from the eye, it is unlikely to reflect back into the camera's lens. This is so effective that some manufacturers design the flash bracket as a battery (providing more power, quicker recycling times and longer battery life) while also functioning as a grip (Fig 232).

▶ **Fig 233**
Stroboscopic flash, which
fires multiple times during a
single exposure.

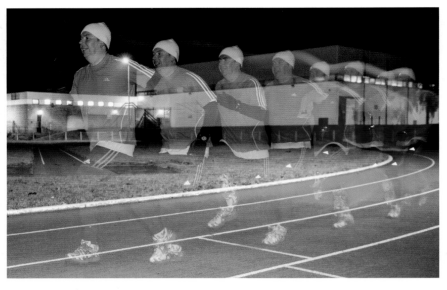

▶ **Fig 234**
Controls available on an
external flash unit.

▲ **Figs 235 and 236**
The position of the flash head changes depending on the focal
length of the lens: (left) 200mm and (right) 18mm.

Strobes and special effects

The camera's built-in flash can activate (depending
on the output level) every three or four seconds.
External flash units generally have a slightly faster
recycle time. Most also have a strobe function allow-
ing the flash to output in quick succession without
the need for recharge. Different frequencies and
flash durations can be specified. In Fig 233, the flash
was set to activate eight times in two seconds.

Manual control of the flash

Generally, flash output is determined via TTL meter-
ing (with flash exposure compensation available to
fine-tune). External flash offers a greater range of
options, such as the capacity to specify output and
distance (Fig 234).

Zoom function

The majority of camera/lens combinations are so-
phisticated enough to communicate the focal length
of the lens to the flash. The flash unit responds by
zooming the flash head to widen or narrow the flash
output pattern so that it only illuminates the area of
the scene that is seen through the lens (Fig 235 and
236).

Using the flash 'off camera'

Usually, both built-in and external units are fired
from the hot shoe directly above the camera lens,
but there are situations in which side or backlight-
ing can provide more creative options for the
photographer (Fig 237).

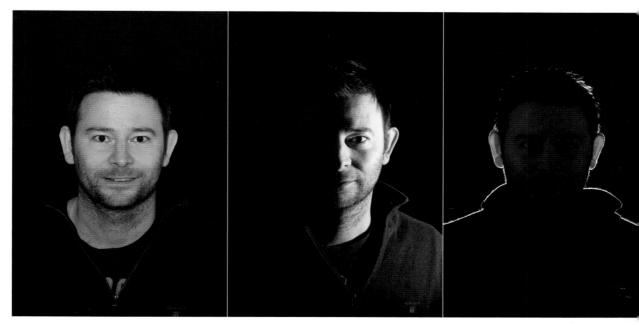

▲ Fig 237
On-camera flash: front lighting, side lighting and backlighting.

◀ Fig 238
Built-in flash sync socket.

▲ Fig 239
Front lighting (left) and side lighting from off-camera flash (right).

To enable the external flash to be used in this way, it must communicate with the camera despite not being mounted on the hot shoe. One way of achieving this is via the camera's flash sync socket (Fig 238), which is used to connect the camera (via sync cable) to a remote flash unit. A lower-specification camera is unlikely to feature a sync socket, but an adapter can be mounted on the hot shoe to provide one (Fig 217). Wireless solutions are now taking over from sync cables, because they provide both greater freedom of movement and increased reliability.

Central positioning of the flash can result in flat images, while moving the flash to the side of the subject creates shadow and contrast. In Fig 239, the first image (left) was lit by a flash attached to the hot shoe; the second (right) was illuminated by a flash 90 degrees to the right. In the second example, the lighting and directional shadows have created a 3D effect emphasizing form, shape and texture.

▲ Fig 241
Flash to the right of the photographer (note the position of the catch light in the eyes); a second flash lights the background.

▲ Fig 242
A flash was placed above the model (lighting the wall); another light was placed to the photographer's right at 45 degrees to the model; a third was positioned some distance further back on the photographer's left to fill shadows.

Using multiple flash sources

A second flash unit may be added to fill or soften some of the shadows cast by the first. The process is straightforward. An external flash unit can detect and respond to another unit – the camera activates one flash light, then the other (or others), detect the light and fire in response. The secondary flash units are subordinates or 'slaves' to the main light. The majority of studio images are created with three lights or fewer.

Figs 240, 241 and 242 were lit with a variety of light sources. By identifying highlight and shadow areas it is possible to work out how many flash units were fired, the direction of the light and the power output of each light. Multiple flash units combined with a selection of light modifiers bring studio techniques within the grasp of hobby photographers.

SUMMARY

In certain situations, external flash extends shooting options beyond those offered by the built-in equivalent. External devices may be connected to the camera via the camera's hot shoe or a sync socket. One of the main benefits of external flash units is that they provide increased power (measured as a guide number). The additional power is more controllable using manual settings (when compared to the flash exposure compensation available for built-in flash).

Flash light may also be softened or diffused through the use of light modifiers. Without modifiers it is still possible to alter the quality of light by adjusting or rotating the flash head to bounce light from ceilings, nearby walls or using a bounce card. Specialist light modifiers can change the light output considerably; the ring flash provides a specific quality of light well suited to both beauty and macro photography. Additional specialist functions such as stroboscopic flash output also become available when using external flash.

The slightly higher position of the external flash in relation to the lens provides increased protection against red-eye; this protection increases further when the flash is used with a bracket or hammer grip. External flash units also adjust and accommodate for the focal length of the lens/camera combination being used. A flash used with a wide-angle lens emits light in relation to the angle of view of the lens.

It is possible to discharge external flash without being physically connected to the camera. This technique can be used to provide off-centre lighting, to emphasize texture and form. Additional units (known as slaves) can also be triggered wirelessly by the first to enable multiple units to light the subject.

External flash provides significant advancement for photographers in terms of the flexibility, power and quality of the light source. The difference in aesthetic between built-in and external can make the difference between an amateur snapshot and a professional photograph.

▶ Fig 240
Single flash positioned above the model and to the right of the photographer.

Chapter 14

Understanding Focus, Metering and Drive Modes

- An introduction to focus modes (AF/MF, subject tracking, face recognition and focus points).
- Choosing a focus point manually.
- Situations to use manual focus.
- Back button focusing.
- An introduction to camera metering.
- Types of metering: centre-weighted, matrix, spot and partial.
- Exposure bracketing, dynamic range and HDR.
- An introduction to drive modes: motor drive (continuous shooting); quiet mode; mirror lock-up mode; self-timer; time-lapse and interval timer.
- Multiple exposure mode.

Basic camera function involves exposure, initially controlled via the parameters of the exposure triangle and then later by the addition of flash. Next comes an understanding of the utility functions of the camera. These include ensuring the subject of the photograph remains sharp (focusing), analysis of scene brightness (metering) and the behaviour of the shutter once activated (drive modes).

◀ **Fig 243**
Challenging scenes require finer control of camera operations.

AN INTRODUCTION TO FOCUS MODES (AF/MF, SUBJECT TRACKING, FACE RECOGNITION, FOCUS POINTS)

There is a range of different auto-focus (AF) systems at work in contemporary cameras. A common feature of all methods is that they work by detecting contrast and using it to identify edge detail. The camera presumes that maximum contrast at a given point translates to maximum sharpness. Some cameras rely on a single sensor in the centre of the frame while others feature multiple AF points. Some cameras are able to identify whether a subject is moving and can track the motion keeping the subject in focus. Other focus modes (such as face detection) work by seeking shapes, patterns and subjects.

Before exploring sophisticated focus modes it is helpful to consider the default behaviour of AF when the camera is set to automatic focus mode. When the camera shutter release is half-pressed the camera engages the AF mechanism. The lens will attempt to find a subject (using a focus detection point in the centre of the frame). The camera may beep to confirm when a subject has been identified and focus is locked. The viewfinder is likely to display an icon confirming that the lens has successfully focused. The next step is to fully depress the shutter and let the camera take the photograph.

If the subject happens to be positioned off centre, automatic focus can be problematic (Fig 244). It may also be an issue if two subjects are present but neither occupies the centre of the frame – for example,

▲ Fig 244
The default focus point may be the middle of the frame. If the subject is not centrally positioned, this can lead to focusing errors.

▲ Fig 245
AF-Lock keeps the flower on the left of the viewfinder in focus when using the centre AF point.

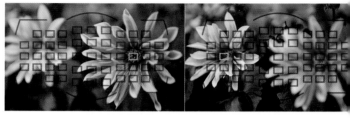

▲ Fig 246
DSLRs offer a range of focus points that can be manually selected to specify the point of focus.

two people standing in front of a landscape. In this scenario, the photographer can choose to compose the photograph with one of the subjects occupying the centre of the viewfinder, half-depressing the shutter to lock focus and then recomposing (without releasing the shutter) before fully depressing to capture the image. An alternative is to use the camera's AF-Lock button, which performs the same function as half-depressing the shutter. In Fig 245 the left image was created in default focus mode. For the second image the picture was composed with the left flower in the centre of the frame, AF-Lock was activated before the camera was moved and the image recomposed with the left flower in focus.

CHOOSING A FOCUS POINT MANUALLY

An alternative method of modifying the area targeted by the auto-focus system is to manually specify the focus point. This avoids the requirement to move the camera to recompose or use AF-Lock. Most cameras offer a range of focus points that may be selected in groups or individually; the effect in

Fig 245 could have been equally achieved by manually selecting AF points (Fig 246).

For still or slow-moving subjects manually specifying the focus point in use can be effective. Additional options may need to be considered when the subject is moving quickly. The camera's default behaviour is AF-S (single auto-focus). AF-S will attempt to lock focus when the shutter is half-depressed; once locked, it will not track any movement. If either the subject or photographer moves, the shutter must be released and re-depressed in order to achieve focus. An alternative is to allow the camera to lock and track the subject in focus. This option (sometimes known as 'use all focus points') removes the responsibility for maintaining focus from the photographer and instructs the camera to maintain focus on the subject that has been locked. This mode is especially useful if the subject is moving unpredictably or erratically and may serve wildlife or sports photographers well.

A benefit of allowing the camera to track subjects in focus mode is that, as the subject moves position within the frame, the camera can switch between

▲ Figs 247 and 248
Cameras provide a range of focus tracking options.

▲ Fig 249
Continuous AF and focus tracking assist with tracking moving subjects.

▲ Fig 250
Face-detection focus mode.

sensor points much more quickly than the photographer could do manually. This works well when combined with AF-C (also known as continuous auto-focus). AF-C tracks movement in all directions of the subject for the duration that the shutter remains half-depressed. AF-C also engages 'release priority' rather than 'focus priority' (meaning the camera will not wait to lock focus before capturing the image). This increases the risk that the photograph will not be correctly focused but avoids 'shutter lag' (the term given to the delay between the shutter being depressed and the photograph being taken).

For the majority of subjects, either manually selecting the focus point or using AF-Lock and recomposing will serve perfectly well. For certain subjects, faster and more accurate methods of achieving focus are required. Face detection mode is simple but effective in this context. It works by analysing the scene for patterns that the camera recognizes as facial (either human or animal), detecting the subject

according to that analysis and prioritizing focus on these areas. Face detection is fast, and avoids the requirement to recompose or use AF-Lock.

Some compact and bridge cameras have enhanced this feature by allowing a bank of familiar faces (usually friends of the photographer) to be specified and stored within the camera's memory. When the AF is activated, the camera scans the scene for faces and matches them against the camera's known memory bank. In a busy crowd scene the camera is able to prioritize focus on the familiar faces.

Auto-focus performance varies depending on the specification of both camera and lens. A lens equipped with a large maximum aperture provides a brighter viewfinder and a more responsive AF system (*see* Chapter 3). When low light prevents focus the camera is likely to activate the AF illuminator light (also known as AF assist) (Fig 251). The AF illuminator aims to provide sufficient light to enable

◀ **Fig 251**
The AF illuminator light
assists the camera to lock
focus in dark conditions.

▲ Fig 252
Auto-focus can be confused by objects or detail in the foreground:
(left) the focus is on the fence, while (right) the focus is on the
moving car.

the camera to focus and is generally effective for a
range of around three metres.

SITUATIONS
TO USE MANUAL FOCUS

Auto-focus generally performs well but there will still
be situations when manual focus is required. Auto-
focus struggles when there is a lack of contrast in the
scene or poor differentiation between subject and
background. For example, when shooting animals at
a zoo the camera would not know whether to focus
on the bars of the cage or the tiger within. Another
example may be at racing circuits; in Fig 252, the
camera's AF selected the fence as the point of focus
rather than the action beyond.

Bright or high-contrast lighting conditions can
also be problematic for AF. Cameras see the world
tonally, which makes scenes like Fig 253 particularly
confusing.

Auto-focus can be deactivated in favour of using
manual focus. On DSLR cameras manual focus
mode is usually engaged by switching both the lens
and the camera body to manual mode (labelled MF).

▲ Fig 253
High-contrast lighting such as this dappled effect is problematic for
auto-focus systems.

BACK BUTTON FOCUSING

By default the shutter release button has two functions. First, when pressed halfway down the auto-focus system is activated and the camera seeks to lock focus. Second, when pressed harder the camera takes the photograph. These are two distinct actions and it is possible to configure the camera so that each of these functions is activated in a different way (known as back button focusing). When using this technique, activation of the AF system is transferred to another button (usually located on the back of the camera).

A benefit of this technique is that it breaks the link between focus and releasing the shutter. This means the photographer is free to move around the subject without the need to refocus and recompose (assuming that the distance between photographer and subject remains constant). Also, if the photographer is focusing through a subject (such as the fence in Fig 252), the camera will not re-check focus each time the shutter is activated.

AN INTRODUCTION TO CAMERA METERING

To inform its exposure decisions the camera uses an internal light meter to assess the brightness of the scene from light coming 'through the lens' (TTL). TTL metering systems are very convenient but they are not particularly accurate. This is because they measure reflected light and different textures, colours and materials vary in their reflective properties

◀ Fig 254
18 per cent reflective grey.

and qualities. A more accurate light reading can be achieved by measuring the light that lands upon a subject (known as incidental metering) rather than the light reflected. This is possible for nearby static subjects using a hand-held light meter but is impractical for the majority of shooting scenarios (landscape, sports, pets, and so on).

So TTL meters can be inconsistent, but in-built metering systems do work well and can be used to create accurate and consistent exposures.

Some camera meters measure brightness levels alone, but more modern metering technologies, such as Canon's IFCL (Intelligent Focus Colour Luminosity metering) and Nikon's 3D colour matrix metering, use colour information in addition to tone. When activated (usually by pressing the shutter), the subject tone is mixed dynamically together to form a general grey. The tone present in a snow scene will generate a lighter grey average than a night landscape. The camera then adjusts exposure parameters so that, once the lights and darks of the scene are mixed together, the average tone should match 18 per cent grey (Fig 254).

Averaging the tonal information contained within a scene works surprisingly well in most circumstances. For situations where inaccurate exposures are generated, the camera provides a range of more precise metering modes.

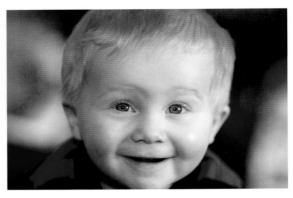

▲ Fig 256
Centre-weighted metering is ideal when the subject is generally located within the middle of the frame.

▲ Fig 255
The blue area illustrates the area of the viewfinder that is assigned greatest exposure emphasis (1 centre-weighted metering, 2 matrix metering, 3 spot metering and 4 partial metering).

TYPES OF METERING (CENTRE-WEIGHTED, MATRIX, SPOT AND PARTIAL)

By selecting a metering mode the photographer instructs the camera which area of the viewfinder should be given priority when deciding upon the correct exposure. There are four standard metering options found on most cameras: centre-weighted, matrix, spot and partial. Depending on the subject, each of these modes could meter the same scene differently. The distribution of how the camera interprets exposure priority is illustrated in Fig 255.

Centre-weighted metering
Centre-weighted metering prioritizes the middle 60 per cent of the viewfinder before feathering the rest of the emphasis out to the periphery of the frame. This mode performs well for most subjects because it aims to correctly expose whatever is in the middle of the viewfinder (usually the main subject). Centre-weighted also copes well with landscapes featuring bright skies at the top and darker tones for the land. One benefit (or disadvantage,

depending on point of view) is that centre-weighted metering simply responds to the lighting level in the viewfinder. The camera is not trying to guess the subject or calculate exposure using pre-defined scene patterns.

Matrix (also known as evaluative) metering
Centre-weighted metering is simple and effective, but can be easily fooled. Matrix is a metering mode that combines the general principle of centre-weighted with an element of camera intelligence. The camera divides the scene into multiple segments and then uses algorithms to gather data from the various segments and compares them to thousands of patterns from a wide range of subjects and conditions. Pattern recognition enables the camera to identify and expose for challenging lighting conditions more successfully. For example, backlit portraits and shooting situations are more likely to be recognized and compensated for when using matrix metering.

Spot metering
Because of its improved accuracy, many photographers select matrix as their default metering mode. Matrix is generally reliable, but there are still situations in which a more accurate form of metering is required. For these situations, spot metering is a helpful tool.

▶ Fig 257
Matrix metering copes
well with challenging
metering situations such
as backlighting, reflections,
shadows and people.

Both centre-weighted and matrix-metering modes measure the majority of a scene. Spot metering, on the other hand, takes a reading from a very small area of the scene (usually about 2 per cent of the viewfinder). The spot metering area is usually located at the very centre of the viewfinder, but it can also be configured to correspond to the active focus point. When the mode is selected, the camera bases all of its exposure decisions upon the brightness level within the area of the spot (ignoring all brightness and tone present in the remaining 98 per cent of the viewfinder). Spot metering is very accurate when a precise part of the scene needs to be exposed correctly.

One example of spot metering could be when photographing the moon. Using standard metering mode it is likely that the camera would overexpose the moon (Fig 258), to compensate for the dark sky taking up most of the frame. This is problematic for the main subject (the moon) because the overexposure loses detail. The surface textures of the moon are lost to pure white. Spot metering prioritizes the moon's texture as the most important element in the scene, ignoring the surrounding night sky (Fig 259).

▲ Figs 258 and 259
Spot metering enables precise metering, which allows the
photographer to bias exposure to specific areas within the frame.

▲ Fig 260
Partial metering places a greater emphasis to the middle 10–15 per cent of the frame.

▲ Fig 261
High-contrast scenes exceed the dynamic range of the camera's sensor.

Partial metering

Spot metering is useful for isolating a tiny area of the frame although its precision can sometimes be too specific. Partial metering uses the same principle but bases exposure decisions upon a larger area (usually around 10–15 per cent of the frame). Partial metering is useful for metering subjects of mixed tonality located within the centre of the viewfinder. Unlike centre-weighted metering, there is no feathering of exposure emphasis towards the periphery of the frame.

EXPOSURE BRACKETING, DYNAMIC RANGE AND HDR

--

Human vision is able to differentiate between a wide range of brightness levels because it has a broad 'dynamic range'. Dynamic range defines the breadth and capacity to perceive increments of light and dark tones. When converted to photographic

language the latitude of the eye is estimated to range up to twenty stops of light. This means humans can see detail in highlights and shadows simultaneously. Camera sensors have a much lower dynamic range (usually around twelve stops). This shortfall in dynamic range means that a scene may appear to the photographer's eye to hold a range of detail, but this is lost when recorded by the camera sensor.

One example of this effect, with which many photographers will be familiar, is when photographing a landscape – the sky can appear light blue with subtle white clouds, but the camera records the entire sky as white. The photographer can rectify this by metering for the sky, but then as a consequence the land becomes unacceptably dark. In both these photographs the photographer is struggling to control dynamic range because the range of tone present in the scene exceeds the range of tone that can be recorded by the camera's sensor. Cameras have difficulty recording scenes featuring extreme

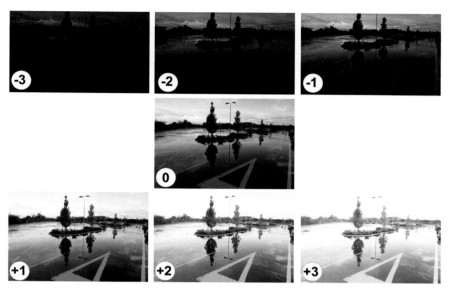

◀ Fig 263
Seven photographs of a high-contrast scene photographed using exposure bracketing.

▲ Fig 262
Exposure bracketing functions are located in camera menus and define how many images are bracketed and the exposure difference between them.

contrast, regardless of which metering mode is selected. Exposing to get detail in the shadows means that the highlights burn out to white (and vice versa) (Fig 261). In the example, none of the five individual photographs was able to capture the range of tone that was visible to the human eye at the time when the photograph was taken.

Because camera sensors have a limited dynamic range, cameras offer an exposure bracketing function (also known as Automatic Exposure Bracketing or AEB) (Fig 262).

Bracketing is the term given to taking a number of photographs of the same scene using different camera settings. Auto Exposure Bracketing mode (AEB) instructs the camera to take a photograph at the metered reading, followed by two further images; the first is overexposed and the second underexposed. The benefit of exposure bracketing is that any metering errors will normally be mitigated by at least one of the three exposures. The default setting in AEB is to produce three images although cameras offer significantly more creative control in the exposure-bracketing menu. For example, it is perfectly possible to set the camera to shoot seven images (three underexposed, one as metered and three overexposed) (Fig 263).

HIGH DYNAMIC RANGE (HDR)

A relatively recent innovation of digital photography is a technique known as high dynamic range photography (HDR). HDR is used to capture a far greater range of tone than is possible to record in a single image. The principle of HDR is similar to bracketing (and HDR can be combined with bracketing). Once shot, the bracketed exposures are merged, to extract the full range of shadow and highlight detail from the sequence.

HDR can be performed in camera or using software. Camera HDR is somewhat clumsy as there is limited input to the final image, whereas the software options provide extensive control over the relationship between the frames and rendering of the hybrid photograph (known as tone mapping). HDR works most effectively with still, high-contrast subjects such as landscapes. A typical workflow is to use a tripod and the camera's AEB bracketing function to create a range of exposures. The resulting frames are loaded into manipulation software such as Adobe Photoshop so that tone mapping can be precisely controlled. This technique can be very effective and create photographs in a 'hyper-real' style.

▲ Fig 264
An example of high dynamic range photography, featuring details in both highlights and shadows.

Bracketing is demonstrated by the images in Fig 263, which were combined in Adobe Photoshop to create a high dynamic range composite of the frames.

AN INTRODUCTION TO DRIVE MODES

A 'drive mode' is the behaviour by which the camera takes a photograph and then readies itself for the next. In normal circumstances, the camera will take a photograph when the shutter release is fully depressed and then wait for the shutter to be pressed again before it takes any further photographs. There are situations when it is helpful to change this action as the default preference.

Examples of drive modes include motor drive, sometimes called continuous shooting or burst mode (used for shooting frames in quick succession); quiet mode (for more discreet situations); self-timer (for a delay and hands-free shutter release); and interval timer (to capture a sequence of images over a period of time).

Motor drive (continuous shooting)

It is sometimes convenient to press and hold the shutter release when photographing an image sequence. Most cameras have a continuous shooting mode that will continue to fire the shutter for as

◀ Fig 265
Example of a drive mode menu (Canon).

long as the shutter release is held down (until either the memory card runs out of space or the battery expires). Continuous shooting mode is usually specified in the drive mode menu (Fig 265).

The speed of the continuous shooting is measured in frames per second (fps). Currently, high-specification modern cameras can shoot up to twelve fps. In Fig 266 the camera was set to continuous shooting to record a fast-moving vehicle passing the photographer's position.

Continuous shooting mode must be used with sufficiently fast shutter speeds. If the camera is set to use slower speeds (or used in automatic mode), the camera may not be able to reach its maximum frame rate.

Quiet mode

In certain surroundings camera beeps, movements and shutter sounds can be too conspicuous, for example, when shooting a wedding ceremony. The goal of the photographer is usually to be as inconspicuous as possible, but this can be difficult if the camera is beeping to confirm focus, and the sound of the shutter echoes around a quiet church. Many compact cameras equipped with electronic shutters offer silent shooting mode, which is ideal for sound-sensitive shooting situations. Such cameras lack the flexibility of a DSLR but, unfortunately, DLSRs are currently unable to operate completely silently. Some do include a 'quiet mode' setting, which works in two ways: first, it deactivates the electronic noises that the camera makes, such as the focus confirmation beep; and, second, it tries to reduce the shutter noise, by slowing down the movement of the mirror flicking up (which does introduce a risk of shutter lag). Quiet mode does not guarantee that the camera will allow

▲ Fig 266
Capturing a fast-moving subject using continuous shooting at 6fps.

▲ Fig 267
Quiet mode (Q) dampens the noise of the shutter and deactivates the camera's confirmatory beeps.

▲ Fig 268
Mup (mirror lock-up mode) can be selected in menus or on the camera drive mode selector (Nikon).

▲ Fig 269
Mirror lock-up mode reduces internal vibrations when the camera is activated, to provide a sharper image.

the photographer to operate without being noticed. For street photography, or in environments where photography is prohibited, you need to be aware that, unless manually deactivated, the AF illuminator light will continue to function and give you away!

Mirror lock-up mode

Mirror lock-up mode (also known as Mup, *see* Chapter 8) is a drive mode that maximizes the sharpness of an image. This technique is particularly effective when using slow shutter speeds (while the camera is mounted on a tripod). When the camera is set to Mup mode the mirror in the DSLR flicks up out of the way when the shutter is pressed for the first time. When the shutter is depressed for the second time, the mirror has already moved, and camera vibrations caused by the movement of the mirror take place before the shutter actually fires (Fig 268).

Vibrations can be reduced even more if the photographer activates the camera without actually touching it. Remote release can be achieved by either using a remote control or setting the self-timer. The benefit of using the self-timer with the mirror lock-up mode is that there is time for the vibrations

caused by the finger depressing the shutter to fade before the image is captured. In Fig 269 the camera was set to use a shutter speed of two seconds to blur the movement of the escalator. Because Mup was used with a tripod and remote release, the stationary objects within frame are as sharp as possible.

▲ Fig 270
Self-timer icon.

Self-timer

The self-timer introduces a delay between the moment when the shutter release is depressed and the photograph being taken. The self-timer was originally invented to allow photographers to take pictures of themselves or to join the group they have framed in the viewfinder. The delay is usually around ten seconds, but shorter delays may also be selected. While the camera is counting down, the AF illuminator light may blink and/or the camera may emit beeping sounds; these effects will increase in frequency as the shutter prepares to fire. Self-timers have been a feature of cameras since early designs, and their clockwork origins have inspired the icon design (Fig 270).

▲ Fig 271
'Selfies' and group shots including the photographer can be activated using wink recognition.

▶ Fig 272
The interval timer can be used to create multiple frames and to generate a composite (using appropriate software).

One variation is the wink-activated self-timer. The photographer arranges the participants within a scene and depresses the shutter, then the camera engages face recognition and identifies the photographer's facial pattern. When the photographer winks, the camera detects the facial movement and triggers a two-second delay before firing the shutter (Fig 271).

Time-lapse and interval timer

In addition to the self-timer many modern cameras are equipped with both an interval timer and time-lapse function. These two settings are similar. Time-lapse allows the photographer to record images over a period of time and then experience the resulting frames as a movie. Settings such as frequency and frame rate are configurable within camera menus. Time-lapse movies can vary considerably depending on the time that elapses between frames. Short intervals of around five seconds are ideal for traffic movements or sunsets, whereas slower time-lapses might use a frame every minute for subjects such as shadows moving throughout the day. If the subject is a longer project, such as a construction site or a plant growing, then delays of up to 30 minutes between frames are not unusual. When the time-lapse finishes, the camera will process the files and

▲ Fig 273
Menu options to specify the variables associated with interval shooting.

◀ Fig 274
Multiple exposures combine numerous photographs in the same image.

create a movie that is ready to view.

The interval timer is similar, although, because the output is photographic rather than video, each frame has far greater flexibility and quality. When the photographs captured by the interval timer are combined with compositing software it is possible to experience the frame sequence not just as a movie, but also as a still image. In Fig 272, with the camera mounted on a tripod a hundred photographs were taken with the subject moving to a new seat between frames. The resulting composite was achieved through a combination of the interval timer and digital imaging software (Adobe Photoshop).

SUMMARY

There are a range of camera settings that control key aspects of the ways in which the camera functions before, after and during the moment when the shutter is activated (focus, metering and drive modes).

The default behaviour of the auto-focus system is to focus upon detail within the centre of the frame. Focus is achieved by half-depressing the shutter release. Subjects on the edge of the viewfinder can be brought in to focus by placing them in the middle of the frame, half-pressing the shutter release (or holding AF-Lock), and recomposing before fully depressing the shutter. As an alternative to recomposing it is possible to manually select the specific AF point within the viewfinder.

Moving subjects present a focusing challenge. AF modes include movement tracking options (such as AF-C), and may also lock to subject-specific patterns through modes such as face recognition. Despite sophisticated focus modes, some situations can prove so problematic for AF modes that manual focus may need to be engaged.

Camera metering modes measure the brightness of a scene using TTL metering. Centre-weighted, matrix, spot and partial metering prioritize different areas of the viewfinder.

Auto exposure bracketing (AEB) is a way of producing multiple images with different exposure settings of the same scene. The mode is configurable to shoot a range of exposures and ideal for capturing high-contrast subjects. AEB can also be useful in shooting situations where the dynamic range of the subject exceeds the capability of the sensor to deliver a full tonal range. AEB can be combined with high dynamic range photography to create the distinctive 'hyper-real' effect of HDR.

The shooting modes of the camera define what happens when the shutter release is depressed. Continuous shooting (also known as burst mode or motor drive) may be activated to shoot an increased frame rate. Further drive modes are available within the camera menus. These include self-timer (introducing a delay between pressing the shutter and the photograph being taken), quiet mode (reducing camera noises) and mirror lock-up (pre-lifting the mirror inside the camera to reduce internal vibrations). Variations include time-lapse settings and the interval timer. These differ in a number of ways but the most significant distinctions are that time-lapse uses smaller frames intended for video output, whereas interval has the full range of photographic options for creating high-quality images. Finally, multiple exposure mode provides a way of compositing two or more images together in camera.

Focus, metering and drive modes are crucial techniques used in conjunction with the exposure settings to ensure a sharp, well-timed, properly exposed image.

The internal timer is activated through the camera's menu (Fig 273). There are a number of variables to specify: when to start shooting, the frequency of taking a photograph (the interval), and how many photographs are to be captured before the sequence is finished.

Multiple exposure mode

Multiple exposure mode is a way of combining two or more images on the same frame. Once the mode has been activated in the camera menu (Fig 274), the camera waits for multiple images to be taken before overlaying them one on top of the other, to create a composite. This technique is a creative way of creating a visual juxtaposition without using imaging software.

Understanding Colour:
White Balance, Picture Styles and Colour Spaces

- Cameras and colour.
- White balance: introduction; auto white balance (AWB); limitations of AWB; white balance presets; mixed lighting sources; defining a custom white balance; manually defining Kelvin values; software white balance; using a grey card.
- Introduction to picture styles.
- Colour spaces (sRGB and Adobe RGB).
- Shooting black and white.

Quality photography requires an understanding of the concept of colour and, specifically, of the 'in-camera' settings of white balance, picture styles and colour profiles. (The information given here assumes that the camera is shooting JPEG images, unless stated otherwise. Raw photography provides alternative workflows for colour; *see* Chapter 18.)

CAMERAS AND COLOUR

Colour can be a subjective and slippery subject, challenging to define and ambiguous on different devices. A detailed study of colour quickly becomes technical and could demand many pages of text. For more on concepts related to colour, the construction of the digital file and the raw format, *see* later chapters. What follows here is not a full explanation of colour theory, but a guide to some of the camera's colour-related settings, which should help you to make informed decisions and inform your further reading.

WHITE BALANCE

Introduction

Unlike human beings, the camera is unaware of the ambient hue of its surroundings. It would not, for example, be able to distinguish whether it was in a room with green walls or a room with white walls lit by a green bulb. Because the human eye reports to the brain and the brain is able to process the ambient light levels and respond to the corresponding hue, it can differentiate. This capability is easily illustrated by considering the appearance of a sheet of plain white paper. Whether the paper is seen by a person in candlelight (warm orange in colour) or under the midday sun (a cooler, blue-tinted light), to the human eye the colour of the paper will remain constant – white. The same piece of paper would be seen slightly differently by a camera. In candlelight, it would reflect the warm tones and appear as orange, whereas in cooler lighting it would be rendered blue (Fig 276).

White balance (WB) is the camera's tool for correcting colour variations caused by lighting conditions. Before exploring the menus, settings and buttons it is useful to understand the scale and units that cameras use to define WB values. The colour casts (warm or cool tones) are referred to as 'colour temperature' and the units of measurement are defined in terms of Kelvin (K). Higher K values relate to the bluer end of the scale while warmer tones have lower values. In practice, colour temperatures over around 5500K are considered cool colours while lower colour temperatures (2500–3000K) are referred to as warm (giving yellow and amber hues). As an approximate guide, the numeric values of

◀ Fig 275
White balance is used to describe the colour temperature of light.

▲ **Fig 276**
The camera records colour differently depending on the lighting conditions and the same piece of white paper will show slight variations under different light sources. White balance is the camera's tool for maintaining colour neutrality.

typical lighting conditions are as follows:

- Candlelight 2000K
- Tungsten bulbs 3000K
- Sunset or sunrise 4000K
- Fluorescent lamps 5000K
- Camera flash 5000K
- Daylight at midday 5500K
- Overcast sky or shade 7000+K

In addition to the scale of blue to orange (which works on the blue to yellow axis of the colour wheel), digital camera white balance uses a second scale that works upon the green–magenta shift. This is used less frequently but is helpful when compensating for colour casts introduced by fluorescent lighting.

Auto White Balance (AWB)

For most leisure photographers AWB is likely to be the most convenient setting for everyday use. Generally, with AWB you can 'set, then forget'. When the camera is set to AWB it assesses each shot individually and generates a unique white balance value for each photograph. This can be very helpful because light temperature changes all the time; for example, simple ambient changes such as a cloud drifting in front of the sun can dramatically alter the warmth of the scene.

White balance settings are applied after the photograph has been taken but before the JPEG file is saved to the memory card. When the shutter fires, the camera captures the scene. Next, the camera analyses the colour data by comparing individual RGB channels, and the processor tries to identify a neutral subject or tone. Having identified a mathematical colour cast (bias towards a particular colour), the camera attempts to equalize the numbers to balance the colour channels. Generally speaking, this method is very effective and consistent, particularly when taking photographs outdoors and in daylight conditions.

Limitations of AWB

Like all automated camera modes, AWB is fallible, and certain subjects and situations create problems. In low light or mixed lighting conditions AWB is far less reliable. AWB assumes that the subject is colour neutral, which is frequently not the case. For example, if the subject is a blue car against a blue background, the camera would register a colour cast and compensate by adding yellow. The photograph of the blue car would therefore lose some of its saturation. Equally, if the subject had a variety of naturally occurring warm tones the camera's automatic settings would soften them by adding some blue.

AWB is also problematic if colour accuracy or consistency between images is important. The flawed nature of the automatic settings is illustrated by photographing different-coloured outfits against

▲ Fig 277
AWB is unsuitable for subjects that demand colour accuracy or consistency.

◀ Fig 278
The camera's WB settings menu (standard across most cameras).

▲ Fig 279
In this instance AWB has made an accurate assessment of the colour temperature of the scene.

▲ Fig 280
Choosing different white balance presets changes the mood of a scene.

a white background (Fig 277). Clearly, the inconsistency would be very obvious when the finished files were displayed next to each other on a web page or in print. The problem is that the camera is influenced by the colour of each garment. The red jumper would cause the camera to detect a slight red cast to the scene and compensate by adding some green. When the green jumper is photographed, the reverse would happen. When the images are displayed side by side, a slight colour shift is visible in the white backgrounds.

White Balance Presets

When consistency is more important than convenience, the WB menu offers a range of preset options (Fig 278). Selecting a preset option is a way of notifying the camera of the lighting conditions in which the photograph is being taken. This assists the camera to discriminate between lighting conditions (which become known values) and the colour of the subject.

Presets are shortcuts designed for common shooting conditions. They apply pre-defined values of Kelvin to the image data (rather than interpreting and applying a dynamic value as assigned on the fly). When a preset is specified (assuming shooting conditions remain constant), there are no issues with colour consistency. Preset options vary between cameras but the most common are Daylight, Cloudy, Shade, Tungsten, Fluorescent and Flash. Each of these adds warmer or cooler tones in a range of different intensities.

WB presets are most frequently applied to correct colour, but they can also be used creatively to change the mood and feeling of a photograph. In Fig 279 the camera was set to AWB and has successfully recorded the wooded landscape scene with a similar colour temperature to the conditions at the time of shooting.

Colour accuracy is not always the goal, and the same scene can be recorded with different WB presets to produce a range of results (Fig 280). For example, changing WB presets can make a winter scene appear like a spring day. Alternatively, the

▲ Fig 281
Warm tones applied.

▲ Fig 282
Cool tones applied.

varying intensities of blues can make foliage appear autumnal or lush. However, presets (and their associated icons) are just the camera manufacturer's best guess at ideal conditions and it is wise to experiment with them. Some scenes benefit from a warming effect (Fig 281) while others work better with cooler tones (Fig 282).

Remember when using white balance presets for creative intent that presets are 'sticky'. This means that, once set, they stay selected (even if the camera is switched off). It is important to return the camera to AWB or to an appropriate preset.

Mixed Lighting Sources

WB presets are expedient shortcuts to defining colour temperature. They offer the photographer more control than AWB but remain limited in their range. Presets also assume that the scene is lit by a single light source. This is infrequently the case and, for mixed-lighting scenarios, alternative WB strategies are required.

Multiple light sources are a common cause of errors in white balance. AWB generates an average white balance value for the entire scene and then applies it to the whole image. Presets can be rather a blunt instrument because they are biased to one of the light temperatures present in the scene. In reality, there is no 'correct' white balance value for

images such as Fig 283, because the scene contains both tungsten and daylight. There are alternatives that can provide consistent results by producing a customized WB value for the conditions. These work by allowing the photographer to manually specify a Kelvin value.

Defining a Custom White Balance

When the illuminants of a scene contain mixed colour temperature, the photographer is presented with a challenge. The custom WB setting (usually located in the same camera menu as the range of presets and represented by the icon shown in Fig 284) is a way of generating a WB value specifically for the current lighting conditions and saving it as a temporary preset.

Custom WB requires the photographer to shoot a subject of 'neutral reference' (usually a piece of white paper under the same lighting conditions as the intended subject). The resulting file is then used to evaluate the lighting conditions with the known white point. Custom WB provides a very accurate value but is only valid for as long as the lighting conditions remain constant. If the lighting conditions change, a new custom preset must be recorded. The process of how a custom white balance is captured varies by manufacturer. If in doubt, it is wise to check the instruction manual of the camera.

Fig 283
Some scenes contain a mix of different coloured light sources.

Fig 284
The custom WB option.

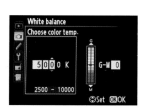

Fig 285
It is usually possible to manually set the colour temperature using Kelvin values.

Manually Defining Kelvin Values

Many cameras give the option for manual specification of the WB value in terms of Kelvin (usually between 2500K and 6000K). This setting gives a very precise level of colour control (Fig 285).

Fig 286
A banquet lit by candlelight and flash is a challenging white balance scenario.

Software White Balance

Mainly, WB options apply colour temperature corrections 'in camera'. An alternative way of working is to apply WB settings afterwards in software. If shooting in JPEG mode, remember that this is a destructive process (pixel information decreases slightly with each edit). When shooting raw, however (see Chapter 18), WB adjustments are made non-destructively. A software workflow (making the changes using a computer rather than in camera) is the ideal way of managing WB values because it combines the convenience of AWB with the flexibility of manually setting the white point. Convenience should not be underestimated. While making photographs the photographer is juggling multiple variables – aperture, shutter, ISO, flash power, changing ambient light levels – while potentially interacting with a subject. Specifying exact white balance values is something that can be done later on a computer.

A description of the photographer's thought processes and workflow used to create Fig 286 might help to determine when it is best to assign WB values. The scene was particularly challenging because the banquet was lit by a combination of candles, orange fairy lights and weak halogen floodlights (just out of shot). As a result, the scene appeared

▲ Fig 287
The white balance
eyedropper tool is used to
identify subjects that should
be colour neutral.

dimly lit to the eye and with a strong warm orange tint. To create the exposure, camera flash was required. If the picture had been lit using just ambient light the shutter speed would have been too slow to freeze the movement of the diners and the ISO would have needed to be around 6400, which would have introduced unacceptable noise. The required white balance value was therefore somewhere between 3000K (candles) and 5500K (flash). Left to its own devices, AWB would have detected an orange cast. The camera processor would also have known that the camera was firing the flash and may well have chosen a suitable compromise. However, in commercial photography, it is not advisable to rely on luck. If the camera had prioritized flash hues for WB, the area of the scene that the flash had not reached would have remained orange while the foreground would have taken on a blue-ish tint.

In situations such as these, the preferred workflow for photographers is to leave the camera set to AWB and then manually define WB values later using software on a computer. The benefit of this is that very precise WB values can be assigned and this allows the photographer to keep a sense of the warm candlelight while the shirts and tablecloths in the foreground remain close to white.

For the banquet image, the file was opened in Adobe Lightroom. The white balance was set using an eyedropper tool on a neutral subject (a diner's white shirt) (Fig 287). This is a quick way of creating and applying an accurate non-destructive custom WB value. By defining the white shirt as a point of neutral reference, the software equalizes the RGB values of the pixels in the whole image (similar to the custom white balance mode in camera). In this instance a shirt was used to define neutrality as a starting point before a few extra Kelvin were removed using software sliders to preserve a sense of the warm tone associated with the candlelight.

Using a Grey Card

Not every scene features a white shirt to act as a point of reference. An alternative to relying on good fortune and guesswork is to add a neutral subject to the scene by shooting with a grey card or similar photographic accessory. Grey cards are traditionally associated with camera metering (they are 18 per cent grey, to match the meter average) but many can also be used to provide a reliable and consistent point of neutral reference. This method provides an accurate and consistent white balance value and is particularly useful for studio photographers.

◄ Fig 288
An alternative to using a
grey card is the Lastolite Xpo
balance.

▲ Figs 289 and 290
The picture style/picture control menus found in Canon and Nikon cameras.

INTRODUCTION TO PICTURE STYLES

Once the photograph has been taken and white balance values have been defined, the camera processes the data contained in the file. This process specifies and applies values of sharpness, contrast, saturation and colour tone before creating the JPEG file. Cameras use 'standard processing' by default. The exact processing recipe varies by manufacturer, although it usually provides a small amount of enhancement creating vivid colours and a contrast level suitable for general subjects. As with AWB, it is perfectly acceptable to leave standard processing as the everyday setting on the camera. Camera menus (known as picture styles or picture controls) offer choices for how the image data may be processed and the JPEG created.

Before digital technology, cameras used film to record exposures. Different manufacturers' emulsions, grains, layers and dye recipes gave different colour experiences of the same scene. Films would vary through alternative contrast reproductions or sensitivities to particular colours. The picture style presets are the modern-day equivalent and provide the photographer with a simple method of influencing image-processing parameters.

Picture style presets offer an alternative interpretation of colour and contrast handling and are tailored to particular subjects. The portrait preset, for example, works by gently saturating colours (with the exception of skin tones). The preset works by brightening the colour range (around the red/orange

▲ Fig 291
Portrait picture style flatters skin tone.

and yellow hues). This adjustment boosts skin while retaining the general correct exposure for the scene in terms of brightness. Sharpening is also slightly reduced, to provide softer and more flattering skin reproduction (Fig 291).

Landscape scenes usually benefit from lush saturated greens and deep blues. The landscape preset works to this advantage specifically by adding saturation to the blues and greens of an image. The contrast and sharpening details are increased to bring out details in the scene.

The neutral preset is used when increased saturation would push colours too far to their extremes. Processing can sometimes cause a loss of detail with, for example, light grey becoming white or deeper orange tones being lost to red. The neutral preset seeks to record the greatest latitude by keeping as much detail as possible within the confines of the JPEG's tonal range. It works by slightly reducing

▲ Fig 292
Landscape picture style boosts natural hues.

▲ Fig 293
Neutral picture style avoids over-saturation.

overall saturation and reducing contrast. Unlike the portrait or landscape presets, it neither boosts nor suppresses any specific hues. The effect of this mode is to allow subtle detail and nuances of colour to reproduce.

The faithful picture style aspires to record colour as close as possible to the scene experienced by the photographer at the time of capture. The mode works by reducing overall contrast and avoids saturating the colours beyond their natural state – vivid colours remain vivid while less saturated hues remain subtle. This mode could be suitable when colour accuracy is important, for example, when photographing a painting or coloured garments to be viewed and sold online.

Picture style presets are relatively blunt and clumsy instruments for colour control but they can be useful for photographers who shoot JPEG and do not have access to editing software.

▶ Fig 294
Faithful picture style renders a natural reproduction of colour.

◀ Fig 295
Camera menus offer a choice
between sRGB and Adobe
RGB colour spaces.

COLOUR SPACES
(SRGB AND ADOBE RGB)

Colour spaces (also known as colour profiles) relate
to the construction of the digital file; for detailed
information, *see* Chapter 17. Briefly, the basic
function of the colour spaces in their simplest
form is to act as a kind of 'passport' that travels with
the photograph beyond the camera. It is there to
preserve the appearance of the colours when the file
travels between different devices such as computers,
monitors and printers.

The two most common options for colour space
found in camera menus are Standard RGB (sRGB)
and Adobe RGB (Fig 295). The most popular is sRGB,
which is recommended for images that will be
printed without any manipulation. Adobe RGB is an
alternative; it actually provides a greater number of
colours, although, without processing, colours may
not be appear as vivid as with sRGB.

If unsure of which colour space to use,
photographers should shoot the same scene using
Adobe RGB and sRGB and print both files using
their normal printer (without changing any other
camera variables). The preferred aesthetic can then
be evaluated and the colour space can be left set to
that option.

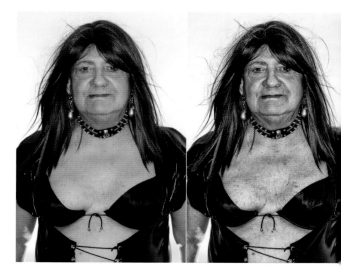

▲ Fig 296
Black and white photography can emphasize form, detail and
texture.

SHOOTING
BLACK AND WHITE

Monochrome photography is a powerful medium,
with line, shape, form and texture describing a
subject free from the distraction of colour. There is
insufficient space here to detail a complete workflow
in relation to the digital black and white process,
but the fundamentals of camera settings can be
described very simply. The most important advice
is to avoid using the option to shoot monochrome
in the picture styles menu! This setting works by
reducing the three colour channels to a single
channel of brightness information. While this does
technically provide a black and white image, it does
so by removing the colour information and assign-
ing tone values to each of the subjects, independent
of their hue. This method often generates a flat and
lifeless image.

▲ Fig 297
A red filter applied to the right-hand image increases contrast in the sky by darkening the blue hues found in the image.

A far better way of producing monochrome images is to shoot in colour and then convert the image to black and white afterwards using software. In the days of film, photographers would use coloured filters in front of the lens to change the brightness values of particular colours. One common example was the use of a red filter to darken the appearance of a blue sky without affecting other colours – the effect was to make white clouds stand out against the blue background (Fig 297)

Coloured glass filters are less frequently used by contemporary photographers. Instead, the colour file is converted and the brightness values of colours are manipulated digitally. This technique has the combined benefit of capturing data in all three (RGB) colour channels, enabling the photographer to extract detail from each channel and assign the most appropriate tonal values for the hues. Once tonal values are assigned to the colour channels, the subject can change dramatically when converted to black and white. In Fig 298 the red pepper takes on a dramatically different appearance depending on whether the black and white conversion emphasizes either the red, green or blue channels.

SUMMARY

For some photographers, colour settings can be fascinating, exciting and liberating whereas others are content to allow the automatic functions to do their job. Whatever the preference, there are situations in which an understanding of colour settings will enable the photographer to modify the mood of an image to suit their intentions.

White balance settings are used to control colour temperature through units of Kelvin. When set to AWB the camera automatically detects colour bias and applies compensation to achieve neutrality. For greater levels of colour consistency, pre-defined WB presets can be applied to notify the camera of the shooting conditions. For greater functionality, either custom settings or manually defining K values can be used.

Picture styles are another variety of camera colour settings, but these are used to define the treatment of colour (rather than respond to lighting conditions). Subject-specific presets enable photographers to prioritize colour saturation, contrast and sharpening.

Colour transmits through photography even when creating black and white images. The examples given here demonstrate the power of hues in relation to the luminance of specific colours and their respective greys.

◀ Fig 298
Converting to black and white using data contained in the individual red, green and blue colour channels provides a very different monochrome aesthetic.

Chapter 16

Understanding How to View, Access and Enhance Photographs

- Viewing images.
- Deleting images in camera.
- Advanced viewing to access file data.
- Accessing metadata.
- Privacy, security and copyright settings.
- Editing images in camera (the retouch menu).
- Editing movies in camera.

▲ **Fig 300**
Camera playback icon. This button switches the camera from recording images to reviewing photographs already taken.

▲ **Fig 301**
Button functions change dependent on mode. Blue graphics zoom in and out of photographs while in playback mode. The white icons determine the functionality of the buttons when set to shooting mode.

Camera knowledge is most frequently associated with controlling exposure. However, modifying images is not restricted to the rendering of light. Cameras also offer a variety of playback options to view captured files, access to metadata to deconstruct the file, and a range of image enhancement possibilities via filters and algorithms.

VIEWING IMAGES

Following each shutter actuation the camera's default behaviour is to display the recently captured photograph on its LCD screen. The image appears for a limited time and it can be reactivated on most cameras by pressing the play back button (Fig 300).

Cameras have two modes of function: recording data or playing it back. Consequently, many buttons on the camera have two functions. These buttons perform differently depending on the mode to which the camera is set. For example, on the

DSLR illustrated in Fig 301 the button changes the auto-focus point while shooting. However, when the camera is set to playback mode, the same button provides the option to zoom into and navigate a file already stored on the card.

When viewing photographs some cameras are prone to activating their battery-saving modes too quickly. It can be very annoying if the LCD screen dims after just two seconds of displaying the captured frame. Most cameras provide an option to define the duration for which an image is displayed, and how long the camera must be inactive before the camera automatically shuts down. The ideal setting combines convenience of access to files while extending the battery life.

A good starting point when viewing images on the camera is to learn how to zoom into the detail of the image. This is an important skill because the LCD screen only displays a few hundred thousand pixels whereas the file itself is likely to contain many millions. Certain detail – whether a person has blinked, or whether the exact point of focus is on

◀ **Fig 299**
Reviewing images in camera allows fine detail of exposure and focus to be checked while shooting.

▲ Fig 302
Canon options for specifying
the length of time before
battery-saving mode
activates.

▲ Fig 303
The duration of the image
review.

▲ Fig 305
Contact sheet/image index view.

▲ Fig 304
Zooming in magnifies the view of the image, allowing close
inspection of an area.

◀ Fig 306
The trash can button erases
images in playback mode.

DELETING IMAGES IN CAMERA

the eyes or tip of the nose – can easily be missed.
Portrait and event photographers frequently zoom in
to check the faces of people contained within group
shots. A mistake when shooting can mean many
hours spent correcting photographs in post-produc-
tion. Zooming in and out is typically done using the
+ and - buttons (Fig 301); on compact cameras the
lens zoom switch often performs the same function.
Once zoomed in, a thumbnail of the whole image
can be displayed to assist with navigation (Fig 304).

In addition to magnifying a single frame cameras
also give the option of zooming back further to
provide a contact sheet view (also known as image
index view) (Fig 305).

The fastest way of deleting a single file is to press the
trash can button while in playback mode (Fig 306).
There are times when all of the images contained
on the card may need to be deleted at the same
time. So that all the images do not have to be deleted
individually, there is an option, usually found in the
playback menu, to erase everything stored on the
card. Another option is to format the memory card.

The options of formatting and erasing both
delete the files on the memory card but they actually
perform slightly different duties. When erasing is
chosen, the camera makes the files invisible but
writes a marker that advises any device reading the
card that the sectors are available to be rewritten. On
the other hand, formatting wipes all the data off the
card, making data recovery much harder. Formatting

▲ Figs 307 and 308
The file protect button on Nikon cameras and the protect menu found in Canons.

◄ Fig 309
Playback options menu, used to specify the information that is displayed with photographs on the camera's LCD screen.

the card is recommended when installing a new card or if a card is suffering any performance issues or file corruptions.

It is possible to protect files from accidental deletion, usually via a dedicated button on the camera or menu option (Figs 307 and 308). The protect function is useful when all of the images on the card need to be erased with the exception of a select few. Protecting the few can be much faster than deleting the rest of the individual files one by one.

ADVANCED VIEWING TO ACCESS FILE DATA

Following the activation of the shutter, the default behaviour is to display a full-screen preview of the resulting photograph. This preview is normally accompanied by the file name and some limited detail and is useful for judging framing and composition. Alternative views of the file can be easily accessed through the command dial or menu navigation buttons. These may include full-screen image, overview, RGB histogram and shooting data. The amount of detail displayed in playback mode can usually be configured in the camera's playback options menu (Fig 309).

Depending on the details specified in the playback menu, a range of information may be displayed (or accessed by scrolling through screens).

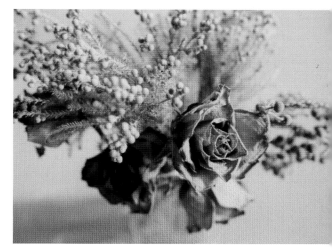

▲ Fig 310
Image-only view.

Image only

This mode provides a full-screen view of the photograph without the distraction of text. Some image-only modes also include the option of displaying which of the camera's AF points was used (Fig 310).

Overview

This mode is a hybrid of all other modes. It contains a thumbnail image of the pixel data combined with a composite histogram and the most important information about camera settings and data (Fig 311).

▶ Fig 311
Overview of shooting data.

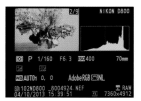

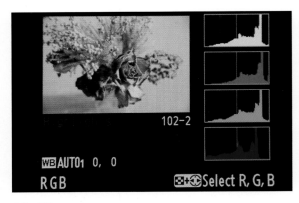

▲ Fig 312
RGB histogram view.

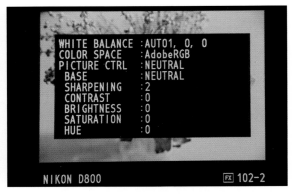

▲ Fig 313
Shooting data.

RGB histogram view

This view is helpful when assessing colour. (For more on RGB data and histograms, *see* Chapter 17.) This viewing mode gives the photographer the opportunity to assess the image data contained within individual colour channels (Fig 312).

Shooting data view

When a camera takes a photograph it records more than just the light that created the exposure. The other data recorded at the same time, and embedded within the file, include the make and model of camera, the lens, aperture setting, shutter speed, ISO, exposure mode, date, time, white balance setting, flash power, and exposure compensation settings. These are all saved and bundled up with the JPEG file. Shooting data view enables the photographer to access the information in camera (Fig 313).

Less common playback views

More unusual playback views, available on different cameras, include GPS overview screens (for cameras that feature geo tagging) and highlight clipping warnings (that feature blinking areas when highlights are overexposed). Rather than assess the histogram, many photographers choose to leave the highlight clipping warnings switched on as an exposure indicator. It is common practice to leave the camera in the default view and then scroll through other views when more detail is required.

ACCESSING METADATA

Metadata is the term given for data about data. In a photographic context this refers to the non-pictorial information that the camera embeds into the file. This key information includes date, time, flash setting, exposure mode, white balance settings, colour modes, AF mode, flash settings, JPEG compression levels, and so on. Metadata can be useful when understanding how an image was produced, but it is also helpful when the file travels beyond the camera. Post-production software such as Adobe Photoshop, Bridge and Lightroom uses metadata to manage, filter and enhance images.

PRIVACY, SECURITY AND COPYRIGHT SETTINGS

Metadata is useful but it does pose inherent risks to privacy and security. For example, if a GPS module is fitted to the camera (or a photograph is taken with a mobile phone camera), the file pinpoints the date, time and location with the serial number of the camera. When shared online it is possible for viewers of the photograph to access that information and, potentially, identify the author.

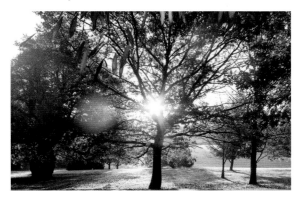

◀ **Fig 314**
Copyright settings. Once activated each file the camera produces has the photographer's copyright statement (and/or contact details embedded).

▲ **Figs 315 and 316**
Filter effects and retouch menus both manipulate file data in different ways.

In some instances, being identified as the author of a photograph is desirable; indeed, it is a right under copyright law. When images are shared, there can be a blurring between ethics and ownership. Photographers who wish to assert their ownership of their images can assign and embed a copyright statement within the metadata of each photograph the camera takes (Fig 314).

EDITING IMAGES IN CAMERA (THE RETOUCH MENU)

Most photographers use editing software to make basic image adjustments to their digital photographs. For those without computer access there is a range of retouch options available 'in camera'. These are somewhat clumsy when compared with the precision of software editing, with decisions affecting millions of pixels being made on a very small, non-calibrated screen. However, in comparison with no retouching at all, in-camera options do produce an improved result.

In-camera enhancement options typically fall into two categories: image corrections (removal of faults such as red-eye or colour casts) and image manipulations that apply filters or special effects to the image. Corrections vary by camera manufacturer, but common settings include colour balance, distortion control, straightening horizons and boosting shadows. Filters also vary, but common examples include skylight filtration, colour and tone warming, individual colour channel intensifiers and monochrome and sepia effects.

▲ **Fig 317**
As shot (yellow cast).

▲ **Fig 318**
Modified colour balance

Colour balance

There are situations in which the camera's white balance settings will be unable to mitigate a colour cast. In these instances colour balance retouching may be used to remove (or introduce) colour casts. In Fig 318 the image has received a boost in the cyan and magenta channels and a reduction in the yellow.

◀ Fig 319
Wide-angle lens distortion
has rendered straight lines as
curves.

◀ Fig 320
Distortion control straightens
curved lines.

Distortion control

All lenses have certain characteristics that can manifest visually as image distortion. The distortion control option offered by digital cameras is used to mitigate barrel (bloating in the centre of the frame) and pin-cushion (pinched effect) distortion. This effect is most noticeable on images that use wide-angle lenses to photograph subjects that contain straight lines (Fig 319).

▶ **Fig 321**
Horizon straightening applied
in camera.

Straighten horizon

For images that have been photographed from
an uneven stance the straighten horizon option
analyses the image and ensures that the horizon is
horizontal within the frame.

Shadow boosting

Many cameras include a mode for boosting the
brightness of the shadows independent to the rest
of the exposure. Nikon titles this function as Active
D-Lighting, while Canon calls it Auto Lighting
Optimizer (ALO). Both settings can be adjusted to lift
shadows and contrast to simulate a subtle fill flash
effect. This is a useful adjustment in high-contrast
shooting conditions, when the darker grey tones
may be rendered by the camera as black.

Digital filters can also be applied to the image
post capture. Nikon refer to these as 'Filter Effects',
while Canon call them 'Creative Filters'. Filters usu-
ally apply a colour adjustment to the entire image.

▲ **Fig 322**
Left-hand image as shot; right-hand image has had shadow
boosting applied. The effect is visible in the darker areas. Areas in
the shadows such as the textures inside the hut are brightened
independent of mid-tones and highlights.

▲ Fig 323
Skylight filter applied in camera reduces the appearance of haze.

EDITING MOVIES IN CAMERA

Most cameras include the facility to shoot movies. These can range from small, low-resolution clips to huge, uncompressed, high-definition footage. In-camera movie-editing software can be quick and useful for trimming clips and assigning basic edits. From a stills perspective, the movie-editing mode is useful because it enables the camera to export individual movie frames as static images. Although

Skylight Filter

This filter digitally removes the subtle blue haze that can appear from atmospheric diffraction caused by shooting distant landscape scenes. Note the lack of haze on the horizon in Fig 323.

Warming Filter

With this filter the camera applies a subtle orange tone to provide a warming hue to the photograph.

Colour intensifiers (R, G or B)

These filters boost the brightness and saturation of one of the individual colour channels (red, green or blue). Fig 325 illustrates the effect of intensifying the blue channel incrementally. The other colours remain unaffected.

Monochrome and sepia

This filter has a similar purpose to the monochrome picture style option (*see* page 157). Rather than shooting using a single channel of black and white tone, this option is a filter that removes colour information from a colour file afterwards.

Sepia is related to monochrome insofar as the colour is removed in the same way. A brown tint is added to the shadows to mimic the traditional darkroom process of sepia toning.

▲ Fig 324
Warming filter applied in camera.

▲ Fig 325
Colour intensifier filter (blue channel) applied in camera.

this is convenient, it is not a recommended method of producing photographs because exported frames do not have the exposure controls, range of size or the quality of photographs shot in still image modes.

▲ Fig 326
Monochrome conversion from colour original.

▲ Fig 327
A sepia filter applies a brown tone to the darker areas of the photograph.

SUMMARY

There are many options for the photographer in image playback and in-camera post-production and enhancement menus. Setting the camera to playback mode causes buttons and dials to take on different functions. Once images are saved to the memory card they can be viewed as individual images, as a collection of thumbnails, or full frame. They can then be zoomed into, enabling the photographer to check detail such as blinking eyes or focus. This access enables photographers to quickly assess captured images while shooting and make informed decisions on the fly for subsequent exposures.

Playback options also give access to file metadata, which provides information on camera settings and how, when and where the file was created. Metadata can be used to assess the image in camera and is read by software when photographs are transferred to a computer. Image metadata is potentially accessible by others, therefore both privacy and copyright settings may need to be specified or restricted.

Image manipulation menus are divided into 'corrections' and 'enhancements'. Corrections resolve inherent camera faults whereas enhancements introduce aesthetic improvements via filters. The camera's image-modification options are imprecise tools. A better alternative is to transfer images and make critical decisions regarding colour, cropping and exposure using fine increments on a calibrated computer monitor.

So it is easy to view, interact with and edit files, but what are the exact characteristics of the digital file, and what is the purpose of the histogram that appears in multiple playback modes?

Chapter 17

Understanding the Digital File

- An overview of camera file formats.
- Camera sensors.
- Camera resolution (image size).
- Image quality (compression).
- Bit depth.
- The histogram.
- Understanding RGB (red, green and blue).
- Colour spaces/profiles.
- Why does all this technical information matter?

Photographers can build upon their knowledge of the playback options by exploring the construction of the digital file and photographic technical standards (including file formats and colour spaces). The camera interface is able to make seemingly very technical and complex decisions accessible to everyone. For all photographers, a working knowledge of these settings can assist with shooting and post-production workflow.

in existence. The benefit of shooting JPEG is that the file can be read without any specialist software on almost any digital device capable of displaying pictures. The downside to JPEG is that it is a 'lossy' format. This means that the JPEG image is compressed, which means that not all sensor data captured during the exposure is recorded to the card. Compression rates range from imperceptible to obvious degradation with compression artefacts. The greater the amount of compression, the smaller the file size, which means that more JPEGs can be stored on a memory card when compared with other formats.

TIFF (Tagged Image File Format) is uncompressed and has traditionally been used as a printing format, due to the greater amount of data available when compared with JPEG.

The raw file is a relatively new file format that provides all of the sensor data without any camera interpretation. This format is of great importance to photographers (*see* Chapter 18).

AN OVERVIEW OF CAMERA FILE FORMATS

By default, digital cameras generate JPEG files, with an option to produce certain other types of file. The three main types of file found in modern cameras are JPEG, TIFF and raw.

The JPEG (Joint Photographic Experts Group) is the most prevalent imaging format currently

CAMERA SENSORS

The sensor is arguably the most important part of the digital camera; correspondingly, sensor technology is the fastest-developing aspect of camera development. The surface of the sensor is covered in millions of tiny cavities known as photosites. Each photosite reacts in response to light by measuring and communicating the intensity of the light (brightness) to the camera's processor as an electrical signal. When combined and interpreted, these millions of tiny brightness values make up the

◀ Fig 328
Digital images are mad up of millions of pixels, each pixel has values of red, green and blue that determine its colour.

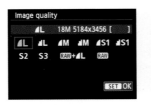

◀ Fig 329
Nikon D4 camera sensor.

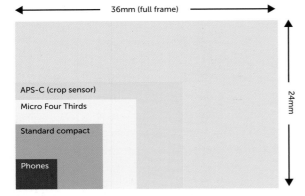

▲ Fig 330
A range of sensor sizes available in modern cameras.

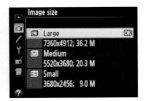

▲ Figs 331 and 332
Image size and image quality menus on both Canon and Nikon.

the names – Nikon's are 'DX' models while Canon's are APS-C. However, variation is reduced when full frame sensors are involved. The name refers to a camera sensor that is physically around the same size as a piece of 35mm film. Full frame sensors (also known as 'FX' on Nikon models) are found on higher-specification DSLRs.

The benefits of larger sensors (in addition to increased pixel resolution) include better dynamic range, better performance in low-light situations, improved noise handling and a greater potential for lenses, for example, in depth-of-field control (*see* Chapter 8). Lenses are designed with a particular sensor size in mind (*see* Chapter 4); if they are used on a camera with a different sensor size, focal length changes. For example, a 50mm FX lens would become a 75mm lens when used on a camera using a crop DX sensor. This is known as the 'crop factor'.

CAMERA RESOLUTION (IMAGE SIZE)

The camera sensor is capable of capturing a specific number of pixels. This number varies according to the camera's specification and may be expressed as either a megapixel number, such as 38MP (thirty-eight million pixels), or as a pixel dimension (horizontal × vertical axis), such as 7200 × 5400px. These are two different ways of saying the same thing. Cameras also offer the option to shoot at lower resolutions when required (Figs 331 and 332).

mosaic of dots that form the building blocks of the digital image; these are called pixels.

Early digital camera sensors were tiny and could reproduce only a very limited number of colours. As technology progressed, sensors increased in both quality and size, to the point at which the sizes of modern sensors (measured in megapixel values) have now begun to plateau. Indeed, Canon has actually reduced the pixel count in one of its latest ranges of compact cameras, favouring quality (the size of the individual photosites) over quantity (the number of photosites).

Sensors are defined in terms of their physical size (Fig 330) and the quantity of megapixels (one million pixels) that they generate in a single exposure. Currently, higher-specification compact cameras offer pixel harvests of around twenty megapixels, while mid-range and pro-level DSLRs can reach up to forty. DSLR camera sensors are usually larger and yield more pixels than the sensors found in compacts. DSLRs offer two physical sensor sizes: crop sensor and full frame. The exact dimensions of the crop sensor vary between manufacturers, as do

When set to a lower resolution than native the camera captures fewer pixels in each shot. This translates directly to the size of print that can be produced. For example, when printed at 300 dots per inch, the following guidelines apply:

Size in pixels	Print size
7360 × 4912	62.3cm × 41.6cm
5520 × 3680	46.7cm × 31.2cm
3680 × 2456	31.2 × 20.8cm

IMAGE QUALITY (COMPRESSION)

The number of pixels that comprise an image is one indicator of 'how large' the picture is (in respect of its physical size). A second indicator of size (often found in the same settings menu, or with a separate button) is image quality. Quality settings dictate how much compression is applied to the file. Compression reduces the file size without affecting the quantity of pixels, and is useful for storing more images on a small memory card. However, it significantly reduces the quality of the photograph.

Cameras generally offer quality options of fine, normal or basic; these options may alternatively be named low, medium or high, or represented by icons or star ratings. Canon cameras display image quality options as icons indicating smooth curve (fine) or blocky (basic) (Figs 334 and 335).

▶ Fig 333
Quality settings may also be accessed via buttons on the camera.

▲ Figs 334 and 335
Nikon image compression options and Canon quality icons.

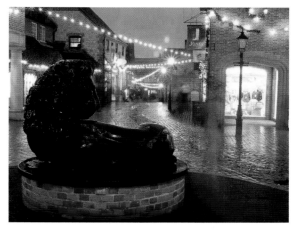

▲ Fig 336
Image compression introduces visual artefacts.

Image compression is based on ratios. Depending on the subject and compression algorithm used, 10:1 (reducing the file size by a factor of 10, so that, for example, a 10MB file becomes a 1MB file) is generally considered to be the maximum amount of compression that may be applied before degradation is visible. When this compression ratio is exceeded, the file begins to appear blocky, displaying increased noise, lack of contrast at edge detail and compression artefacts. At small sizes the effects of compression are less significant.

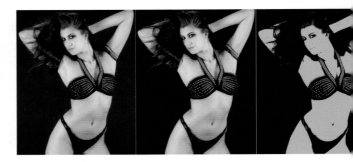

▲ Fig 338
The effect of bit depth: (left) 8-bit (16,777, 216 colours);
(middle) 4-bit (16 colours); (right) 1-bit (2 colours).

▲ Fig 337
Close-up comparison of quality settings (fine compression versus heavy compression).

The effect of compression is easier to see close up. Fig 337 illustrates the severity of image degradation and visible compression artefacts.

Compression ratios vary by manufacturer although typically the ratios applied by cameras are fine (1:4), normal (1:8) and basic (1:16). When considering which to use, best practice is to select fine. The other options are a throwback to when camera memory cards were capable of storing only a few images. Most photographers choose to shoot everything at the camera's highest possible size and quality settings, knowing that a copy of the image can be reduced in size and compressed later if required.

BIT DEPTH

The term 'bit depth' originates from computing terminology and refers to the total number of colours that can be present in the file. Digital cameras (and computers) use ones and zeros to store data. An individual one or zero is known as a 'bit'. The more bits, the greater amount of colour data that the file contains. An 8-bit file gives a range of 0–255 bits per colour channel (red, green and blue), providing a total of 16,777,216 tones.

The JPEG format limits the file to 8 bits per colour channel, while raw allows higher bit depths such as 12- or 14-bit. In theory, the higher the bit depth, the more colours the file contains. In practice, once the bit depth exceeds 12-bit, human vision is unable to differentiate between the additional colours. Reducing bit depth creates banding and posterization; this is most noticeable in subjects containing smooth gradients of colour.

THE HISTOGRAM

The histogram is one of the most underrated and misunderstood features included on digital cameras. At first glance, it can appear confusing, but it is simply a bar graph that displays the distribution and frequency of tone present within a photograph. The horizontal axis represents brightness (with black at the left edge and white at the right); the vertical axis denotes the quantity of pixels with a particular tone. The histogram (Fig 339) is a very useful indicator of exposure, tonality and contrast. Adelson's Illusion (*see* Chapter 2) demonstrates that human perception of brightness is easily fooled. The camera's LCD screen cannot be trusted, whereas the histogram is a mathematical representation of brightness.

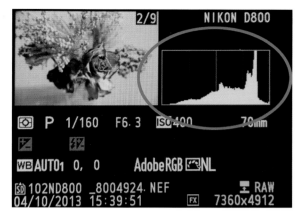

▲ Fig 339
The camera's histogram (circled).

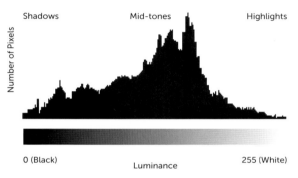

Shadows Mid-tones Highlights

Number of Pixels

0 (Black) Luminance 255 (White)

▲ Fig 340
The histogram is a graph showing the frequency and distribution of tone in a photograph.

JPEG files (8-bit) are comprised of 0–255 levels of brightness. These numerical shades are represented in the histogram. A pixel with a value of 0 is pure black, while a pixel with a value of 255 is white. Middle grey is the mid-point, at 127. Shadows have low numbers whereas highlights have high numbers (Fig 340).

The histogram acts as a guide, notifying the photographer where image data is placed upon the brightness scale. The same subject exposed differently generates different histograms (Fig 341).

Notice that the middle exposure clusters tone data in the centre of the exposure scale. The darker image features the tone shifted to the left edge, while in the overexposed image the data is clustered to

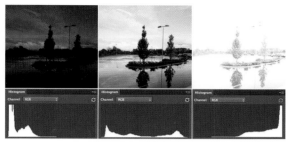

▲ Fig 341
The histogram changes depending on the exposure.

the right of the histogram. Without even seeing the image it is possible to see which of the photographs is brightest from glancing at the histogram. These graphs are not ambiguous; they are fixed to the 0–255 scale of the pixel brightness that represents the building blocks of the digital photograph. If a display cannot be trusted (for example, when a computer monitor has not been calibrated or an LCD screen is in sunlight), the histogram is an honest representation of the pixel data combined in the file. If an image looks a bit dark on screen but the histogram shows that it is properly exposed, the histogram should be believed – and the monitor may need recalibrating.

While it is helpful for identifying general exposure traits, the histogram is perhaps most useful when shooting subjects at the extremes of brightness levels. For example, in Figs 342 and 343, regardless of exposure, the subjects themselves do not feature a broad range of tone. A black cat photographed at night should naturally be a dark image. Therefore, when it is exposed with care, the histogram should contain most of the tonal distribution along the left-hand edge. The opposite would be the case for a sheep surrounded by snow. In automatic modes the camera will be unaware that these subjects are lighter or darker than normal and would seek to centralize the histogram data (resulting in over- or underexposure). Dialling in exposure compensation can shift the distribution of tone either right (+ values) or left (- values) (see Chapter 7).

▲ Fig 344
A high-contrast scene is shown by the histogram as having data in the shadows (left side), and highlights (right side), but no mid-tones (middle).

▲ Figs 342 and 343
The data shown in the histogram is a mathematical indicator of exposure.

▲ Fig 345
A subject with inherently high contrast ratio.

The histogram is also used to assess contrast. For example, if the black cat is surrounded by snow (Fig 344), the resulting scene contains extremes of both dark and light tones, with very little data in the mid-tone area. The histogram for the photograph reflects this by showing pixel information in the dark area (right) and the light area (white) but no information in the mid-tones.

The histogram is particularly useful for making fine judgements as to which areas of the subject appear as pure black or pure white. When data falls off either end of the histogram this is known as 'clipping'. In Fig 344, the overexposure has caused the highlights to be clipped (subtle light greys in the snow are lost to pure white). This is displayed as a spike on the right-hand edge; while this would have been difficult to spot at the time of shooting, the histogram alerts the photographer to the risk of clipped tones.

Histograms are useful as a guide rather than a rule. It can be helpful to think of the histogram as the representation of how the dynamic range captured by the sensor fits into the smaller JPEG container. In Fig 345 the intention was to increase subject contrast beyond the range of the camera's sensor, in order to produce a silhouette. Checking the histogram while shooting provided reassurance that the lighting intensity and exposure settings would result in pure white highlights with jet-black shadow tones.

The histogram deals with brightness (a composite of the three colour channels), but it can also be extended in most DSLR cameras to illustrate brightness values individually in the red, green and blue channels (*see* Fig 312). In order to read the coloured histogram in the camera's playback mode, it is necessary to have an appreciation of RGB.

UNDERSTANDING RGB (RED, GREEN AND BLUE)

The camera's sensor records colour by combining red, green and blue in varying proportions to create the colours in the visual spectrum (*see* Chapter 2). In the case of a digital camera recording 8-bit colour, each of the three colour channels records a separate histogram (between 0–255). Any pixel in the digital image has an RGB value that acts as a mathematical reference to its colour.

To understand what happens in the camera and relate it to the histogram it is helpful to consider the process of the photographic exposure. The sensor is exposed when the shutter opens. Wavelengths of light enter the camera through the lens and are focused upon the sensor where millions of photosites measure the intensity of the light. Each

◄ Fig 346
The Bayer pattern (named after Bryce Bayer, an engineer working for Kodak, who is credited with its invention).

photosite records intensity values between 0–255. If a photosite records no light at all, its value will be 0; if the photosite is oversaturated with light, it will record a value of 255. Values in between represent shades of grey. For black and white photography, this would suffice. For colour photography, the photosites are required to measure the colour of the light rather than just the amount. To achieve this, each photosite is equipped with a tiny filter so that it only records the intensity of light wavelengths that correspond to either red, green or blue. The arrangement of these colour-filtered photosites is important – they are distributed in the sequence of the Bayer pattern (Fig 346).

The Bayer pattern contains twice as many green photosites as red or blue. The human eye is more sensitive to green than to the other colours, so the extra green information is required to reproduce colours that match human vision. The camera's processor interprets the resulting data and uses the Bayer pattern information to produce a file of pixels. Each of these then incorporates both brightness and colour information in the correct order for the image to be built up by a computer. The image is then presented (be it the image on the playback screen on the camera or the computer screen once uploaded to a PC), representing what was captured. Each pixel has an RGB number that mathematically describes its colour and brightness value.

▲ Fig 347
Digital photographs are made up of individual pixels; each pixel has an RGB number. This red pixel sampled from the leaf is made up of R210, G32, and B52.

▲ Fig 348
A night image comprising red highlights, blue mid-tones and green shadows. Highlight clipping is circled on the histogram.

Fig 347 shows an enlarged section of a photograph revealing the mosaic of pixels that comprise a photograph, and the associated RGB numbers. The image shows red leaves against a grey wall. By zooming into the white square area the individual pixels can be viewed. The specific colour of the chosen pixel is shown as R210 G32 B52. As expected, the pixel has a greater concentration of red than of either green or blue. Every pixel in the image has an individual RGB number.

The camera's RGB histogram playback mode provides an opportunity to analyse the individual colour channel histograms. These may be used to identify a cast (an excess of data) in the shadows, mid-tone or highlights. It is also possible to assess whether highlights are truly clipped (it is possible that the luminance histogram shows the highlights to be clipped when there may still be detail in one of the colour channels). Fig 348 illustrates a photograph with red highlights, green shadows and blue mid-tones. The luminance histogram for this image (top) shows a small spike in the highlights. This small peak (circled in yellow) indicates that data have fallen

outside the camera's range of 0–255. Analysis of the RGB histogram shows that the overexposure is present only in the red channel (the brightest part of the model's skin tone). The red channel is generally brighter compared with the greens and blues that make up the mid-tones and shadows.

COLOUR SPACES/PROFILES

With a basic grasp of RGB numbers, the next step is to consider the camera's colour space options. The colour space defines the way that RGB values relate to the colours they represent on different devices. For example, a pixel with RGB values of R:255, G:0, B:0 would be a very vivid red. Without an embedded colour space working as a point of reference, the pixel would have a different intensity of red on a range of different devices (camera, phone, scanner, TV) and lack consistency on output devices such as printers.

▲ Fig 349
The colour wheel.

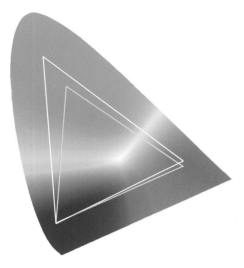

▲ Fig 350
Colour spaces: sRGB (yellow) and Adobe RGB (white).

Colour spaces represent the science of measuring colour physically and describing it mathematically; or, to put it another way, if RGB numbers are the players, then the colour space is the pitch. The two most common spaces available in camera menus are sRGB and Adobe RGB. There is mixed opinion among photographers as to which is the 'best' colour space to select. Theoretically, Adobe RGB offers a wider range of colours, although, in order to access the additional data the file needs to be colour-managed in post-production and then converted back to sRGB for most forms of output. If the file is not properly processed the colours will appear duller than if sRGB is used.

sRGB is the default colour space for cameras, web images, and most home and commercial printers. One advantage of sRGB is that images can be shared instantly, with a fuller range of more vibrant colours. Unless the photographer has an established workflow that involves colour management in post-production, sRGB will probably provide the best results. In order to understand what the colour space actually is, it is helpful to view it as a 2D model.

Colour is traditionally represented via the colour wheel (*see* Chapter 2) (Fig 349). A colour space is similarly represented, except, rather than being circular, the representation extends to the three corners of RGB to form a shape that defines its component parameters. Fig 350 displays a mathematically defined XYZ colour space detailing colours that may be perceived by human vision. (It is based upon a model originally created by the International Commission on Illumination.) Within the colour space, sRGB and Adobe RGB are labelled. Each space is capable of reproducing a slightly different range of colours.

WHY DOES ALL THIS TECHNICAL INFORMATION MATTER?

Some of these technical aspects can appear daunting and even irrelevant, especially as many photographers survive without any knowledge of them. However, it is important to have at least some

▲ Fig 351
Implied relationship between pixels and dpi. 4000 pixels, printed at 300dpi, makes a print of 13in wide; if printed at 150dpi the print could be 26in wide.

▲ Fig 352
CMYK is a colour space used by printers (marked in purple). It is capable of reproducing far fewer colours than either of the RGB colour spaces (*see* Fig 350).

understanding of the technicalities because this will result in better-quality photographs. Understanding the camera naturally leads to an understanding of the digital file it creates. This is especially true in respect of printing. Image size is a particularly important factor. Images on computer screens are typically displayed at around 72 pixels per inch (ppi), whereas most inkjet printers will be far less forgiving, using around 300 dots per inch (dpi). In the printing process, pixels captured by the camera need to be converted to dots (using a process called half-toning). A greater number of pixels provides more detail to print photographs at larger sizes or with finer quality.

Fig 351 uses a 12-megapixel file as an example; the file dimensions are 4000 × 3000 pixels. With 4000 'dots/pixels' on the horizontal length the 12-megapixel file can print at a maximum of 13in wide × 10in tall at 300dpi. If the photograph is cropped, the size reduces further. The image quality settings are of importance when printing, as

anything other than finest quality introduces compression artefacts to the file. The file could be printed at larger sizes by reducing the dpi, or upscaling the size using software, but both options degrade the quality of the file and resulting print.

In respect of colour, there is likely to be some variation between the bright vibrant photograph created by the camera and the image that exits the printer. This is because the camera uses RGB colour mode (mixing light), known as an additive colour space, whereas the printer uses CMYK (Cyan, Magenta, Yellow and Black), which is a subtractive colour space that mixes dyes. CMYK is device dependent, although as a colour space it has a much smaller range of colours than RGB. This means that the most vibrant and saturated colours cannot be printed. Prints can also appear duller than the version seen on the camera screen; this is because the printer contains no white ink so the brightest possible tone is the base luminance of the paper used.

SUMMARY

A deconstruction of the digital photograph generated by the camera and a basic understanding of the technicalities involved – the camera's sensor, the concept of photosites and the digital photograph as a mosaic of coloured pixels – are certainly relevant to most photographers. The size of the sensor (and the number of photosites) govern the camera's resolution. The size of the image is measured in megapixels while the size of the file is measured in megabytes.

File formats dictate how data from the sensor is processed and saved, and the decision to shoot JPEG, TIFF or raw is a compromise of convenience versus higher image quality. JPEG is the most common format in use, although it is a compressed format. Compression reduces image quality and introduces artefacts when compared with TIFF or raw. The image quality settings available in camera define the ratio of compression that is applied to the file. Bit depth is a measure of how many colours may be captured in a single shot.

The histogram is a tool for quickly reading the frequency and distribution of tone within the file, and may be used to assess tonality, contrast, clipping and colour. The RGB histogram allows the photographer to examine the brightness values of individual colour channels. This technical information is particularly important when printing (and in the conversion that takes place from RGB space to CMYK). For example, for the printed version of this book, the pictures were captured using a digital camera (RGB), but were printed using inks (CMYK). On an e-book, the pictures are displayed via a screen (RGB), making them more saturated and vibrant to the viewer's eye. An awareness of the limitations of colour space can inform the photographer's choice of colour settings and subsequent workflows in post-production. For those less concerned with manipulation and enhancement, sRGB is fine to 'set and forget'.

The discrepancy between what is seen on the camera screen and the finished print can be reduced by using an sRGB colour space. Additionally, using a calibrated monitor and soft-proofing pictures as CMYK will assist in pre-visualizing how colours will appear in the print. A final aid to print accuracy is the use of ICC (International Colour Consortium) profiles. The ICC defines colour standards and is designed to ensure that the colour in the image (as per the colour space) is translated to the closest possible option for the output device (based on the printer make, model, ink manufacturer and paper choice). ICC profiles are files that are easily downloadable from printer and paper manufacturers for inclusion in post-production software and printer drivers.

This technical information may be a little intimidating – this book is about understanding your camera, not about the processes that are involved in translating a captured image into an exhibition-quality print. Producing a large, accurate, high-quality print that reflects the full potential of a quality camera does indeed involve several processes. However, modern cameras have made great improvements in terms of accuracy and, for most photographers wishing to create a small print using the facilities in a camera shop or a store offering to print images, the sRGB JPEG straight from the camera/card may well prove perfectly acceptable.

Chapter 18

Understanding the Raw Format

- What is the raw format?
- Selecting raw in camera.
- Workflows compared (shooting both).
- Advantages and disadvantages of JPEG.
- Advantages and disadvantages of raw.
- Software considerations for raw.
- A workflow/scenario of why most professionals shoot raw.

D igital cameras offer the option to produce a range of different image file formats. One of the most misunderstood camera formats is raw. Common questions include what is the raw format and why should it be used, and why do raw pictures look flat and dull. The answers to these questions lie in the workflow. Raw photography is not appropriate for everyone: there are situations and scenarios in which raw could be the most appropriate shooting format, but for some photographers the drawbacks of the format outweigh the benefits. An understanding of the principles of shooting raw will help you decide whether or not to adopt the format in your work.

WHAT IS THE RAW FORMAT?

First, unlike JPEG and TIFF, the term 'raw' is not an acronym. Raw files are so-called because of the literal definition of the word – 'uncooked', or, in the context of digital photography, unprocessed. The requirement for 'processing' aligns neatly with the photographic legacy of film, which, once it had

◀ Fig 353
Some challenging scenes require use of the Raw format.

▲ Fig 354
Straight from the camera a raw file appears soft, dull and washed out.

▲ Fig 355
A JPEG photograph is sharper and generally more polished than a raw file, and will yield a far better print without any enhancement or manipulation.

been exposed to light, needed to be developed in a particular set of chemicals for precise amounts of time in order to become a negative. Variations in the chemistry, temperatures or duration would change the density, colour and tone of the negative. Once

it had been produced, the negative could be used to create a positive (print). This sequence of events is relevant to an understanding of the digital raw format. When shooting JPEG the camera exposes the sensor to light and then the camera 'develops' the file ready for printing. The difference when shooting raw files is that data recorded by the sensor is saved to the memory card without any camera processing (undeveloped). The raw file can be thought of as a frame of exposed film that is waiting to be developed.

To begin to demystify the raw format, it is helpful to define starting principles. If two cameras were placed side by side, with the first one set to shoot JPEG and the second recording a raw file, there would be a number of differences between the two resulting photographs (Figs 354 and 355). The most important point to observe from the exercise is that JPEG simply looks better. It has improved contrast and appears sharper, the colours are more vivid and the file benefits from a fuller tonal range, featuring deeper blacks and crisper whites. The JPEG is sharper and generally more polished in comparison with the flat, washed-out tones of the raw file. So, why shoot raw file when the result looks flat and dull? The answer lies in the 'potential' of the image data captured in the raw.

To explain this, it is useful to continue the analogy with analogue film. Just like a negative, the raw file contains far more information than can be produced in a print (or contained within a JPEG file). As a result, the raw file takes up much more memory space yet the photograph looks worse. To release the potential from the raw file the photographer must take charge of processing the sensor data. This involves making quality judgements by eye rather than allowing the camera's processor to develop the data itself.

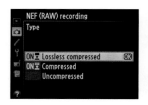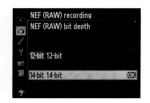

▲ **Figs 356 and 357**
Raw compression and bit-depth options.

SELECTING RAW IN CAMERA

The first step to shooting raw is to select the format in camera. Not all compact cameras offer raw as a capture format; for the majority of other cameras, format choice is usually located in the image quality/size menus (*see* Fig 334, page 173). When raw is selected, size cannot usually be specified (the full capacity of the sensor is used), although, depending on the model of camera, different levels of compression to the raw file may be offered. Fig 356 illustrates a typical menu. First, 'uncompressed' means that no compression is applied. Second, 'lossless compression' applies compression algorithms that can reduce the file size by around 40 per cent without affecting image quality. Third, selecting 'compressed raw' reduces the file size by up to 60 per cent (although the algorithms are not reversible). Manufacturers claim that compression effects are barely perceivable.

Raw files also give the photographer the choice whether to shoot in 12-bit or 14-bit (Fig 357). There are more colours contained within 14-bit files but the usefulness of this additional data will depend on the intended post-production workflow.

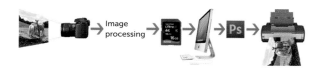

USING TWO MEMORY CARDS

Some DSLR cameras allow two memory cards to be installed. In this instance it is possible to instruct the camera to write the raw files to one card while saving the JPEGs on the other. This can be useful if the files need to be shared immediately and if the photographer wishes to retain the flexibility of the raw data.

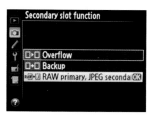

◀ Fig 358
Some cameras offer the option of storing raw and JPEG on separate memory cards.

▲ Fig 359
A JPEG workflow shows processing adjustments being made before the data is saved to the memory card.

WORKFLOWS COMPARED (SHOOTING BOTH)

Perhaps the clearest way of demonstrating the differences between JPEG and raw is by comparing the two different workflows of taking a photograph and making a print. Fig 359 illustrates the sequence of events that take place between photographer, camera, sensor, processor, memory card, computer and printer when shooting JPEG.

First, when the shutter is depressed the camera responds to the exposure settings and admits light to the sensor. The camera's processor then evaluates data collected by each photosite and 'interprets' it. A number of important decisions are made inside the camera, including exposure: although metering and exposure choices inform the amount of light physically entering the camera, the sensor has a greater dynamic range than the JPEG file so some information is discarded. The processor works out the mid-point based on the subject brightness and prioritizes the tone that it considers most likely to be

▲ Fig 360
Controlling the brightness of highlights and shadows gives a huge amount of control to photographers trying to balance delicate tones.

important. Highlights and shadows (black and white points) are also defined and fixed. These are among the most critical decisions made while creating the JPEG. The processor chooses where to place the black and white points (which can result in 'clipping', or loss of detail at either end of the histogram). In challenging scenes, such as Fig 360, the range of contrast makes it difficult for the camera to decide which areas of shadow or highlights require detail, and which do not.

▲ Fig 362
Curvilinear distortion (left), with rectilinear correction applied (right).

▲ Fig 361
Noise handling applied during JPEG processing seeks to blur the artefacts caused by noise while preserving edge and textural detail.

The data clipped are discarded and cannot be recovered. It is at this stage of processing that shadow-boosting effects (such as Nikon's active D-Lighting) may be applied and auto white balance settings (or preset) are imposed on the image data.

JPEG processing also balances the sharpness of the file against sensor noise. In Fig 361, a very high ISO speed (6400) was used, which resulted in significant image noise. JPEG processing attempts to keep the critical elements of the pixel data sharp by increasing contrast between what the camera believes are edges (which gives the illusion of sharpening), while slightly blurring the 'non-edges' to reduce the appearance of noise.

Lens aberrations are also tackled by the camera during the processing stage. Known issues, such as vignette (darkening in the corners) and curvilinear distortion (straight lines curving due to wide-angle and fisheye lenses), may be detected and corrected.

There are many other subtle processing decisions that take place in camera, such as contrast settings, defining colour saturation and vibrance

levels. Additionally, once the sensor data has been processed, picture style settings are applied to the captured data. Critically, it is only when these in-camera adjustments have been applied that the pixel data is crystallized into the RGB numbers. The processor then compresses the data (subject to the basic, normal or fine preference specified), to create a JPEG file. Once created, the file is saved to the camera's memory card with an embedded colour space and appropriate metadata.

The next stage of the JPEG workflow is to transfer the image on to a computer where an operating system reads the embedded colour space/profile to interpret and display the photograph in relation to the colour space of the monitor. The image may then be enhanced using image-editing software and then printed, or simply printed as it is. If properly managed the RGB file will be mapped to the ICC profile of the printer, media and ink.

A huge amount of processing has taken place inside the camera and, crucially, without significant influence from the photographer. The resulting print may look great, but the disadvantage of JPEG is that the photographer has very limited control over how the processing adjustments are applied.

The raw workflow is different (Fig 363), although it begins in the same way. When the shutter is depressed, the camera admits light. Once the light has entered the camera, its brightness values are recorded by the sensor. The next stage is where raw format deviates from JPEG.

Fig 363
A raw workflow allows
processing adjustments to
take place in software on
a computer rather than in
camera.

▲ Fig 364
Different types of raw files include DNG (Adobe Digital Negative),
NEF (Nikon), PEF (Pentax), CR2 (Canon), and FFF (Hasselblad).

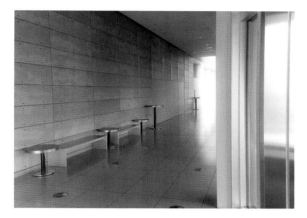

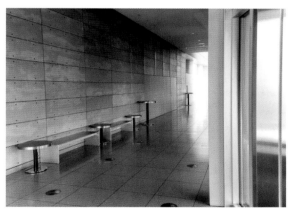

The processor does not make any changes to the sensor data or attempt to interpret it. The raw data, comprising of ones and zeros generated by the photosites, are simply saved to the card in an un-interpreted format. The adjustments described in the JPEG workflow are entirely absent from the raw file. The next stage is for the raw file is to be transferred to a computer, although, unlike a JPEG, the raw file cannot not be read or opened without specialist software. Without software, raw files appear as icons rather than thumbnails (Fig 364).

Once the raw file has been opened using the appropriate software, choices that were made in camera during the JPEG workflow can then be applied manually. Processing decisions are made by the photographer using precise tools and fine increments to obtain the absolute best possible outcome from the sensor data. In Fig 365 wide-angle lens distortion, colour temperature, exposure, highlight clipping, sharpening and low vibrance are important factors in the processing of the photograph. Rather than leave these decisions to chance, each variable is defined precisely, using software rather than in camera.

During processing software offers an option to 'enable lens profile correction'. This function downloads and applies a profile that automatically corrects for known imperfections of a specific lens.

▲ Figs 365 and 366
An unprocessed raw file (top), and a processed one (bottom).

The profile corrects distortion and edge darkening and may be finely adjusted. In Fig 366 the profile has been used to straighten the vertical lines and remove distortion while a small amount of lens vignetting has remained to draw the eye to the centre of the frame. White balance has been defined by identify-ing neutral aspects of the subject while care has been taken to differentiate between the light greys and whites (avoiding unwanted clipping).

Sharpening is another variable that is automatically assigned to images created as JPEGs but becomes available to the photographer when shooting raw. Even when the subject is in focus, inherent flaws in sensors and lenses blur the image slightly. Sharpening corrects viewer perception of this softness using an optical illusion. This process works by increasing contrast at edge details. Most modern cameras provide a reasonably good standard of sharpening in JPEG mode, but raw allows significant fine-tuning. There are a number of options to specify how sharpening is applied and to what extent (some may be found in camera, while others are applied in software):

- Amount: changes the amount of contrast applied to the edge.
- Radius: varies the width of the edge where contrast is increased.
- Detail: suppresses the halos that can appear with excessive sharpening.
- Masking: restricts the sharpening effect to the most pronounced edges.

Sharpening will not fix camera shake or camera blurs but on a correctly focused image it will significantly increase textures and emphasize detail. Caution should be exercised, as the over-application of sharpening can create halos around areas of detail. Best practice is to view the image at full size (100 per cent view), ensuring that one pixel created by the camera is represented by a pixel on a computer monitor, and adjust to taste. Fig 367 shows the result of sharpening on a close-up section.

Another major benefit that raw has over JPEG is that the processing decisions are 'non-destructive'. Decisions made by the photographer during processing are saved separately to the actual pixels. These choices exist as a tiny line of computer code that lives in the same folder as the raw file. This is known as a sidecar file and it has the same name as the raw file but with the suffix .xmp. When a

▲ Fig 367
(left) Raw file as shot (soft); (middle) acceptable sharpening; (right) over-sharpening in image processing. Sections are magnified from squared area for ease of demonstration.

▲ Fig 368
Raw file displayed in computer OS with dedicated .xmp file in the same folder.

computer opens a raw file, it checks the host folder for an .xmp file with the corresponding name. If a file is present the computer applies the instructions before displaying the file (Fig 368).

The benefit of non-destructive editing is that the pixel data is never altered. All of the original sensor data remains intact, however much manipulation takes place. Once processing decisions have been made, the file can be read by image-editing software (such as Photoshop), or exported as a readable format such as TIFF or JPEG ready for printing.

ADVANTAGES AND DISADVANTAGES OF JPEG

The advantages of JPEG are numerous; it is a tried and tested format and has long been established as the most popular and portable image format. Camera processing uses algorithms that have been refined over many generations of cameras. Modern cameras create great images that can be viewed and printed without the need for image editing, and can be displayed on a variety of devices and platforms without the need for any specialist software. JPEG is also fast and convenient, used by photographers working in the media, shooting sports and other events, and by journalists in the field. The file can be emailed, uploaded, Tweeted, posted to Facebook or shared in many other ways within a few seconds of the shutter firing.

The disadvantages of the JPEG format stem from file compression and lack of control in the processing stage. JPEG disregards sensor data during processing and subsequently each time the file is resaved, as saving algorithms recompress the file and remove further detail. For photographers who require the finest quality, JPEG is a less desirable format.

ADVANTAGES AND DISADVANTAGES OF RAW

The main advantage of the raw file is the potential that lies in the sensor data; the disadvantages are the time, skill and effort required to extract that potential. When shooting raw, it is possible to work on the histogram data to rescue burnt-out highlights, or find subtle detail within the shadows. Depending on the software used it is possible to work with sensor data like fluid, placing it and stretching it on

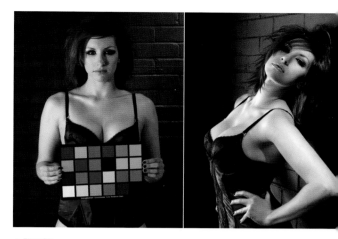

▲ Fig 369
A colour checker chart can be used to ensure colour accuracy and to inform decision-making during raw processing.

the histogram where it is needed. The mid-tones can be changed without affecting the highlights or shadows, and the level of control is immense. Think of the sensor data and histogram as the budget, and the processing decisions as the way of spending it. The more data captured at the time of shooting, the greater the possibilities for processing the image.

Raw also enables WB values to be assigned very specifically. Neutral areas can be identified at pixel level (using the process described in Chapter 15). The rest of the scene will be compensated by the same colour shift. For scenes where white does not need to be fully 'corrected', this flexibility enables the photographer to apply subtle hints of colour in precise increments of Kelvin. Although this can also be achieved with JPEG, when applied to the raw file the process is non-destructive (in other words, it does not alter the original sensor data). This flexibility can be used to precise effect, for photographers requiring the best colour accuracy, such as fashion photographers and those reproducing art works or archiving. Professional colour charts such as the Gretag Mcbeth Colour Checker card (used in Fig 369) have known RGB values and are designed to be consistent under various light sources. The coloured swatches have spectral reflectance values that match

▲ Fig 370
Batch processing using
Adobe Lightroom.

▲ Fig 371
There are situations when
curvilinear distortion is
desirable to maintain a sense
of perspective.

those of human skin, flora, and so on. Once the sensor data is processed and the RGB values are aligned to the reference card, processing choices can be applied to all images shot under the same lighting conditions.

Using the colour checker chart as a point of colour reference, software can remove casts from the known colour values in the chart. These settings can then be applied easily to other photographs taken at the same time. This is known as batch

processing, and means that, while the first raw file may take a few minutes to process, many more can be processed with a single click (assuming lighting conditions do not change). Fig 370 illustrates the Adobe Lightroom interface. Raw processing does not have to be complicated or time-consuming; it can be as simple as copy/paste.

Lens issues may also be resolved while raw processing. In some circumstances it may be desirable to include some distortion (particularly as

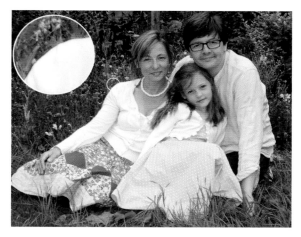

▲ Fig 372
Chromatic aberration (purple fringing on highlights – magnified in the circled area) is easily removed in raw processing.

ADOBE DNG FILE

Acknowledging the need for a proprietary raw format, Adobe created a generic lossless raw format known as DNG (Digital Negative) in 2007. The DNG file acts as a standardized file structure – it can be thought of as an 'envelope' that stores the manufacturer's proprietary files. Although it has not yet been adopted by the International Standards Association, DNG is gaining ground in the market. Some camera manufacturers (including Leica, Pentax, Casio, Ricoh, Hasselblad and Samsung) provide the option to shoot DNG as a native capture format within their cameras.

DNG has an additional benefit: the 'envelope' contains the sidecar .xmp data rather than saving it as a separate file. This keeps the processing choices in the same place as the pixel data, making it much simpler to keep track when files are moved around.

For cameras not equipped with DNG as a native capture format, camera files can easily be converted to DNG, through either a free tool on the Adobe website (adobe. com/downloads.html) or as an option when importing to Adobe Lightroom.

the correction process crops detail at the edge of the frame). In Fig 371 a wide-angle lens was used to photograph a bride and groom within the confined space of a car. Partial rectilinear correction maintains a sense of the space and avoids distorting the occupants.

Chromatic aberrations are also easily resolved. As light travels though glass or water, the different wavelengths (colours) travel at different speeds (*see* Chapter 4). Similarly, when the path of light is bent through the lens and is not sufficiently corrected by the lens designer, coloured fringing appears where the wavelengths separate. This is most obvious at areas of high contrast, such as telephone wires against a bright sky. In Fig 372, a white top in front of a darker background has resulted in a purple fringe. When shooting raw, these faults are simply resolved.

There are clear benefits to shooting raw, in terms of quality, lack of compression and processing flexibility. A further advantage is that a raw file can be modified in numerous ways without taking up further disk space. For example, a 25MB JPEG saved as a cropped version, a black and white version, and a retouched version would create three separate files (totalling approximately 45MB). Numerous versions of the same raw photograph can be created without

taking up additional space, because the choices applied to the copies do not exist as pixels. Instead, editing decisions are saved as tiny snippets of computer code (.xmp files).

Disadvantages of raw are associated with the cumbersome nature of the file and the time and effort involve in processing. The awkwardness of the format originates from the lack of standardization. Raw files are relatively new (established in 2004), whereas JPEGs have been used since 1992. As yet, camera manufacturers have not defined a proprietary raw format; for example, Nikon use .NEF, while

Canon CR2 and Hasselblad use .FFF. To add to the confusion, manufacturers are continually developing their own raw formats, so that a raw file from a modern camera may not open in a raw file reader by the same manufacturer from several years ago.

Another potential drawback of raw is the lack of archival support. For example, as raw continues to evolve, it is unclear whether camera manufacturers will include support for older camera files in newer software. The likelihood is that they will not, and photographers will be faced with a challenge similar to finding a printer driver for a 1995 printer compatible with a computer operating system fifty years from now. Even today, compatibility is limited; until it has been processed, the raw file cannot easily be shared online.

▲ Fig 373
Wedding dance photographed in low light using flash. The JPEG processing in camera has clipped both highlights and shadow detail.

SOFTWARE CONSIDERATIONS FOR RAW

Cameras usually ship with a bespoke application for processing their raw files. These are usually free and may give some enhanced functionality for the particular model of camera. Disadvantages of bespoke applications are that they are limited in terms of updates and functionality. They can also be unsuitable for photographers who use more than one make of camera.

Another option is to use Adobe Photoshop (which includes a raw processor plug-in called Adobe Camera Raw). This plug-in provides an interface to process and convert raw data into a format with which the computer (and Photoshop) can work.

A more robust and sustainable option is to use a raw file manager such as Adobe Lightroom or Apple Aperture. These programs both process raw files and manage image archives by managing the ingestion, storage and processing of all image files. A raw file manager makes the whole raw workflow considerably easier. Both software packages provide

seamless integration with Adobe Photoshop for more advanced image manipulation once the raw file has been processed.

A WORKFLOW/SCENARIO OF WHY MOST PROFESSIONALS SHOOT RAW

To some photographers, the raw format may appear to be just an extra layer of inconvenience between activating the shutter and viewing the print. However, when the requirement is to extract every last drop of performance from the camera, raw is the format of choice. The following scenario is intended to illustrate the thought process of the photographer shooting and processing raw. For ease of comparison, the photograph was captured in both JPEG and raw simultaneously (using a professional-specification DSLR).

The scene is challenging. It is the first dance at a wedding (Fig 373). The conditions are reasonably dark and the subjects are moving. Some exposure balancing is required and the desired exposure is

▶ **Fig 374**
Processing the raw file using Adobe Camera Raw.

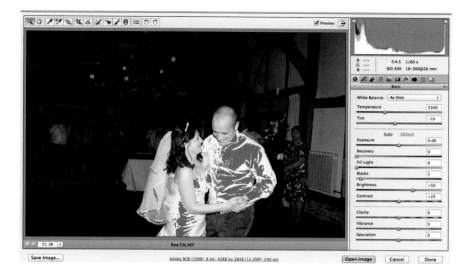

ISO 200, with a shutter speed of 1/60th and aperture of ƒ4.5. The shutter speed was chosen to be fast enough to avoid subject movement but slow enough to allow some of the ambient light to expose in the background. Available light was insufficient so the flash had to be fired as a supplementary light source. Ideally, the flash would have been bounced off the ceiling or a nearby wall, but this was not possible due to the location. To soften the light, a flash diffuser was fitted and the output of the flash was increased by one stop to compensate.

The resulting image data spreads to the extremes of light and dark tone. On the left side of the histogram the shadow areas were compressed to black; on the right edge of the histogram the highlights of the bride's dress and groom's waistcoat were hit by the bright flash. Shot as a JPEG, even with careful balancing of the exposure triangle, the contrast was too great to allow both shadow and highlight detail to manifest. In-camera processing clipped off shadow details and highlights when creating the JPEG. As a result the dark greys have been brought down to black, while the delicate and subtle highlight details (most noticeable in the texture of clothing) have been lost to white. Additionally, the camera

has not coped well with the colour of the mixed light sources. The file suffers from a range of other flaws including lens aberrations, excess contrast, and softness in the finer detail (referred to photographically as clarity). This file could be manipulated using an image editor, but the process would be destructive to the pixel data and no amount of manipulation would be able to rescue the highlight and shadow details lost during JPEG processing.

The camera captured a second version at the same time as a raw file. The processing adjustments that were previously made by the camera become informed choices made by the photographer. Fig 374 shows the raw file being processed in Adobe Camera Raw (ACR). The red and blue areas are 'clipping warnings'. These act as a preview to illustrate the areas of pixel data where brightness exceeds 255 (pure white) or 0 (black). The red areas show the highlight detail being lost to white, while blue illustrates shadow areas that become pure black. By moving sliders, the image data captured by the sensor can be recovered from beyond the boundaries of the histogram and pulled back in to the finished photograph.

▲ **Figs 375 and 376**
Recovery of highlight detail in the skin and waistcoat was possible
using the increased data contained within the raw file (right).

This procedure is particularly critical for the high-lights. The subtle textures in the groom's waistcoat were lost during the JPEG processing. Using the raw data, the exact point at which light grey becomes white can be defined manually. The red clipping warning makes it simple to see which of the lightest greys are lost to white rather than having to judge by eye. By using the highlight recovery slider the detail captured in the brightest tones can be pulled back into the gamut so that the texture of the waistcoat is included (Fig 375).

The processed raw file has far greater detail in the highlights of the clothing and the shadow areas in the background have been rendered at a brighter level to show the audience to the dance. Once processed, a copy of the raw file can easily be saved as a JPEG file (if required) for sharing and printing.

This example shows why, in some conditions, when total control of the image data is required, raw is the format of choice. When compared side by side with the JPEG, the benefit of manually processing the raw file is clear (Figs 376 and 377).

▲ Fig 377
The processed raw file, with corrected white balance and recovered highlights and shadows.

SUMMARY

Raw is a significant advancement from JPEG, and a far greater leap forward than merely swapping file format. The possibilities offered by raw mean that a fundamental change is required in the way that the photographer approaches light, exposure, workflow and photography in general. The format itself does not improve pictures – indeed, unprocessed raw files look terrible when compared with JPEGs – but the increased latitude of data that raw provides can change photography and its possibilities at every stage.

Through explanation and example it has been possible to assign some value to shooting raw. There are a number of types of raw file as well as a variety of camera-based image options, such as compression and bit depth, which influence quality and file size.

Some photographers choose to shoot only raw; others never find reason to leave the convenience of the JPEG. An understanding of the general principles of the format should allow you to make an informed choice as to the suitability of the raw format for your own subjects and workflow. Photographers who enjoy the post-production process and require the highest-quality image will find raw to be an ideal format. Photographers who shoot thousands of images under different lighting conditions and require a fast turnaround are less likely to choose raw.

Chapter 19

Closing Thoughts

The aim of this book has been to encourage you first to consider and reflect upon your own personal tastes within photography, before leading you on a journey into the functions and settings required to control the camera creatively. The intention has been gradually to transfer authorship of the photograph from the camera back to the photographer. You may have begun reading with the personal objective of switching your camera out of automatic mode. Hopefully, having now read the book, it is clearer that the decision to shoot in either automatic or manual modes should be an informed choice. In some instances, automatic mode is the most convenient and expedient way of creating a picture. At other times, control over some or all of the exposure parameters must be exercised in order to create the desired aesthetic (Fig 378).

With an understanding of the concept of exposure – the exposure triangle and its relationship with the camera's exposure modes (Automatic, Program, Aperture Priority, Shutter Priority and Manual) – any scene can be approached and recorded in many different ways. With the addition of flash, the exposure possibilities are wide-ranging. Knowing how to control the camera manually (and when it is appropriate to do so) is a powerful enabler to becoming a more confident and capable photographer.

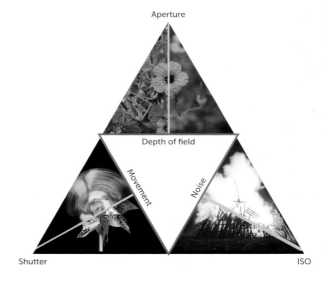

▲ Fig 379
The exposure triangle illustrating how modifying the parameters affects the resulting image.

◀ Fig 378
Understanding the camera unlocks a greater range of creative image making potential.

Today, camera settings and menus that relate to some of the technical aspects of digital photography, such as file construction, colour handling and file formats, open up the technology to all photo-graphers. In-built enhancement and manipulation options add to the possibilities, although it must not be forgotten that post-production is most effective when completed on a large, calibrated computer monitor.

However the photograph is captured and managed, obtaining optimal data directly from the camera should be the first step in any effective photographic workflow. Once recorded, data can be manipulated to create and reinterpret a photograph in infinite ways. (One example is Fig 8, which was shot in portrait orientation originally before being flipped and mirrored to create a symmetrical image.)

Some photographers may elect to expose in automatic modes, others manual. Some photographers favour the raw format, while others use JPEG. Whichever options are selected, the photographer should be equipped to make an informed choice to achieve the desired image. This is critical, because photography is not just about producing pictures, it is a visual language, and it is through learning and understanding the camera that the photographer's communication skills, vocabulary and fluency as an artist develop.

Glossary

aberration optical imperfections introduced by lenses.

acceptable focus detail considered sharp to the eye.

AdobeRGB colour space option available in most cameras.

ambient light light that exists in a given scene (unmodified by any photographic lighting such as flash).

angle of view width of the scene that the camera can see through the lens. A long lens (telephoto) zooms in on a subject and has a narrow angle of view compared with wide angle.

aperture the hole inside the lens through which light travels to hit the sensor. The aperture is adjustable, the photographer can make the hole larger by selecting a high f-number or smaller by choosing a low f-number.

aperture priority exposure mode that may be marked as A, or AV on the camera. When activated the photographer specifies the desired aperture value and the camera works out the appropriate shutter speed based on lighting conditions.

aspect ratio relationship between the horizontal and vertical lengths of a sensor or print. Most frequently used in relation to print sizes and expressed as the relationship between the width and height (e.g. 10×8in or 7×5in).

autofocus (AF) the cameras autofocus system.

Auto White Balance (AWB) the camera estimates the temperature of ambient light and compensates by adjusting colour values to maintain neutral tones.

backlighting a strong light source located behind the subject facing the lens.

bokeh relates to the way that a lens renders the area of the photograph that is out of focus due to falling beyond the depth of field.

bounce flash directing flash output on to ceilings or walls with the intention of diffusing the reflected light.

bracketing taking multiple photographs of the same scene at different settings.

bulb setting when set, the camera shutter stays open for as long as the shutter release remains depressed.

blown highlights describes the effect when the lightest tones in a photograph become pure white (and cease to contain any detail).

camera shake blur or softness of image caused by camera moving during the exposure.

catch light the term given for the reflection of a light source in the subjects' eyes.

centre weighted metering mode where increased priority is given to subjects located in the centre of the viewfinder.

colour space mathematical model used by cameras and computers to describe the appearance of colours. Cameras typically offer sRGB or Adobe RGB. A colour space describes colour information to devices such as computers, monitors and printers.

Compact Flash type of memory card used in digital cameras.

compression process to reduce the file size of a photograph.

compression artefact visible manifestation of excessive image compression (groups of pixels appear blocky as information is removed from the picture).

close-up term used when a subject is tightly framed and in close proximity to the lens (not to be confused with macro photography).

composition the arrangement of the key elements within a scene.

crop factor the amount focal length changes when a full frame lens is used on a camera with a crop sensor (typically this is ×1.5 meaning that a 50mm lens becomes a 75mm lens).

crop sensor camera image sensor that is smaller than a traditional 35mm negative frame.

Cyan, Magenta, Yellow and blacK (CMYK) colour model used in printing.

dedicated flash flash unit designed to function with a specific camera. Dedicated flash communicates information such as exposure settings, metering, focal length, sync-speed while also informing the camera's exposure calculations.

depth of field distance between the nearest and farthest subjects that appear in acceptable focus.

diffusion process of softening light. Photographic diffusion works by scattering particles of light by passing them through semi-opaque materials or bouncing light from walls or ceilings.

dioptre dial attached to the viewfinder, adjusts the view to suit the optical prescription of the photographer.

Digital Single-Lens-Reflex (DSLR) camera popular type of camera that allows the use of interchangeable lenses.

digital zoom used in cameras without zoom lenses or when the longest extreme of the lens zoom has been reached. Digital zoom is not a true zoom (see optical zoom); it works by enlarging the pixels captured by the sensor. This process gives the appearance of zooming in, but degrades the quality of the image.

Digital Negative File (.DNG) a raw file format developed by Adobe.

dots per inch (DPI) measure of resolution for the printed image.

dynamic range breadth of dark and light contained within an image. See HDR (High Dynamic Range).

EVF the electronic viewfinder.

Exchangeable Image File Format (EXIF data) information contained within digital photographs such as date created, file name, orientation, compression type, resolution, lens used, exposure settings etc.

exposure term given to allowing light from a scene to fall on the sensor (or alternative light sensitive material).

exposure compensation short cut to increasing or decreasing the camera's chosen exposure.

exposure triangle diagram that demonstrates the relationship between aperture, shutter and ISO.

fill flash similar to fill light, except the source of the light is from flash.

fill light supplementary light source used to fill shadows.

filters pieces of glass that may be placed in front of the lens for various purpose and effect. See neutral density, polarising filter and UV filter.

FireWire common type of computer connection used for connecting devices and hard drives (also known as IEEE1394).

fisheye lens with an extremely wide angle of view that produces strong image distortion.

flash a brief burst of artificial light used to illuminate a scene or fill shadows.

flare effect of unwanted light entering the lens resulting in loss of contrast and visible artefacts.

ƒ-number number that corresponds to the size of the hole through which light travels inside the lens (aperture). A common sequence of numbers is ƒ1.4, ƒ2, ƒ2.8, ƒ4, ƒ5.6, ƒ8, ƒ11 and ƒ16. Each setting lets in either double or half of its neighbour. Smaller numbers relate to larger holes.

focal length unit of measurement (in mm) that refers to the lens's zoom setting. Higher numbers result in greater magnification.

focus the point at which the lens focuses light. An item 'in focus' is sharp, whereas blurred or soft detail is out of focus.

front element the glass at the front of the lens.

full frame sensor camera sensor that is roughly equivalent in size to a piece of 35mm film.

gamut the range of colours that can be reproduced by a given device (such as colour space in use by camera, computer or printer).

golden section theory used by artists to create a visually pleasing composition. Informs the photographic rule of thirds.

greyscale image produced by the camera (or colour image converted in software) that comprises 256 shades of grey.

High-Definition Media Interface (HDMI) modern AV interface that can transfer and play uncompressed HD video. May be also used to connect digital cameras to HD televisions.

High Dynamic Range (HDR) process of bracketing exposures and overlaying them to gain the greatest range of detail from the shadows and highlights (see dynamic range).

histogram digital representation of tone contained within a photograph. Appears as a bar graph in playback mode in most cameras.

hot shoe mounting point on top of the camera used to attach a flash or other accessories.

hunting describes situations when the cameras autofocus cannot achieve focus and the lens scrolls in and out of its full focus range 'hunting' for focus.

image stabilization technology used to compensate for camera shake (also known as vibration reduction).

ISO Speed sensitivity of film (or the sensor of a digital camera) as determined by the International Standards Organization.

Joint Photographic Experts Group (JPEG) common image file format.

Kelvin unit of measurement used to define white balance.

lens hole through which light travels in to the camera. Commonly a glass optical device that converges light and focuses it upon the sensor.

lens hood attachment used to shield the front of the lens from stray light to avoid flare.

lens speed term that describes the maximum aperture of the lens. A fast lens has a smaller ƒ-number such as ƒ1.4, ƒ2 or ƒ2.8.

light modifier accessory used to change the quality of light emitted from a flash or other light source.

lossless compression compression technique where the algorithms used to compress the file size are reversible. Lossless compression does not degrade image quality.

lossy compression compression technique used in JPEG where the algorithms compress the file and remove data at the expense of image quality.

macro lens lens capable of focussing very close up to the subject and photographing very small subjects. True macro has the ability to represent a subject at its actual size (1:1), or larger on the camera's imaging sensor.

matrix metering (also known as multi-zone metering) metering mode where the camera uses scene recognition and processing algorithms to define an ideal exposure for a given scene.

megapixel one million pixels.

metadata Information about the photograph. Includes EXIF data, though can metadata can also hold additional custom information about the file such as subject or keywords.

memory card term given to the storage media used by cameras. Popular types include Secure Digital and Compact Flash cards.

mirror lock up option that reduces the internal vibrations caused by the movement of the mirror in a DSLR camera.

monochrome black and white.

neutral density filter filter fitted to the front element of a lens that reduces the amount of light coming in to the camera. Useful for using longer shutter speeds in light conditions.

noise digital graining effect most visible in low light images and long exposures.

optical zoom the process of zooming a lens by physically moving the internal lens elements to achieve an increased focal length.

overexposure occurs when too much light enters the camera. Subtle overexposure results in blown highlights, more severe overexposure can result in a completely white image.

panning moving the camera horizontally to follow a moving subject.

photomontage collection of images brought together to make one.

pixel building block of the digital image. The smallest square tile in the mosaic of the digital image.

pixels per inch (PPI) measure of resolution of a digital image.

polarizing filter filter fitted to the front element of the lens that prevents reflected light entering the camera while also intensifying the saturation of colours.

pop up flash the camera's built in flash.

prime lens lens with a fixed focal length (not a zoom).

program mode exposure mode where the camera meters light before selecting a combination of the aperture and shutter speed. Program mode allows the photographer to modify the settings using program shift, and to change variables such as white balance, flash control and exposure compensation that are not available in automatic mode.

program shift option to change the camera's chosen exposure combination with another that admits the same amount of light, but in a different way (only available in program mode).

raw file the unprocessed (raw) data from the camera's sensor.

reflector tool or surface used to reflect light on to a subject.

resolution the number of pixels (or printed dots) that make up an image and how closely they are positioned together.

Red, Green and Blue (RGB) the primary colours of light, and the combination of colours used by digital devices to display colours.

ring flash circular-shaped flash unit that emits light from the circumference of the lens, resulting in a directionless and shadow-less light source.

rule of thirds compositional theory used by photographers that divides the viewfinder into nine equal sections. Key detail is placed on the points where the lines intersect.

saturation intensity of colour, greater saturation results in deeper and vivid colours.

SD card type of memory card (Secure Digital).

sepia brown reddish tones used in photography to resemble the aesthetic of an aged monochrome image.

shutter mechanism inside the camera that controls the duration that light may reach the sensor.

shutter lag brief time delay between pressing the shutter release and the photograph being taken.

shutter priority exposure mode that may be marked as S, or TV on the camera. When activated the photographer specifies the desired shutter speed and the camera works out the aperture based on lighting conditions.

slave second flash unit that fires automatically when it detects light emitted from the first.

spot metering metering mode where the camera bases all exposure decisions on very small area of the viewfinder.

sRGB colour space option available in most cameras.

stop unit of exposure, most frequently used in relation to aperture settings. See f-number.

telephoto lens lens that makes the subject appear larger than a standard lens.

TIFF (Tagged Image File Format) an uncompressed file format.

TTL (through the lens) a standard form of exposure metering where the camera bases decisions upon light reflected from the subject/ scene entering through the cameras lens.

tungsten light orange light source provided by electric bulbs (not flash or fluorescent tubes).

underexposure occurs when too little light enters the camera. Subtle underexposure results in crushed shadows where detail is lost, more severe underexposure can result in a completely black image.

USB (Universal Serial Bus) common computer interface for connecting cameras and peripherals.

UV filter circular piece of glass that screws into the front of the lens to protect the front element. The filter also filters out ultra violet light (which reduces haze).

vibration reduction see image stabilization.

viewfinder the window or device through which the photographer may view, compose and focus the camera upon the subject.

vignetting a darkening of the image towards the periphery of the frame.

wide-angle lens lens with a wider angle of view than a standard lens.

white balance colour temperature (how warm or cool the image is), measured in Kelvin.

XMP file file that contains processing decisions relating to a raw file.

zoom lens lens with a variable focal length, e.g. 28–80mm. See prime lens.

Index